Sut.

Painting the Human Figure

Ideas and perception

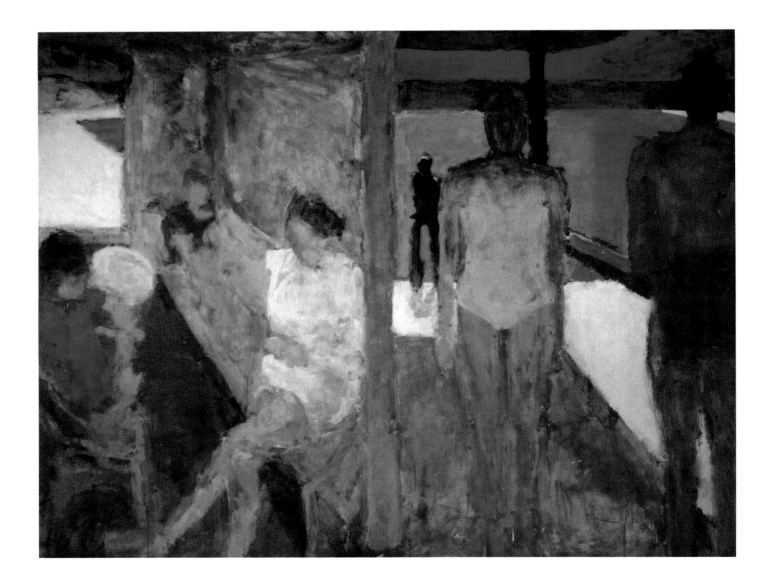

Painting the Human Figure

Ideas and perception

Atul Vohora

THE CROWOOD PRESS

First published in 2012 by
The Crowood Press Ltd
Ramsbury, Marlborough
Wiltshire SN8 2HR

www.crowood.com

British Library Cataloguing-in-Publication Data
A catalogue record for this book is available from the British Library.

ISBN 978 1 84797 357 3

Front cover: Patrick George, *At Arms Length, Susan* (detail)
Back cover: Trevor Felcey, *Claire* (above) and Atul Vohora, *After Bonnard*
Frontispiece: Sargy Mann, *Infinity Pool II*

Typeset by Sharon Dainton, Isis Design, Stroud
Printed and bound in Singapore by Craft Print International.

CONTENTS

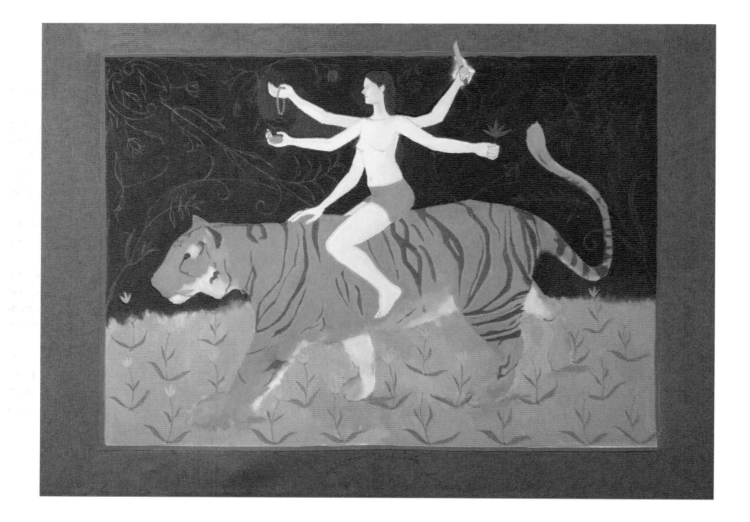

PREFACE

As a painter, the act of looking becomes a gateway into a state where the separation between self and the world is occasionally opened. These strict demarcations are momentarily unfixed. Marking a surface carries a visual and emotional charge that relates directly to this possibility.

Writing about painting is, in part, an opportunity to celebrate the idea of making images and a recognition of something of its necessity, both personally and in a wider sense. The process of making paintings involves a specific kind of looking. At its centre is the idea of constructing visual relationships in a physical material. Looking at and thinking about paintings closely and critically can be a way of informing the process of making. In a very real sense, paintings come from other paintings.

The book examines aspects of perception and ideas about form and visual language. It follows this with an exploration of the interrelationship between form and meaning, with regard to narrative. It makes no claim to be comprehensive and simply seeks to highlight something of the range and possibility inherent in painting. The book refers to many specific examples of paintings, relating ideas in pictures to each other. All the images in the book include, in some form, the human figure. This is not an art historical survey, and the paintings are not discussed in strict chronology.

Many of the illustrations are transcriptions and drawings from paintings. The idea of making a transcription of a painting involves looking in a sustained way at the picture and an attempt to understand the underlying visual construction of the image. Re-imagining paintings in this way makes the relationship between looking and making explicit.

Any reproduction of a painting inevitably carries distortions. The colour is most often affected, although there are also unavoidable implications for the scale of the image.

Painting is a mental, physical and emotional process; the physical material is the substance of the image. There is no real substitute for looking at actual paintings and, while a reproduction can be a useful aid when describing elements of a picture, inevitably it is limited.

It is a privilege to have the opportunity to evaluate and articulate ideas about painting and about individual paintings. Most of these are paintings, which have over time and continue, in the present, to sustain my own work and suggest fresh avenues of exploration.

LEFT: Atul Vohora, Tyger.

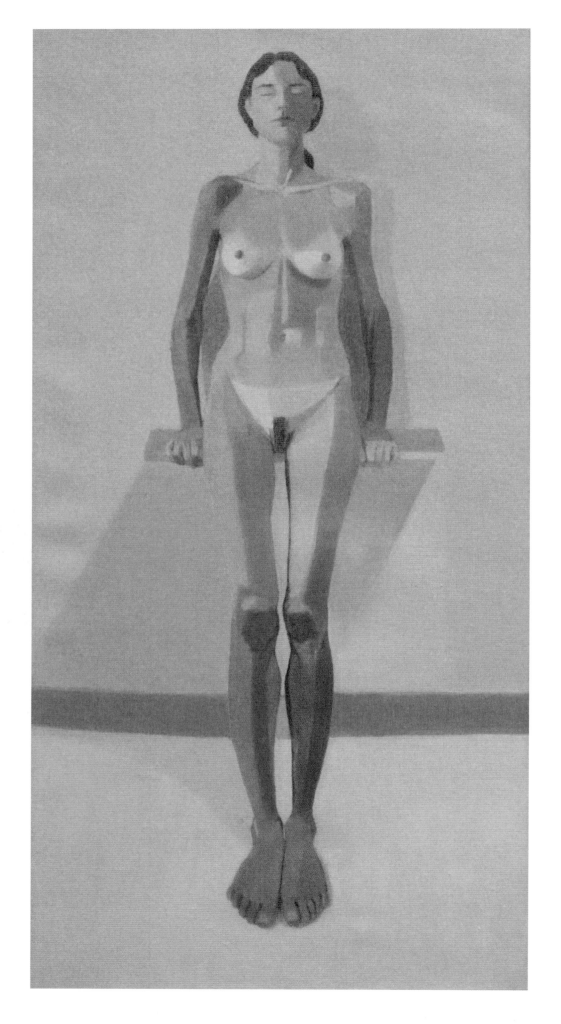

COLOUR

Painting as a form of expression can embody deep truths of human existence. The ability and need to create images has existed largely unchanged for over 30,000 years, in a way that cannot be said of written language. The immediacy of images at sites such as Lascaux can be surprising. While a large body of thought and a certain amount of speculation seeks to locate a specific social or cultural function for these images, no Rosetta stone is needed to translate the hand formed shape of a bison, emerging from fissures in the rock surface. The charged intensity and searing emotion of each line resonates internally, as though to collapse any idea of time, proclaiming a presence. A transformative act of imagination turns mark to line and finally into form.

Painting as an intuitive and experiential activity involves looking. The idea of looking is not a purely optical passive state, it is closer to the sense of seeing or perceiving, as an active function of mind and emotion, and carries at its root the idea of grasping, taking hold of or seeking to understand.

Looking at a painting can be in many ways similar to the act of making painting, in that both require an awareness and sensitivity to difference and similarity as well as an ability to look critically and selectively at an image. The slow disclosure, which is at the heart of looking at a painting, demands a sustained engagement, a persistent act of attention through which the richness of the image becomes apparent.

As an inherently still form, the relationship that paintings have to time is complex. Rhythmical shape making suggests a sense of movement and possible journeys through the image. In the form of marks, touches accumulate across the surface of the

Atul Vohora, *Nu Jambe Droite Levée*, after Pierre Bonnard, 1924. A range of contrasts create light in this intimate painting.

picture. In this sense, the idea of touch forms the basis of an archaeological history of the painting. Layers of paint overlap as

LEFT: *Vertical Curve*, Gregory Ward. The model's body is a constant distance from the eye of the artist. She is painted as though parallel to the picture surface.

Sargy Mann, *Infinity Pool II*. Looking out into searing sunlight.

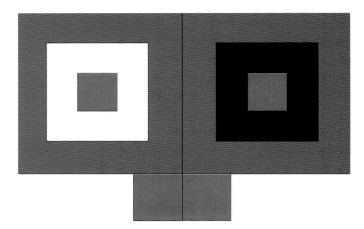

When compared, the identical red squares are dramatically altered by the surrounding white and black bands.

the image begins to emerge.

Seeing depends on the physiology of the eye. The brain receives information from the eye and actively organizes the stream of information being received. There is a determination to understand what is being seen, to find pattern. The brain is active in a cognitive, motor and emotional sense as it starts to order the shape and colours of the visual field presented.

There is however, something rather like alchemy at work in the apparent transformation of coloured mud into gold. Any attempt to analyse painting might advisedly tread lightly to seek to preserve the inherent mystery of this metamorphosis, in the same way that a ruthless dissection of a frog can have a lasting and detrimental effect on the wellbeing of the frog.

In beginning to explore aspects of visual experience, context is quickly revealed as the defining idea. In relation to colour, all perceptions are governed by their relationship to another colour.

A single colour cannot be seen entirely in isolation. It is in the interaction between two or more colours that the identity of each is revealed. Changing any one of the elements of this inter-action transforms each of the others in turn and the nature of the whole.

Seeing colour is an unstable experience, identity is not a fixed attribute, as a combination of the actions of brain and eye means that perceptions of colour are mutable and subject to influence. Equally, the quality of light falling on any surface can have a radical effect on the colour seen. Crucially the pigment

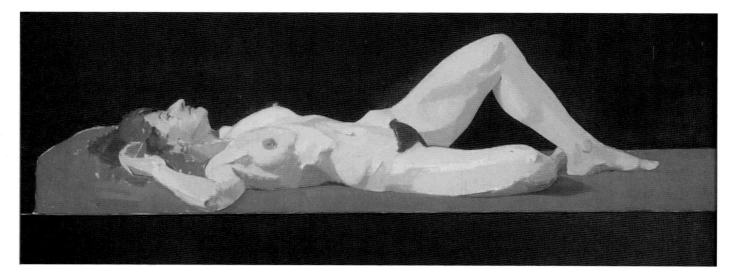

Mary Red Against the Black, Gregory Ward. Lying on the red surface, the lower section of the painting is in front of the model, the upper section of black is behind her.

used does not change; the perception of its nature is altered. Light can vary in colour itself; in an urban environment, orange streetlights can reduce our receptivity to other colours.

The intensity of light will determine to a degree the sensation of a given colour surface. In very low light the eye is more sensitive to variations in light and dark – colour is harder to perceive.

Distance is also an important factor in determining a given colour. Increasing the distance of a surface from the eye diminishes the ability to distinguish difference, as there are more particles of air scattering blue light between the eye and the object, so far hills appear as a pale blue.

There is a long history and evolution of attempts to theorize and define colour systems and codify relations between each note. These include Goethe, Newton, Chevreul and more recently Albers, Rood and Munsell, clear accounts of which are given elsewhere in particular John Gage's *Colour and Culture*, 1993 (Thames and Hudson). Models of colour relationships generate three-dimensional idea-scapes, which map and integrate scales of tone and so on, notably Munsell, who generated a colour system where every colour can be identified by a numerical notation and reproduced, particularly useful for industrial processes that require precise colour matching.

This chapter relates perceptual experiences to ideas in painting.

Light and Dark

Human experience is deeply tied to a dramatic visual contrast between light and dark, the contrast of night and day, of look-

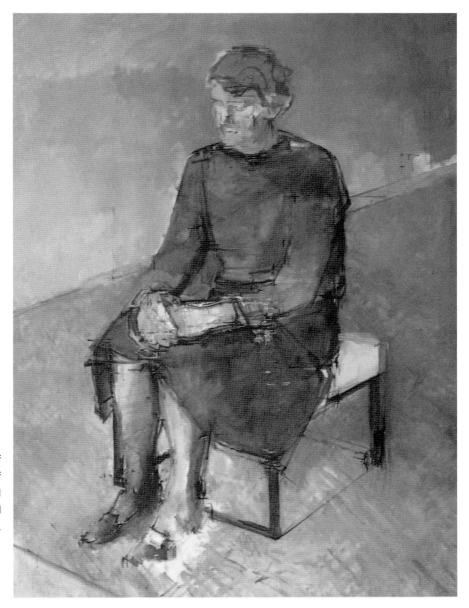

Patrick George, *Anne Crosby*. The contrast of the black skirt and white stool is a point of departure for the intelligent and lyrical continuous search manifest in the fluid redrawing throughout the painting.

ing out through the mouth of a dark cave into brilliant daylight. The same contrast is found too, in fire as the only source of light after sunset, throwing sudden, elusive shapes across rock, incomplete silhouettes picked out in the shifting darkness. Linked to life, to shelter, to food and warmth, the contrast between extremes of light and dark are also related to wonder and mystery, in the poetry of planets and stars, set against a night sky as yet unlit by distant cities, without competition from passing aeroplanes and satellites, a place inhabited by imagination, resonant, inviting stories.

It becomes possible, then, to consider a finger rubbed with ash from the previous night's fire, or perhaps the burnt end of a wooden stump, as it marks pale rock, transforming the face of the stone, carrying with it a charge that mirrors in potency and expressive potential, the sudden clarity of a flame in darkness. As a disruption, the mark is energized and extreme, inviting further additions. Mark grows to line. Line, sinuous, moving, turns and closes on itself making shape. Crude shapes merge, expand, grow, abundant with possibility. Somewhere there is a glimpse, half remembered, almost recognized, of an image seemingly held, unformed, in the rock: 'When I waked, I cried to dream again.' The hand, now guided by a strange intuition, begins a process of searching, touching, uncovering through mark.

In most paintings, it is possible to locate and identify a range of values that correspond with an experience of a scale between light and dark. A tonal scale can be expressed in a series of squares that define equal and significant separations between each step. While both an absolute white and an absolute black do exist, in practice, the limits of the scale are the lightest available white and the darkest available black.

Between the extremes of pure black and pure white lies a world of nuance and transition. Bold contrasts give way to shifts between close values. The expressive range defined by hard and vertiginous drops from light to dark opens to an achromatic melodic possibility. Dramatic modelling in high tonal oppositions becomes a much shallower relief, abrupt staccato transformed to Leonardo's infinite gradations.

It is possible to perceive a much greater number of steps between black and white than are useful in meaningfully describing the idea. In the scale above there are eleven. Immediately the idea of interaction arises; placing squares adjacent to each other has a consequence. Each subsequent value is affected by its neighbour in the scale.

Placing a small opaque white square in the centre of a larger black square and comparing this interaction with the inverse, a black square on the larger white, reveals a perceived spatial action. The small white square appears to lift above the black, whereas the small black square reads almost as a hole in the white.

Equally apparent is a tendency for the white to appear to expand; even though the two smaller squares are of equal size,

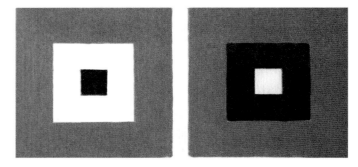

The white square at the centre seems larger than the adjacent black square in these identical diagrams. The white appears to advance above the black, while the black reads as though behind the white border. Finally, the small square on the right appears brighter than the white band on the left.

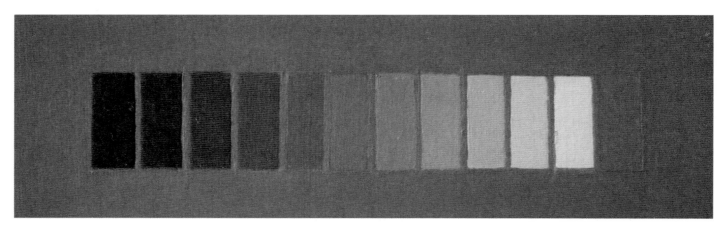

In this tonal scale eleven intervals mark the transition from white to black. The carbon black pigment has a slightly blue tinge.

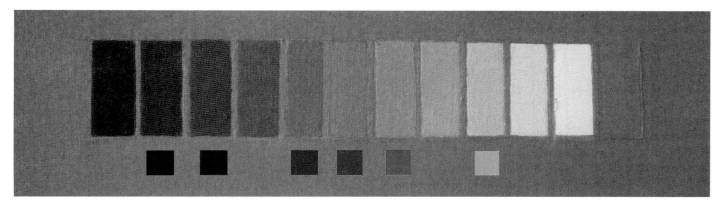

Colours aligned against a tonal scale.

the black square appears to be smaller. The two comparisons are placed within a middle grey field to isolate the interactions. A large difference in value, a strong contrast, allows a clear edge to form. Reducing the difference in value between the two tones makes the perception of an edge less distinct.

All colours can be seen in relation to a tonal scale. Pure pigments can be placed adjacent to a particular value in the scale. It is worth noting that this experience is not quite the same as taking a black and white photograph as inevitably the receptivity of the camera to light and the nature of the printing process are not directly comparable to the sensitivity of the human eye. Also the eye perceives interactions of colour, as demonstrated above, which are not reproduced in quite the same way through photography.

THE HUNTERS IN THE SNOW, PIETER BREUGHEL THE ELDER, 1565

Snow sits heavily over the landscape as three figures return from their hunt carrying little meat, followed by their dogs. People skating and at play on ponds below give scale to the marvellous journey through the space from the top of the near hill down past the ponds, through the village along the river, turning to the far shore. Craggy mountains rise to the top right of the picture, similar in shape to the gabled rooftops below.

Suddenly the darting silhouette of a bird flashes, fully outstretched against the distant horizon, emphasising the immensity and stillness of the valley. A line of trees forms a series of vertical intervals across the surface of the painting, diminishing as they progress down into the valley, crisp, deep notes burnt against the pale hill. They cast no shadow, the snow reflecting and scattering light, eliminating shadow. The branches of the trees rise into the clear sky, each branch finely etched with a layer of snow.

The branches form dark triangles, which trap crystalline fragments of blue, and answer the jagged peaks to the right. The steep rooftops of the near houses form a diagonal with the crest of the falling hill, across the bottom left of the canvas. The verticals of the trees set against the receding horizontals running across the landscape back to the high horizon suggests something of the organization of late Mondrian, red, yellow and blue grey set into the lattice. The columns and arch of the bridge echo the three trunks surrounding the hunters.

PORTRAIT OF MARGARETHA DE GEER, REMBRANDT HARMENSZOON VAN RIJN, C1661

The portrait is an unflinching engagement with the subject. At 78, Margaretha De Geer is painted looking steadily back, holding the painter's gaze with an alert frankness and scrutiny. Rembrandt paints with an uncompromising rigour and yet the image is filled with an abundance of compassion and respect. Her head, set above the brilliance of the broad collar and her hands, bright against the deep gown and darkness of the room, become the focus of the painting. Her left hand leads, pushing forward into the space, commanding the front of the picture. The scale of the left hand seems large in relation to that of the right hand and head. The difference in scale, in part, defines the distance between them.

Light enters from the top left of the painting, flooding the expanse of her wide ruff collar, which radiates with a clear luminosity. The profile casts a shadow over the left shoulder, revealing the projection of the chin and nose on the surface of the collar. The gleaming collar is reflected in the pronounced turn of the cheekbone. The strong light on the head, collar and hands are sharply contrasted against the rich velvet of her gown and the darkened space beyond.

The head has an almost centrifugal density, holding the cen-

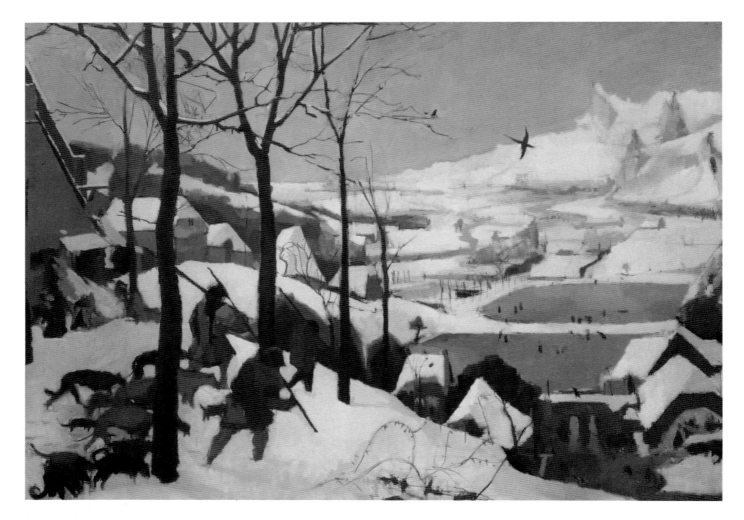

Michael Dowling, *The Hunters in the Snow*, after Pieter Breughel the Elder, 1565. The dark trees etched into the brilliant white landscape invert the expected contrast of light and dark.

tre of the painting, while sustaining and energizing the entire surface. The form is wrought in paint; each brush mark defines and constructs a sense of physicality and presence. The head is absolutely understood as occupying a position in the volume of surrounding space. It is possible to imagine walking behind the chair she sits on, that the head is fully formed with a back, even

if it remains unseen. The material is transformed, paint becomes skin, pulled taut over bone, as though each touch of the brush is in fact touching flesh, finding the hard ridge of the brow, the unwavering line of the jaw, turning from the bridge of the nose to find the deep hollow of the eye socket.

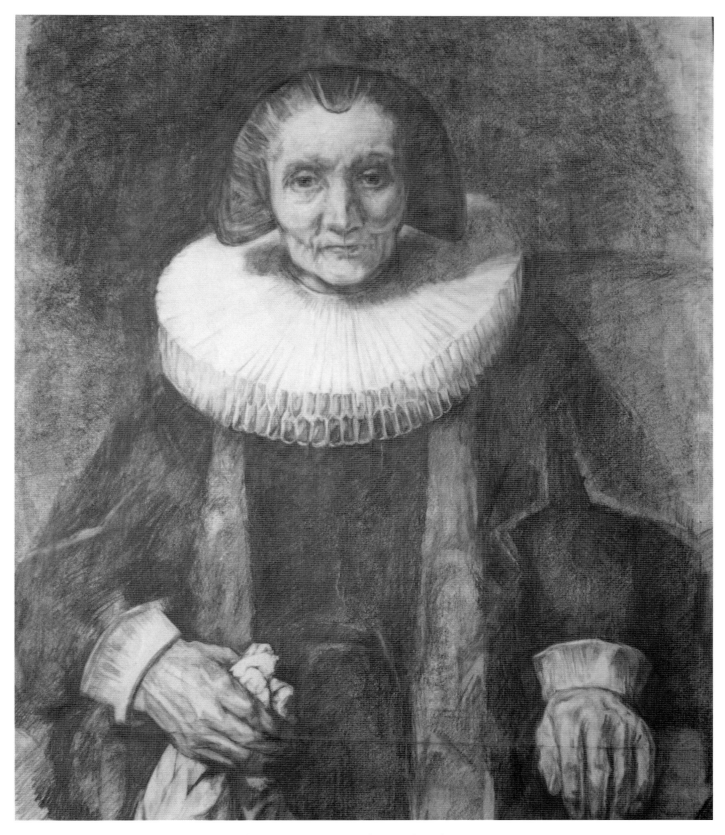

Harriet Piercy, *Portrait of Margaretha de Geer*, after Rembrandt Harmenszoon van Rijn, c 1661.
The unshakeable gaze: the penetrating drawing extends onto a second sheet.

Contrasts of Hue

In attempting to define a colour verbally, the inadequacy of any description becomes apparent very quickly. The word Blue carries as many associations as there may be people trying to imagine the colour intended. Even increasingly elaborate descriptions can only allow for partial clarity.

When presented with a picture of the intended blue, the colour of the page surrounding the 'blue' has the ability to interact with and radically alter the colour perceived. Also, it remains practically impossible to establish if each individual has the same experience of blue. Care must be taken when using words to describe visual events. Words almost certainly cannot be a substitute for ideas communicated in a primarily visual way.

Returning to the scale of values or tones between black and white, it is possible to arrange pure pigment against the scale, to establish a relationship between the tonal scale and each pigment. This suggests that at their purest, all pigments will not necessarily have the same tonal value. Yellow tends to appear near the light end of the scale while blue occupies a position near the black end of the scale.

Visual Remainder

Two colours placed alongside each other tend to polarize and oppose, in effect heightening the perceived difference between the two. This phenomenon, called simultaneous contrast, is at its most visible between colours that appear most dissimilar. In most conditions, on protracted exposure to a single field of saturated colour, the human eye reacts in a very particular way. A patch of colour becomes visible that corresponds to the initial colour although directly opposed in hue. The strange hovering patch, called the visual remainder, can be used to build a series of pairings that illustrates the idea of opposite or complement for each particular colour.

When arranged as diametric oppositions around a circle, the pairs form a familiar and useful conceptual map of hues, which broadly corresponds to the distribution of colour in a spectrum. Two colours opposite each other on the circle form what is called a complementary relationship between hues.

Placing of complementary colours in close proximity produces a form of contrast of high expressive potential.

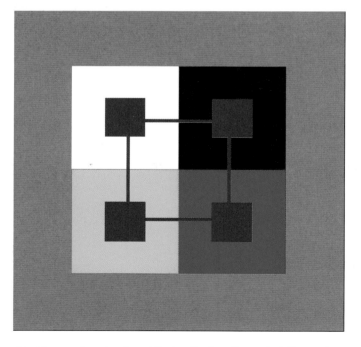

Four types of contrast and their effect on the red at the centre.

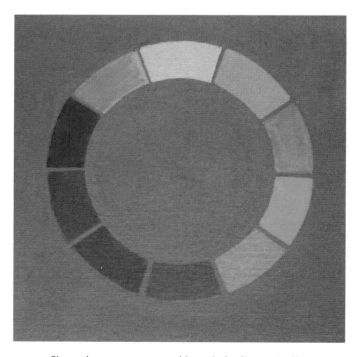

Five colours are arranged in a circle diametrically opposite their corresponding visual remainder.

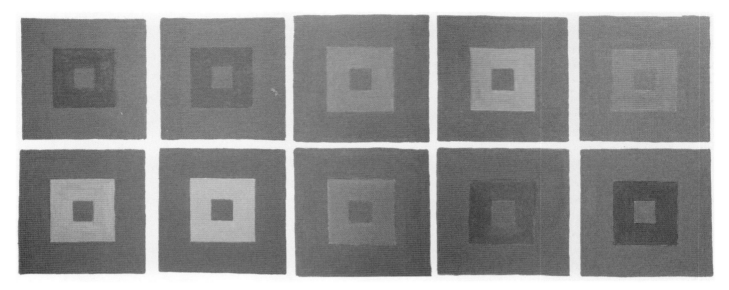

If one of a pair of squares is covered and the eye is fixed on the coloured band at the centre, an after image appears after a minute or so. This is the complementary colour.

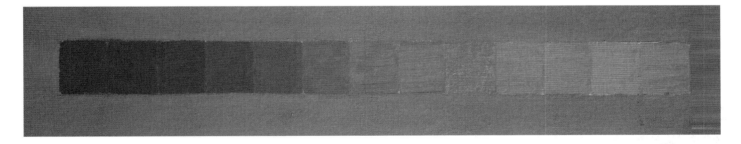

Colour saturation, moving along the axis between red and blue-green, through neutral.

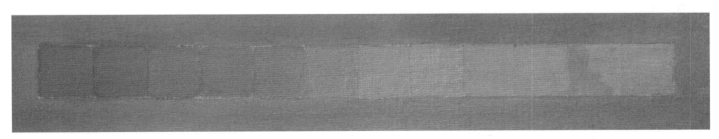

Colour saturation, running from yellow-orange to blue. The tinting strength of the yellow-orange is significantly higher than that of the blue at this tone, so the scale extends asymmetrically.

Colour Saturation

The quality of saturation describes the richness or intensity of a colour. The amount of grey present in a colour determines its relative saturation. A complete absence of grey in a colour means the colour is fully saturated. As colour begins to diminish and approach grey, it can be described as de-saturated. This kind of transition does not involve a change in the perceived tone.

Any colour can be transformed in this way by the incremental addition of small quantities of the complementary colour. Adding two complementary pigments to each other has the effect of neutralizing the colour of each. As any combination of pigments involves adding particles together, the resulting mixture often appears darker than the original so small amounts of white may need to be added to mitigate this effect.

The idea of saturation is closely related to an experience of luminosity. When colours of varied relative intensity are placed close to each other, the juxtaposition can amplify the perceived intensity and luminosity of the first colour. Perceptually, the two colours will tend to polarize each other, the greyer colour seems even less coloured, while the richer colour is heightened. In this way, luminosity can be created atonally. It is not the contrast between light and dark, but the contrast of relative saturation that makes light or pictorial space in the painting.

If the process is combined with a contrast of complementary colours, the contrast appears magnified and is seemingly less jarring than a purely complementary contrast.

Colour Key

The distribution of colours in a painting can be organized in terms of an axial opposition that relates to the circle defined above. This takes the form of a pairing, a combination of complementary colours that produces a tension and balance across the surface of the rectangle. The tension arises from an expectation that sustained looking at any colour induces, for necessary relief or the complementary colour. In this sense, a pairing of complementary colours forms a kind of harmony, the absence of either in the pair results in an agitation or disquiet. In any given contrast of this sort, each member of the pair can be itself divided, so the idea of a colour key often extends to a dialogue between broader colour pairings.

PORTRAIT OF THE DOGE, LEONARDO LOREDAN, GIOVANNI BELLINI, 1501

This is a formal portrait of the Doge at the beginning of his elected rule of the Republic of Venice. A symbolic head of State, the robes he wears reflect his role as visible embodiment of Venet-

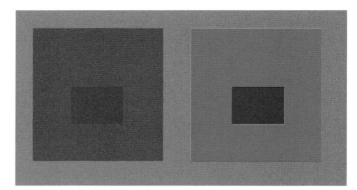

Contrast of saturation means that the red appears brighter against the grey-blue.

ian democracy and prosperity. Strict sumptuosity laws governed a hierarchy of the materials permissible in contemporary dress; the rich brocade of the mantle and cap are marks of his position.

A field of resonant, clear blue surrounds the head and shoulders of the Doge. Light passes across the head from left to right revealing the highly structured form of the skull. The hard ridge of the nose beaking between cavernous eye sockets and the thin mouth lend a sense of severity, which belies the delicacy of the mantle and cap.

Against the luminous glow of the right cheek, Bellini darkens the blue, accentuating the contrast. This relationship inverts, against the darker cheek, the blue is lighter; as a result, it becomes possible to read a considerable distance between the head and the blue.

The hat band, skin, run of buttons on the tunic and horizontal bar across the bottom of the picture are all closely related as types of orange ranging from the yellow in the hat band to the reddest at the bottom. This array of warm colours forms a close harmony, in the variety of red oranges. They create a second harmony in the contrast with the blue.

Colourscape

The three types of contrast outlined above can be integrated into a single model that attempts to describe possible relationships in a three-dimensional form as a colour solid. Moving

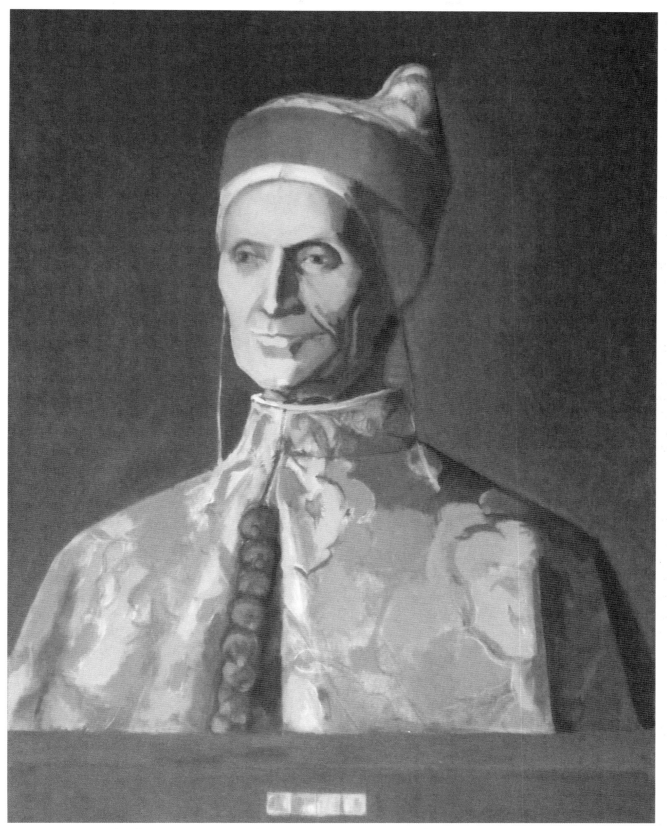

Gabriella Marchini, *Portrait of the Doge, Leonardo Loredan*, after Giovanni Bellini, 1501.
The Doge radiates calm authority. The key is red-orange to blue.

through the internal space of this solid allows for progressions from light to dark, between hues and between degrees of saturation.

The tonal scale describes the central vertical scale, with pure white and pure black as the extremes of top and bottom. The hues are arranged in a spectral sequence, circling around the vertical core with each hue aligned with a position on the tonal scale.

The horizontal distance of a colour from the centre indicates the relative intensity or saturation of the particular colour, with grey or neutral at the centre and pure colour at the edge. A pure hue represents a fully saturated colour. Some pigments are more intense than others.

Taking slices through this irregular solid reveals planes of relationship.

Quantity

A given range of colours in a painting can be considered in terms of the area than each field of colour covers. Often the organization of these areas demonstrates an inequality. In terms of area or quantity, a small amount of a given colour is contrasted with a significantly larger area of another. Altering the area of any element of a composition dramatically alters its visual impact.

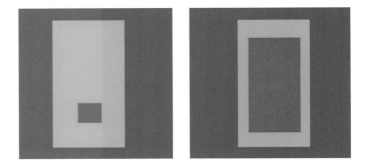

The relative quantities of red and the two blues alter the impact of the two otherwise identical images.

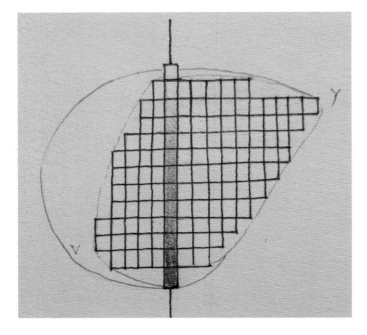

The variations in tone and intensity of each hue
define the shape of the colourscape.

SAINT MICHAEL, PIERO DELLA FRANCESCA, 1469

The National Gallery's Saint Michael demonstrates a marked and rather surprising use of an intense and vibrant red. Ostensibly, the painting is painted in a comparatively muted key of blue and orange and expresses variations of this chord.

The bloodied blade of the cool grey of the sword dramatically cuts through the vertical rhythms of the composition, its point forming a square with the width of the picture, at the bottom of the painting. The eye is pulled to the gaping jaws of the severed serpent's head. The diagonal along the mouth forms a parallel with the underside of the left foot. The shapes are connected in terms of colour, the red in the gaping mouth of the severed head registers as an echo of the intensity and saturation of the red shoes. The red occupies a relatively small area of the composition, yet its effect is emphatic.

The painting is characterized by a relatively high tonality, the bold mass of each form lit from the right. The drawing carries a feeling of assertive, clear shape making. The shapes are distinct and resonant; the luminous blue sky trapped between arm and body has an almost autonomous, abstract value compositionally, as a colour and shape.

The pair of wings framing the torso compares to the two areas of painted marble either side of the legs. The manifest delight with which the jewelled decoration is painted, a reflection of Piero's involvement with a northern miniaturism, is made possible by the relatively recent technological advances in oil painting.

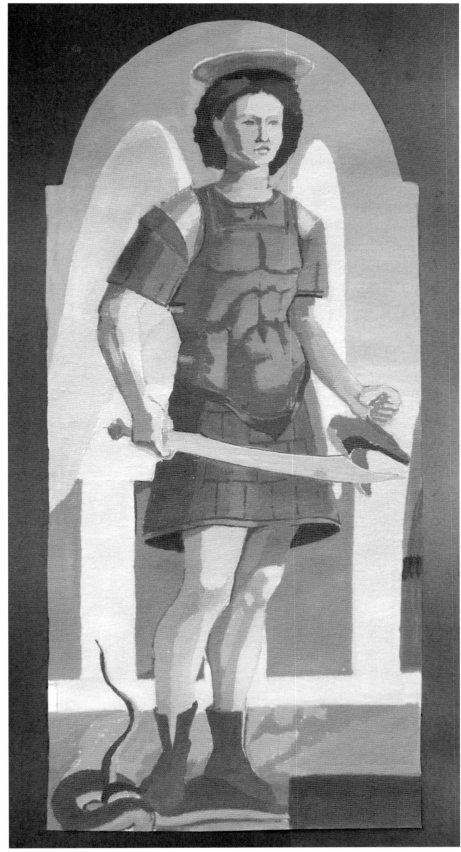

Atul Vohora, *Saint Michael*, after Piero della Francesca, 1469. Saint Michael wears exquisite red shoes. The dimensions of this painting are a root five rectangle.

The raised curve of the serpent's tail forms an identical shape to the band at the base of the chest plate.

The atmosphere of restraint in the composition is echoed in the absence of gesture; St Michael is painted as a powerful and energetic youth, poised rather than moving.

Edges

The nature and quality of an edge function as a part of any experience of contrast. The edge defines a transition from one state to the next, as two colours meet in a painting an edge forms. A severely expressed, hard, clear edge amplifies a sense of difference, and attracts attention visually – it contains a high degree of visual information. Less abrupt changes have the result of retaining an emphasis at the centre of the shape rather than at the edge.

A combination of a range of qualities of edge allows for the construction of visual rhythms, moving quickly between close transitions, arrested by dramatic shifts.

Shape and Colour

Introducing colour into a linear shape has a transformative action on the properties of the shape. Filling the shape with colour can radically alter the perception of the shape. The appearance of the size, its perceived position in a pictorial space and the visual impact of the initial shape are immediately redefined by colour that occupies its internal field.

Whether taking the form of a single mark, a loosely formed patch or a clearly delineated geometric shape, the identity of a colour is inseparable from the idea of its shape.

There have been attempts to examine this relationship closely, most notably at the Bauhaus. Kandinsky, among others, initiated a program, whose aims were to determine the irreducible elements of visual language, the building blocks of any type of visual design. He sought to ascribe specific colours to individual shapes, arriving at the results through a system of surveys. Unsurprisingly there is evidence of a certain amount of conflict even at the time, and the resulting idea of a blue circle, a red square and yellow triangle remains problematic.

The Order of Sensation

The diagrams above demonstrate the significant types of interaction between a large field and a small area. These examples present a stabilized visual experience; when confronted with a more complex image or an object in space it has been found that the eye begins to scan the shapes repeatedly, forming a series of pathways across the image, between nodes or points of high visual information. The eye traces a web across the visual field often repeating patterns of movement and fixation, the act of revisiting contributes to the process of recognition and understanding, suggesting that information is accumulated as ideas are formed about the image or space.

This description of looking depends largely on a stationary viewpoint. When in motion, looking necessarily places greater emphasis on peripheral vision; space is constructed cognitively with an experience of the interplay of constancy and flux.

Sequential and cyclical looking has direct implications on the sensation of a given colour. As the eye moves across the visual field a history is accrued; lingering on a moment of high visual content primes the eye for the next sensation. The idea of visual remainder becomes active at each pause, which means the sensation and idea formed of the identity of any colour depends on the last colour looked at.

In this way looking becomes rather like forming strings of relationship, alighting and leaping between moments, where value and meaning are modified by previous encounters. Altering the sequence of the progression changes the eventual outcome; the order of the sensation is central to an understanding of perceived colour.

The paintings of Cézanne demonstrate a profound under-

The yellow triangle, red square and blue circle: thought to represent universal relationship between colour and regular shape.

Three colours look like two.

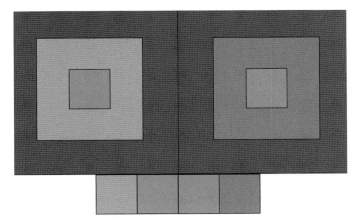

Four colours look like two.

Three colours look like four. It can help to focus between the two images.

standing of the unexpected transformations that arise from a sustained act of looking. Each patch of colour on the canvas becomes an equivalent to the sensation of a particular moment of the visual field. Crucially the mixtures are modified to become part of a web of inter-relationships. Each patch is held in a dense matrix of sensation and connection, with the oscillating modulations of colour suddenly revealed as specific spatial notations.

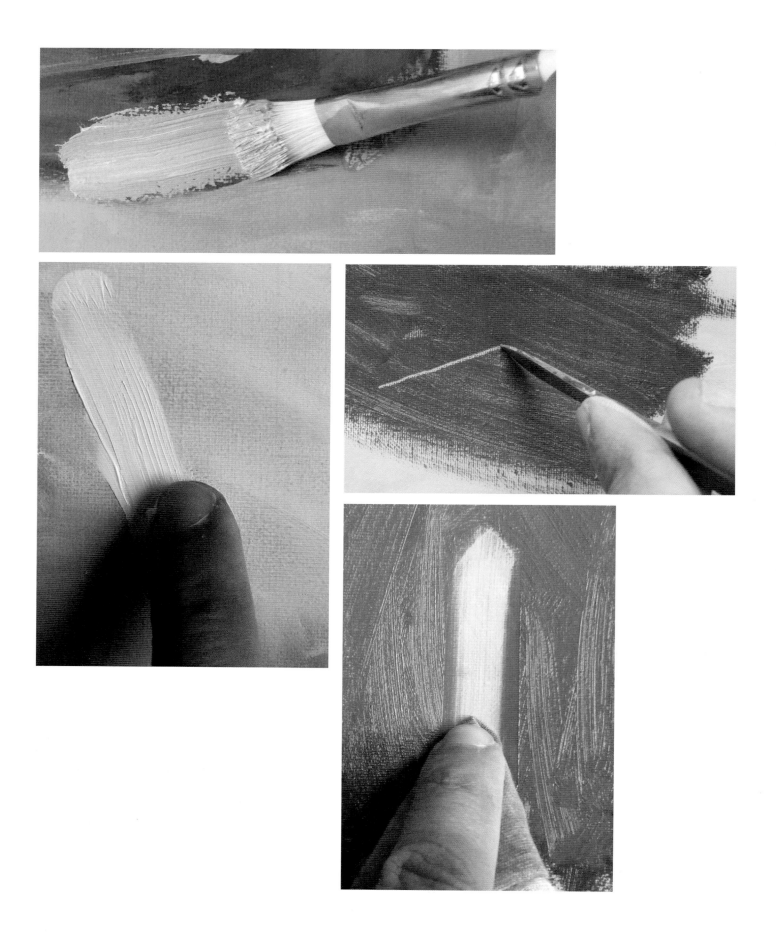

COMPOSITION

Line, Shape and Ordering Space

CONSTRUCTING AN IMAGE FROM IRREDUCIBLE ELEMENTS OF VISUAL LANGUAGE

An unmarked, undivided surface is pregnant with possibility. It provides the context or support for any image. Paintings on rock are in many ways a response to the particular shape of the rock and indeed often emerge directly out of natural formations in the surface of the stone. Images subsequently painted on the walls of buildings carry a memory of this relationship.

The support for a painting, the canvas, panel, piece of paper and so on, can be any shape imaginable. The shape and size of the support significantly affects the nature of the painting. Many artists do use shapes that are surprising, as an integral part of the expressive impact of the painting. Of all the possibilities of shape, the rectangle reoccurs most frequently. It is largely with the advent of portable images, either in books or painted panels and later canvases that the rectangle comes to dominate as a shape for painting. This includes regular shapes formed within a rectangle, the ellipse or circle as well as shapes added to a rectangle, for example the semi-circle.

Expansive Force

The unmarked canvas presents a unified unblemished surface, with something of the same forbidding whiteness as the blank page. The urge arises to mark this surface, to disrupt the impen-

etrable rectangle. Even the finest dot is charged with a potent presence, which is able to energize the rectangle in an incomparable way. Each subsequent touch carries something of this initial impact, although greatly diminished. An accumulation of marks has the effect of reducing the impact of the first. As Matisse says in his 1908 *Notes of a Painter*:

> If I put a black dot on a sheet of white paper, the dot
> will be visible no matter how far away I hold it; it is a
> clear notation. Beside this dot I place another one, and
> then a third, already the clarity is diminished. In order
> for the first dot to maintain its value, I must enlarge it
> as I put others marks on the paper.

Alongside the impact of the first mark comes the possibility of relationship, a note becomes a chord, which in turn becomes part of a phrase. The kind of marks used affect each other, either sustaining an established idea, or obscuring previous possibilities with the vitality of those made more recently. The marks form a web of relationships with each other, and are held in tension with the rectangle as a whole. For every part of the picture to play its appointed role, the scale and registration of each touch as a visible entity must be sufficient. The emphasis between marks will vary but each note needs to be played and understood as part of the whole. Again back to Matisse:

> The entire arrangement of my picture is expressive; the
> place occupied by the figures, the empty spaces
> around them, the proportions.

LEFT: **Marking the surface with paint, using four types of implement: the brush, the hand, a blade to scrape through the paint and a rag.**

Ordering the elements into an expressive whole, as an organizing principle, implies something of the Gestalt idea of a state of being 'pregnant with meaning'. Every part of the surface participates actively in expressing the idea as a 'unified whole' and is charged with this emotion.

The most elemental disruption to a surface is the point, the smallest, visible, filled circular form possible. If this initial point is pulled or stretched, in any direction, along the surface of the rectangle, it begins to form a continuous line. Line can then be considered as a second order of mark, allowing for a range of possible variations of length, thickness and nature. A line can be heavy, fine, fractured, angular or rhythmical, combinations of these aspects of line suggests an active expressive possibility.

A range of linear possibilities.

If a continuous line turns in one direction sufficiently, it will eventually come to meet an earlier incarnation of itself. The line becomes a kind of enclosure, an expression of limit, of a separation between the contained and the excluded. Shape is, in this way, born of line meeting itself, and becomes here, a third order of complexity. A shape can be either wholly or partially filled with mark or colour, which again transforms its appearance.

Each of these kinds of structure, point, line and shape, exists in relation to the support they are on and the nature of the shape of this support. They represent, pared away, the central elements of visual language, combinations and variations of which are generative and able to form images that express complex ideas and emotion.

Any intervention on the surface of the support represents a division. The placement and position on a rectangle, of a point or line or shape has an immediate relationship to the edges and natural internal divisions of that rectangle. In the paintings of Cézanne, the touch of the brush is repeated to form a kind of patch of colour. Parallel brush strokes form small sections of a similar size that are a notation for a particular observed sensation. These patches, or sensations, build across the surface of the painting. Cézanne uses modulations of colour to reveal form, light and space by an almost indirect disclosure. It is almost as though the patches of colour could be thought of as units of a structure that unifies the surface of the painting. The size of the patch allows for a complexity, too large and the range of the painting is lost, too small and the visual clarity of the image suffers.

As a construct, the idea of building a surface using a distinct unit, can be found in the paintings of Poussin. The surface of the painting can be read as a series of sections of colour of a similar size, which are arranged in the pattern of the whole.

In its defining role as support, as the inclusive shape that constitutes the limits of the painted surface, the rectangle is an active part of an experience of looking at a painting.

The Music of Interval

Rectangles themselves can take a variety of possibilities, from the regular square through an infinite series of shapes of different height and width. A rectangle can be described by the relationship of its height to width, which can be called the proportion. A square is a regular rectangle, where the height and width are equal. The square therefore represents a unity. An infinite number of rectangles exist as variations of this relationship, ranging from the square to an infinitely long rectangle of the same height. If the height of the rectangle remains fixed, and the width is extended closer and closer to infinity, the rectangle begins to appear rather like a line.

As a defining structure that provides a sense of scale and context for the painting, the shape or proportion of the rectangle is an integral part of the idea of the painting. Even allowing for an arbitrary selection, the rectangle becomes a point of departure for the imaginative process of the emerging painting. Every subsequent touch or mark is seen in relation to the edge of the rectangle, and so the initial shape is an absolute part of the fabric of every other consideration that follows.

It is possible to identify several distinct strategies for arriving at an appropriate rectangle for a painting. As touched on above, the first can be characterized by an unconscious choice or a kind of indifference to the specific shape, which then quite rapidly becomes an inescapable part of the evolving image. This kind of choice is markedly different from the idea of using a predetermined shape of a particular proportion and size.

A definite choice of rectangle of a very specific proportion could then represent the second type of process. Often preceded by a rigorous search through a series of drawings, or studies, a particular shape is chosen for the painting, which has a clear and established relationship to the scale and placement of the image within the rectangle. Significant alignments resonate within the rectangle in a deliberate and selective way.

Working from an initial image, a painting can expand to claim the surface it requires. The scale and dynamic visual energy of the internal shapes lead to an idea of where the edges of the rectangle lie. This search for the rectangle is expressed as a part of an additive process; canvas is added to the painting until a significant tension is found between image and edge. The painting grows around the image as a consequence of the expansive charge and intensity of the emerging forms. This then represents the next form of search.

Finally, a rectangle can be defined within the edges of the canvas. The found shape is inscribed within the limits of the canvas leaving a border or remainder. Again this second shape is found and felt for as the image itself develops. The internal edge is established and reassessed as the image evolves. There is a similarity with the act of cutting stone; the painting is carved out of the original canvas. The canvas remains visible, the drawn rectangle and the strip that surrounds it are inseparable from the original shape.

Joy of Divisions

Every rectangle divides in ways that painters continue to harness for their dynamic compositional possibilities. Dividing the simple four-sided shape yields an extraordinary and dramatic array of potential arrangements. The most significant way of dividing a rectangle is to join opposite corners with a line to make a diagonal. The diagonal separates the rectangle into two similar triangles; two diagonals meet at the centre of the rec-

tangle and make four smaller triangles.

The centre of the rectangle is an impressively charged position carrying intense visual and psychological associations. A vertical through the centre divides the shape into half; the addition of a horizontal divides the shape again, now into quarters. A centre vertical, centre horizontal and two diagonals define the elemental structures of the rectangle. The process can be extended to find thirds and so on.

The Eyes

At a certain point along the diagonal of a rectangle, the opposite corner sits at a right angle to the diagonal. It is possible to slide a sheet of paper over the rectangle so that one edge of the paper sits on the diagonal. At a certain point, the adjacent edge will pass through the opposite corner of the rectangle. This

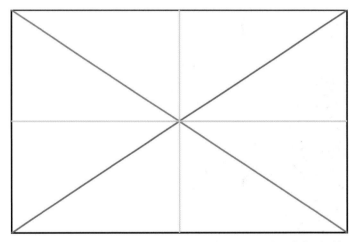

The principle divisions of a rectangle; the diagonal and the half.

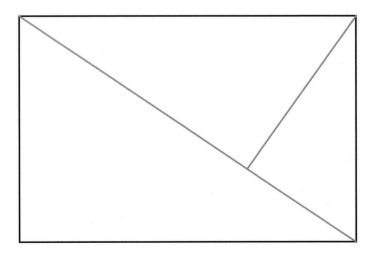

Every rectangle has four eyes. These are where the diagonal intersects a line at right angles from the opposite corner.

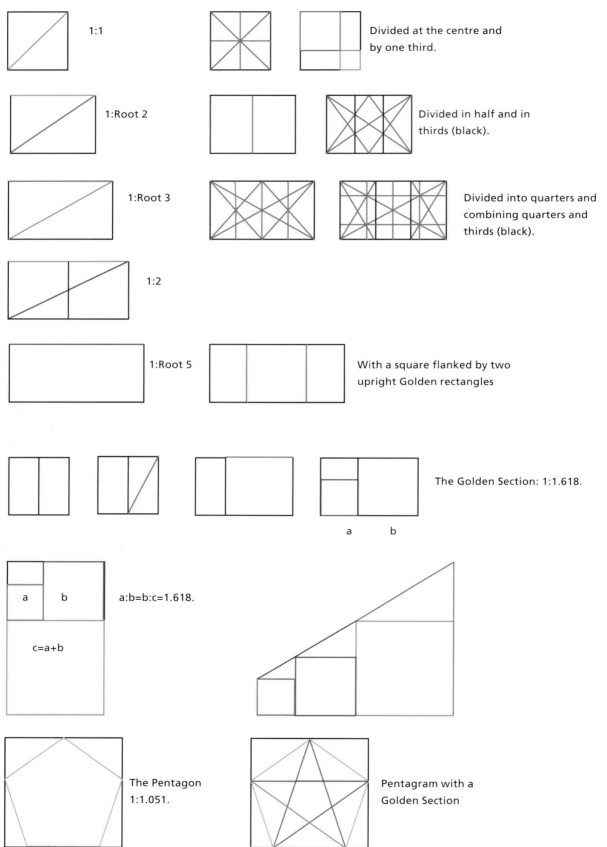

1:1

Divided at the centre and by one third.

1:Root 2

Divided in half and in thirds (black).

1:Root 3

Divided into quarters and combining quarters and thirds (black).

1:2

1:Root 5

With a square flanked by two upright Golden rectangles

The Golden Section: 1:1.618.

a b

a:b=b:c=1.618.

a b

c=a+b

The Pentagon 1:1.051.

Pentagram with a Golden Section

Irrational families.

point is called the eye. Repeating the process from both diagonals to each corner in turn reveals four 'eyes' within the rectangle. When joined vertically and horizontally, the eyes divide the rectangle at the reciprocal of each edge. The position of the eyes varies with the proportion of the rectangle.

Irrational Families

Within the infinite universe of all possible rectangles, it is possible to find patterns and connections between members of what could be called families of shape. One such family of rectangles starts with a square. The sides of the square are equal and it represents unity. One of the principal divisions of a rectangle, the diagonal is used to make the length of the second rectangle of the series, the root 2.

Repeating the same process for each subsequent rectangle generates the series beginning with a square, then root 2, root 3, a double square, and a root 5 rectangle. So each member is connected to a previous and subsequent shape, by the length of their diagonals, and by this process the root 2 rectangle is created from the square and so on. These shapes are surprising in their familiarity.

Root Two Rectangle

This rectangle is immediately recognizable as the shape of the ubiquitous A series of rectangles. It is unique in that when divided in half, two smaller rectangles, of the same proportion, are formed, so two A5 sheets make an A4. Dividing the rectangle through the middle of the longest side leaves two rectangles of half the area but exactly the same shape, two root two rectangles.

Also, dividing the rectangle using the reciprocal, or eye, creates three equal shapes. So in this rectangle the eye lies directly on the thirds. When extended the reciprocal meets the edge of the rectangle at the middle of the longest side. The elemental divisions of this rectangle express a relationship between the numbers two and three.

A new rectangle is made from the diagonal of the root 2, which is a root 3. This rectangle has an affinity for being divided into quarters, and the quarter can be used to find thirds. The next two in the series are the Double Square, and the root 5 rectangle. Both are beautiful shapes and can be found in many works of art. Used together the two rectangles create the final shape, called a Golden Section rectangle. It has the proportion 1:1.618. This is a naturally occurring relationship and often can be found in patterns of growth. The Fibonacci Numbers approximate to this value.

Patterns of Growth

Just as rectangles can be grouped into families according to connecting patterns, so too can numbers be linked into a series. Repeated addition forms the basis of one such family of numbers. The series grows with each addition. So starting with 1+2=3, the first three numbers in the series are 1, 2 and 3. The process is repeated continuously, each time using the last two in the series, so 2+3=5, and, 3+5=8, then again, 5+8=13. After four additions, the series stands at:

1,2,3,5,8,13

As the process is repeated for increasingly larger numbers, the ratio of the last two numbers, 8:13 or 13:21 approaches 1:1.618. As they get larger, the Fibonacci numbers represent an approximation for a particular proportion called the Phi or the Golden Mean. These ratios are close but never exactly equal to Phi, which, as an irrational number cannot be represented by a simple ratio.

The Golden Section Rectangle

The sides of this rectangle are described by the ratio of 1:Phi or 1.618. The rectangle has a very particular relationship to the square, the eyes of the Golden Section rectangle lie absolutely on the edge of an internal square.

To make this rectangle, a square is divided vertically to make two Double Squares. A diagonal is drawn across one of these, and then added to a standing Double Square to make a new shape, the Golden Section rectangle.

Drawing a square in the rectangle, b leaves the smaller square a. Adding a square, here called c, always makes a rectangle of the same proportion. Only the Golden Section rectangle behaves in this way.

As mentioned earlier, the number Phi has a strong connection with the idea of growth expressed as number in nature. Inscribing a square at the edge of the rectangle and repeating this action in the increasingly small shapes left by the square, reveals a rather beautiful spiral of squares within the rectangle, with an immediate association to natural forms such as the spiral of a shell. The edges of each square within the spiral have the same proportion to those of its neighbours in the scale; the spiral descends with the proportion of Phi.

This rectangle is at the heart of *The Golden Calf* by Nicolas Poussin, the intersection of two squares forms a vertical Golden Section rectangle. This is confirmed by the recently amended measurements published by the National Gallery, London. Two large diagonals form axial arms, which separate the tumultuous sky from the complex space below. The shallow relief of

the front of the painting is marked by the delightful lyricism of the dancers' hands, gracefully set against the rhythmical beat of interval, set by their legs. The outstretched hand of the final dancer divides the canvas in half vertically; the right hand edge of the plinth defines the central vertical of the composition. The plinth becomes a kind of unit in the painting marking a quarter of the width. The figures kneeling and standing to the right of the plinth form a crescent focused on the pointing figure in white, held by a spread of diagonals from the bottom left cor-

ner. Two trees frame the centre of the image, dead wood on the right and fresh shoots emerging to the left.

The curious aperture of light cut high in the rock to the left of the painting provides a key to the structure of the painting. It reads as a template for the larger shape revealed by the movement through the figures dropping across the bottom left of the canvas, rising up over the bottom right and completing the shape through the landscape and sky.

The shape begins with the frieze of dancing figures at the left

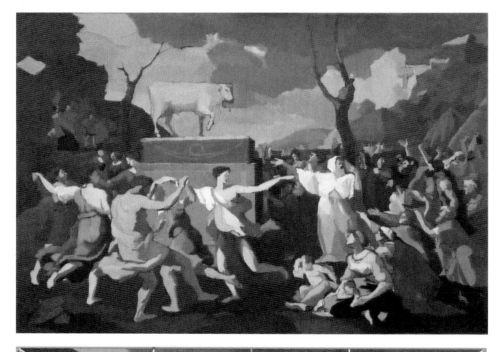

Atul Vohora, *The Golden Calf*, after Nicolas Poussin, 1633–34.
The graceful figures dance with joyful abandon around the golden calf.

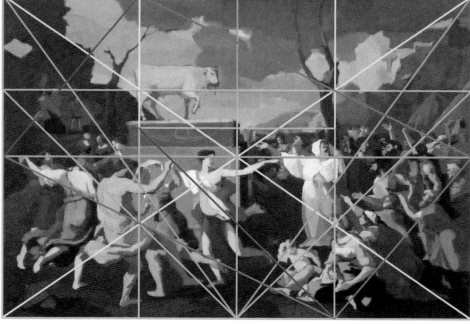

Atul Vohora, *The Golden Calf*, after Nicolas Poussin, 1633–34. The lines show the most significant divisions of the painting and their relationship to the composition. A series of squares underpins the painting. At the centre of two intersecting squares is a Golden Section rectangle. The red line gives a geometric basis for the internal shape described above.

hand edge of the painting, an inverted repeat of the same figures in the painting, *A Bacchanalian Revel before a Term*, 1632-33, Nicolas Poussin, in the National Gallery, London.

The heady mixture of graceful poise and abundant vitality is set against the rectilinear density of the plinth that bears the calf. A clear series of elisions and directional rhymes begins with the raised hands meeting. The movement drops, glancing the top of the garments, frozen, their crystalline forms seemingly carved yet flowing, then continues down through to the lap of the seated woman anchoring the painting at the centre right. The second movement rises from her foot, sweeping back into the space to the distant tent. A staccato of outstretched hands and heads, raised expectantly, surrounds the arching figure of Aaron, who, with arm extended, and starkly visible in his white robes, acts as a centrifugal focus for the crescent of figures. The curve of the tree rising behind echoes his shape in an emphatic restatement of the turn of his body.

Our diamond now rises over the distant figures, their size giving some register to the space in the landscape. As the fallen sun catches the swollen clouds, the glimpses of light lead to the peak of the shape, a luminous moment of gold, before descending along the tender branches of the tree, down to the irate twisted Moses, curiously sidelined in the composition. His towering and imposing form is marginalized.

Variations of chords of yellow, blue and red clothing vibrate across the surface, mingling with minor chords of green, violet and orange. Developed through an elaborate preparatory process, every aspect of the picture seems fully considered and integrated into a sense of the whole rectangle.

The Pentagon

A pentagon standing on its base can be enclosed by a rectangle that touches each of its corners. By joining the five corners internally to make a five-pointed star, the pentagon is divided into a pentagram. This shape expresses an inherent series of Golden Section relationships at almost every intersection.

This rectangle can be found most notably in *The Baptism of Christ*, by Piero della Francesca, in the National Gallery, London. The painting is a combination of half a circle placed above a rectangle containing a pentagon.

THE BAPTISM OF CHRIST, AFTER PIERO DELLA FRANCESCA, 1450s

The central figure of Christ, eyes lowered, crowned by an unmoving dove, faces out from the front of the composition. He stands mid-stream and immediately to his left John the Baptist steps forward, in profile, poised in the act of pouring water, arm extended over the bearded head of Christ. The narrative of

The Baptism is suspended at the instant of the appearance of the dove. It is in the unrustling stillness of this frozen moment that the figures are lit by the crisp, lucid light of the high, blue dome above. The light falls from the right of the painting, revealing tenderly modelled form; the forms themselves seem almost to emit light.

At the centre of the painting is the idea of transformation and change. The flowing stream defines both the space in the painting, as it meanders into the distance and the idea of constant renewal, in the continuous movement of the water.

Christ stands with his feet immersed in the water. His position in the stream is significant as it marks a moment of transition. Immediately behind the feet of the figures, the surface of the water has become an unrippled field reflecting the rising blue of the sky and the distant landscape; in front of their feet, it is translucent and reveals the pebbled bed of the stream. The transformation is from illusion to sparkling clarity. This act of reversal brings the blue shape of the sky to the front and bottom of the composition. Piero harnesses a profound understanding of the natural phenomenon of refraction to create a moving and understated metaphor that is rooted in physical experience.

Surprisingly, the horizon revealed in the reflection between Christ's legs is an unseen portion of the hill, obscured by the width of his shoulders. The gradual fall of the far ridge is reciprocated in the curve of loosely tied fabric around Christ's waist. Piero transplants the narrative to a composite landscape, which evokes the cultivated hills of his birthplace Borgo Sansepolcro. The stumps of felled trees, a consequence of a search for firewood, may equally signal the coming of a messiah, heralded as an axe to fell unfruitful trees.

Christ is painted with his weight borne by the right leg, in a contrapposto pose, directly referencing a classical pre-Christian idiom. The statuesque white robed angel at the centre of the grouping of three angels shares similar roots. The curve of Christ's torso caused by the raised right hip is echoed by the sweeping turn of the stream. On the outer bank of the turn, a man arches forward over the water, in the act of removing his robes. Lifted over his head, the robes render the man both unseeing and anonymous. Undressing is in itself a process of uncovering and change, Christ himself naked but for the diaphanous fabric around his hips.

The painting is a composite of two shapes, a rectangle topped by a slightly narrower half circle. The radius of the circle is half the height of the rectangle, and the rectangle, wider than it is tall, contains a Platonic, regular pentagon. The pronounced vertical emphasis of the composition is marked by a series of asymmetries oscillating either side of the central vertical.

Distinct groupings of figures create an alternating progression into the landscape, the intervals between each columnar vertical as resonant and musical as the forms themselves. A tall

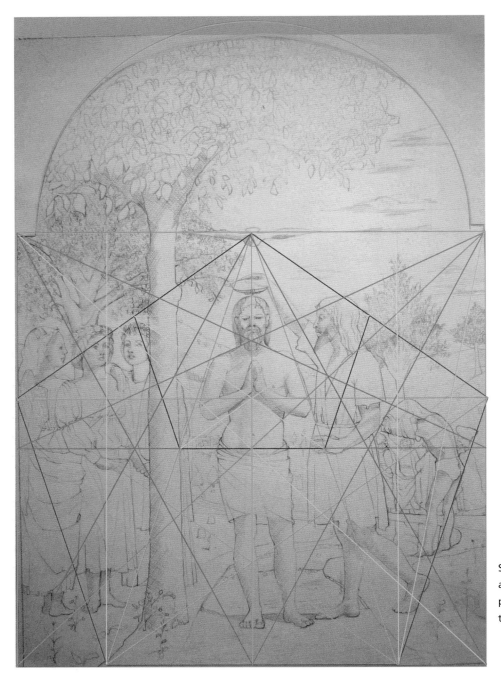

Sarah Richardson, *The Baptism of Christ*, after Piero della Francesca, 1450s. Two pentagons and their pentagrams reveal the internal structure of the image.

walnut tree fed by the clear water of the stream grows on the bank, linking the top and bottom edges of the painting. Its growth is barely contained by the top of the painting, as it pushes up beyond the edge.

The painting formed the central image of a polyptych altarpiece. A painting of God, now lost, would have been positioned directly above *The Baptism*, so completing the iconography of the trinity from beyond the limits of the compositional structure. The surface of the painting has been heavily abraded over time, although remnants of gold suggest descending diagonals

from the top of the composition and faintly visible haloes above the figures.

The cylindrical trunk of the tree echoes the sturdy, monumental construction of the figures at the front of the space. They seem equally rooted and of the earth. This close identification and integration of figure and landscape lends prominence to the natural environment, each element of which seems painted with a revelatory intensity.

An abundance of air, space and light separates the two trees filling the upper portion of the painting. The dense canopy of

leaves encloses the focus of the narrative and this idea of enclosure is echoed by both the raised arm of John the Baptist and arched body of the distant man. His body frames and contrasts with a gathering of elders locked in disputation, one of whose arms appears to point back to the dove. Their heavy, richly coloured robes reflected in the water contrast with the conspicuously plain clothing of the three adjacent figures.

The vivid colours form a pendant to the group of winged angels standing to the left of the painting. The angels are physical, corporeal beings with presence, who occupy a tangible position in space. Youthfully androgynous, they stand with an idealized combination of vigour and sensual grace, the lyrical interplay of their hands and clothing lends a poetic relief to the vertical severity of the composition. As they witness the unfolding baptism, one of the angels gazes out of the painting holding the observer's eye. Seen from below, the figures maintain a kind of enigmatic reserve. The undemonstrative actions and movements in the painting are characterized by a sense of restraint.

A pentagram underpins the very deliberate structure of the painting. A second, half sized pentagram, scaffolds the folded arms and pressed hands of Christ. He stands at a height of three quarters of the width of the panel. The intersections of the diagonals lock the position of his head and shoulders.

The divisions of the rectangle can be seen to inform the relationship between the figures in an imagined pictorial space, as well as their positions on the surface of the painting. Evidence of redrawing in some of the figures suggests a developed intuition at work in the resolution and synthesis of the image. The choice of a particular rectangle and its internal divisions enhances and liberates the emotional force of the painting. The Golden Mean, resonant with patterns of natural growth, is encoded within the form of the pentagram. Inherent in the geometry of the painting, then, is the dynamic potential of growth, here held in a passionate equilibrium, manifest across the surface of the picture.

Allegory and the Rectangle

MINERVA PROTECTS PAX FROM MARS ('PEACE AND WAR'), PETER PAUL RUBENS, 1630

The measurements of the canvas are just smaller than the proportions of an A size or root 2 rectangle. This suggests that Rubens was not working from a specific geometric shape, rather, that the size and edges of the rectangle are arrived at by different means.

A close look at the painting reveals a set of raised ridges running both vertically and horizontally across the surface. By following the ridges it becomes possible to divide the painting into seven distinct rectangular areas. These sections radiate around a central panel and suggest that Rubens began the painting on a relatively small canvas. As the painting evolved, the internal compositional considerations forced a redefinition of both the size and shape of the painting. Rubens continued to add pieces of canvas to the painting as he worked, so that the final shape emerged as the idea for the composition became clearer. The additional sections are stitched onto the first rectangle, resulting in the visible raised ridge.

Given the configuration of the rectangles, it is possible that he changed and enlarged the painting four or five times. It is most likely that the first panel centred on the figure now representing Peace. The second section is almost identical in shape and size, and was placed adjacent to the right. The subsequent addition of long horizontal strips above and below results in a shape close to a square. The figures are arranged along the diagonal of this shape, with the putto initiating the tumbling descent that culminates in the trailing leg of the girl in yellow. In this configuration, winged Cupid stands at the middle of the painting.

The composition is then radically revised by the addition of a wing to the left edge and the introduction of the two standing Maenads. Finally the thinner strips joined to the right hand edge establish the symmetry of the painting, with helmeted Minerva now placed at the centre. So, the process of painting the picture involved dramatic changes to both the scale and shape of the rectangle. These changes take the form of additions to the initial rectangle and reflect the evolution of the pictorial idea. The distribution and position of the figures in the rectangle ultimately crystallized in the final rectangle visible today.

A large diagonal broadly separates the figures into two spaces. In the darker, upper right corner, Mars, and the Fury Alecto, reel away into a ravaged landscape beneath a tumultuous sky. To the bottom left of the painting, however, the figures are pushed forward to the front of the pictorial space and are bathed in light. Below the diagonal, the contrast is extreme, the space now filled with images of abundance, innocence and dancing.

The painting is energized and dynamic; pulsing rhythms turn across the surface. Large spirals emerge and can be found within the composition, with the dramatic core of the painting at the heart of the clockwise spiral, which turns through the figures, holding and unifying them with its centrifugal intensity.

Rubens constructs a pyramid of form at the centre of the composition. Minerva or Wisdom is at the apex, with Peace sitting to the left. Mars, the God of War, is pushed out of the pyramid by Wisdom, leaving an absence opposite Peace. She offers her breast to hungry Plutus, the God of Wealth. Below them, a kneeling Satyr presents a cornucopia or Horn of Plenty, while a leopard rolls benignly at his feet. The base of this pyramid is completed by a crescent of children led by Cupid and one of whom is crowned by Hymen, the God of Marriage. Another of

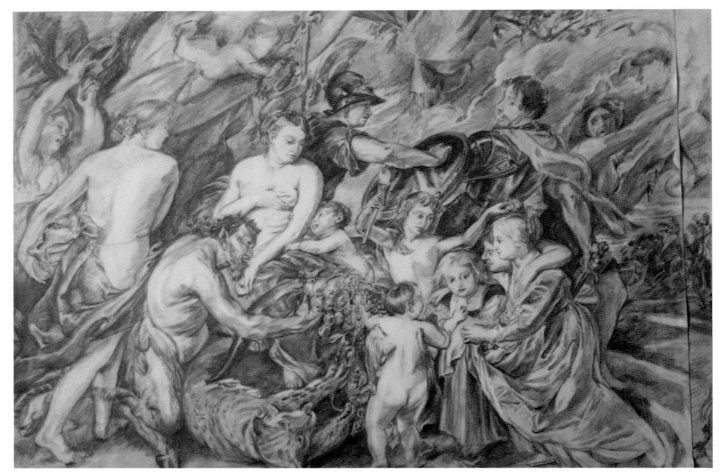

Harriet Piercy, *Minerva Protects Pax from Mars* ('Peace and War'), after Peter Paul Rubens, 1630.
The grey line marks the separate sections of canvas.

the children looks out of the painting at the intended viewer. The children have been identified as the children of Balthazar Gerbier, from a painting of them by Rubens. Rubens stayed with the Gerbier family in Bethnal Green during the year he spent in London negotiating a peace settlement with Charles I on behalf of Philip IV and Isabella. The negotiations were successful and resulted in the Stuart Hapsburg treaty of 1630. Rubens presented the painting to Charles following this success and the allegory is clear; wisdom has prevailed in averting war, the fruits of which are peace, wealth and a safe future.

MAHARAJAH KIRPAL PAL OF BASHOLI SMOKING, C1690

The commanding shape of the Maharajah dominates the painting, his impressive physical presence a reflection of his authority. Clearly drawn, rhythmical curves reveal the full volumes of body, bolster and pot. A wonderful play of shape sets the volume of the pot above the tilted ellipse of the mat it sits on. Throughout the painting there is an arresting duality about the

way in which shapes function. The horizontal surface of the floor is pushed flat against the picture surface as if to resist any illusion of depth, remaining almost purely shape. The emphatic white mat alludes to a sense of the space occupied by the Maharaja, although functions primarily as a flat rectangle, resonating with the verticals of the floor and the internal border of the picture.

As a device the red band defines a limit to the space and yet remains permeable, the figure of the attendant at the left of the picture remains uncontained by this edge. The border then acts equally ambiguously in relation to the ideas of enclosure and transgression. The patterns of the fabric covering the bolster and the clothes of the two attendants equally make no concession to the sense of volume implicit in the drawing of these shapes.

Uninflected clear colours fill each shape. It is the steady turning line that makes volume and form. The clear sweeping curve of the pipe pierces the characteristic field of radiant yellow,

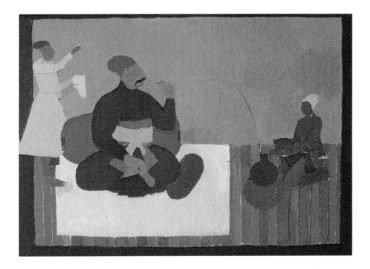

Atul Vohora, *The Pipe*, after *Maharajah Kirpal Pal of Basholi Smoking*. A border surrounds clear fields of luminous colour.

dio. The continually revised shapes are testament to a persistent looking, a rigorous search for this register of the head in the space. The internal edge is absolutely integrated as a coherent part of the language of the painting and gives context to this account of the artist's sustained act of looking.

which floods the upper half of the picture. The yellow plane resonates directly with the burning scarlet of the Maharajah's robe. The orange green and violet form a minor chord, secondary to the charged impact of the yellow and red on the white mat.

GENET, ALBERTO GIACOMETTI, 1954–55

The raised knees dominate the front of the painting, giving a sense of scale to the distance back to the head. The painting is face on, a kind of confrontation between artist and sitter. The knees loom forward pushing the seemingly diminished head away into the space of the picture. The dome of Genet's head has an intense relationship with the rectangle drawn within the limits of the canvas. The forms are enveloped with a pervasive sense of search, restatement, lines repeatedly redrawn that spread as a web across the painting.

The lines create a fabric of possibility that reveals a dynamic tension between form, surface and space. The range of colour in the painting is severely restricted to black, white and ochre. A habitual night bird, this selection of colours by Giacometti would seemingly be least affected by differences between electric light and daylight.

Giacometti's process appears rooted in a set of defining oppositions, white lines etched into the black web make the physical volume of the head, itself somehow a consequence of the pressure of the space that fills the room. As a gravitational centre for the image the head has a charged presence within the rectangle that is an equivalent to the presence of the sitter in the stu-

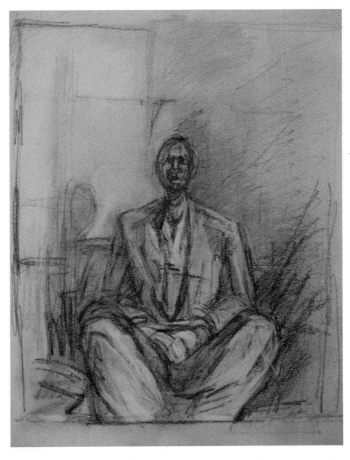

Atul Vohora, *Genet*, after Alberto Giacometti, 1954–55. The edge of the image is painted within the limits of the canvas.

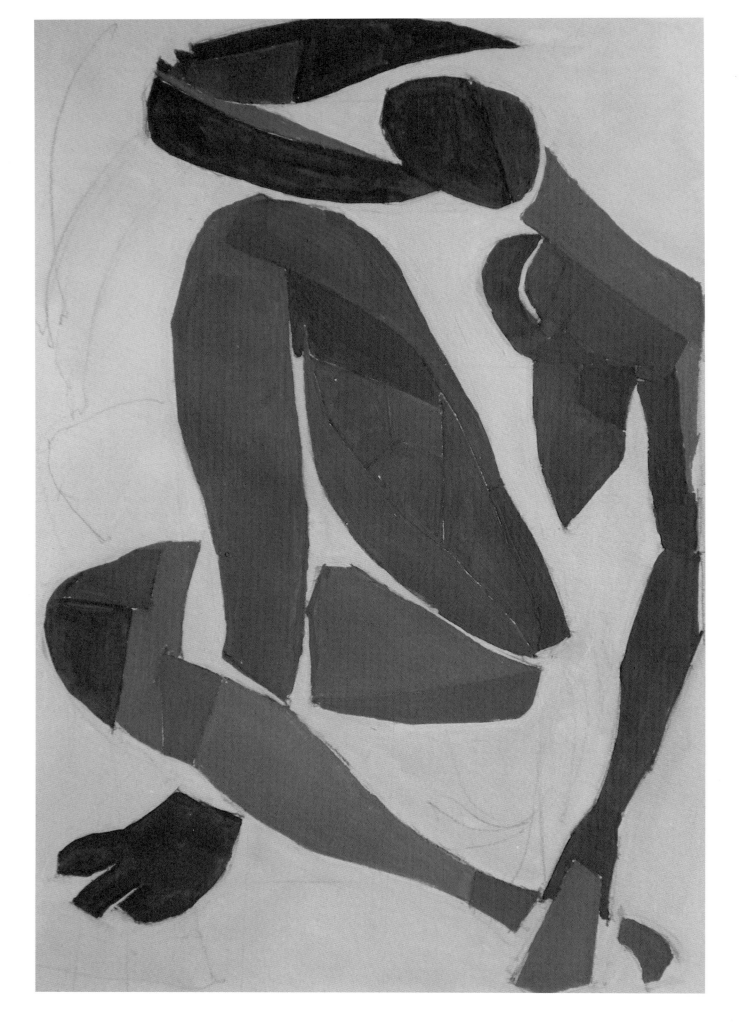

ON MAKING

Drawing can be described as painting with limited means. The terms drawing and painting are useful as general descriptions of a type of image although distinctions between the two (monochrome or slightly coloured, on paper, made with a brush) quickly reveal themselves to be, at best, limited. Trying to separate the two ideas fully becomes an increasingly unsatisfying attempt to define where drawing ends and painting begins. Proposed distinctions of this sort are problematic and taken the wrong way, serve the hardening of ideological positions. Constructing a painting is a layered, complex process, engaging with ideas of organization and structure, primarily led by acute visual sensitivity, of which the act of drawing is very much a part.

Intricate and endlessly moving patterns are a manifestation of this kind of expressive consideration. The impulse to make pattern, to give visual form to a particular sensibility, arises in many cultures and is in itself a simultaneous expression of both individual identity and of belonging.

To begin to order mark and shape, in such a way as to create a recognizable image, is a highly specialized form of pattern making. As an activity, it is inseparable from the shock of recognition, present in the act of identifying image with a specific object. There may or may not be a strong resemblance between the image and the object. In many ways the feeling of recognition is close to an acceptance of the equivalence of mark and colour for the object. The ability to read an image grows out of

Pattern-making across diverse cultures.

LEFT: Atul Vohora, *Blue Nude IV*, after Henri Matisse, 1952.
Carved from pure colour, Matisse draws with a pair of scissors.

an experience of both looking, and of looking at images themselves.

Making and reading an image involves imagination; line and colour are imagined as bird or bison. Even more, the bird or bison is imagined in charcoal or paint. The image becomes inseparable from the material of its construction.

This is essentially a creative act; a means of internalizing and expressing ideas about the visually apprehended world and in this sense seems close to the indigenous Australian idea of singing the world into existence. In its earliest known incarnation, the drawn image was a way of summoning the absent, giving form to the unseen.

The image is tied to the physical movement that each mark records, a series of touches of a hand on the surface. Every gesture expresses a response to the seen or remembered and simultaneously registers the presence of the image-maker. Part of the experience of looking at an image is an often-unconscious physical empathy with the making of it.

As the making of images evolves, an ability to understand the depiction evolves in tandem. Encoded in the image are ideas and beliefs that function equally when looking at the image. Yet there seems a surprising constancy in the making and reading of images, which makes it possible over 30,000 years after they were made, to recognize the rock paintings at Chauvet as animals. These paintings are demanding and intelligent images.

Curiously, people are only represented by the traced outline of a hand. This would seem to imply a convergence of the ideas of presence and touch. The hand signifies both.

The transition from the traced outline to a depiction of a per-

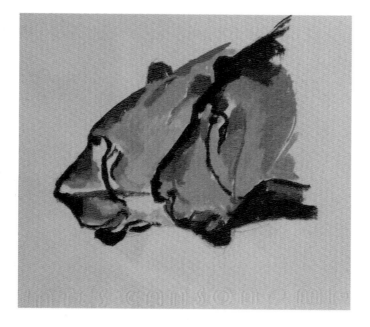

Atul Vohora, *Chauvet Lions*, c 30,000 BCE. The animated heads are painted almost as though caught in the act of hunting.

son is a dramatic shift that speaks of a radical alteration in the perception of self in relation to the world and others. To see, after all, suggests being seen. An image of a person is a kind of psychological expansion; in its crudest form it represents the statement, simply, this is man. The image takes the form of a sign that signifies 'person'. The presence of a human figure in an image implies a separation from the idea latent in the traced hand: I touched this. Instead, the human form is conceptualized and abstracted into the imaginative, pictorial world of the image: this is a person.

From the possibility of constructing a composite of images of people interacting with each other and with other represented forms, comes the idea of depicting human narratives. The image acquires a potency. The ability to make images as a record of an event, to create an image of the appearance of an event is then a preverbal means of storing and transmitting ideas about human experience. Giving visual form to stories about people is a powerful discovery in the construction and transmission of the identity of a group.

Equally, images can be a means of structuring or giving form to emerging metaphysical ideas, a space for exploring and attempting to make sense of the world visually. Totemic sculptures predate painted images of people. The Willendorf woman can be seen as an example of an innate desire to give human, specifically female form to the unknowable and mysterious forces of growth and fertility. Humankind's earliest gods are made in her own image. For these early people, whose lives are tied to the cyclical rhythms of the world for food and shelter, this gender-based association carries a certain charge. At its most extreme, the cult of the woman becomes distorted, giving rise to the phenomenon of sacrifice of the virgin.

Later, images of deities that relate to natural phenomena are often formed of combinations of human and animal forms. A perception of a separation between the human as elevated and the animal as a lower form of existence largely eliminates this kind of imagery, although vigorous strands of images of hybrid deities continue to evolve.

Anxiety about determining whether the deity is the image, resides in the image, or if some kind of separation of deity and image is essential for belief, gives rise to deep misgivings of image making in some cultures. The extreme realism of sixteenth and seventeenth century Spanish polychrome sculpture and energy of the tradition from which it arises, exerted considerable tensions in the face of the censures of the Inquisition, not least due to the latent homoeroticism of some of the sculptures.

As images evolve in complexity the relationship between the particular and the formalized or ideal arises. At its core is the distinction between the image of a person and the image of this person. Representing a particular individual could then be defined as a highly specialized form of depiction, which

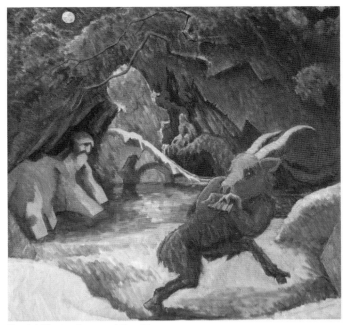

David Shutt, *Pan and the Moon*.
Dancing under a full moon.

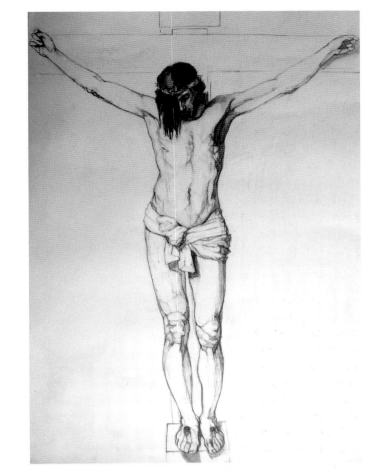

Elizabeth Shields, *Crucifixion*, after Diego Vélasquez. Christ here is seen as physical perfection at the moment of his death. The equation of ideal beauty and death is far removed from Matthias Grünewald's painting of the same event.

demands both an awareness of self, the person making the image, and also an ability to recognize and empathize with the other, as a separate individual.

How to depict a recognizable individual rather than a type the hunter, the hero, requires a departure from the conventions of image making established so far and places the act of looking closer to the making of the image.

Symbols can help identify an individual; depicting an object with which the individual is closely associated links the image to the person. The challenge deepens when trying to ascribe the particular characteristics of a single individual to the image. This act of differentiation makes it possible to recognize the distinction between images of a type of person and an image of a specific person.

Looking as a part of image making then, can be an act of choosing, a process of selecting significant elements from the ceaseless flux of the visual field. Of course, over time new conventions for the representing of an individual are formed which in their turn present inhibitions.

Looking is interwoven with the idea of memory, looking again is a way of refreshing a memory. Raw sense data is transformed by imagination into idea and it is then possible to compare this idea with a new sensation. Memory plays an active part in looking, whether between a succession of glances or in relation to something seen some time ago.

The act of painting holds a direct contradiction to this, in that each mark is an affirmation of present experience, each touch an assertion of now, a confirmation of being. The painting grows from an accumulation of touches, a succession of moments found in the present tense.

The ability to compare, to find difference, inherent in the question 'What is it that makes this person unlike any other person?' is a critical part of this process.

Decorated pottery around the Mediterranean closely describes a trajectory from geometric patterning, to highly developed, spatial and narrative constructions. The descending bands of decoration begin to include stylized notations of people. Finally, the patterning becomes a secondary part of the design, the figures become the focus of the image. The evolution of pictorial possibility emerges with tremendous technical innovation that in some ways makes these visual departures possible to realize.

Painting has an ability to invoke a presence, it makes it possible to feel and experience an encounter in spite of an apparent absence. Walking to the dark recesses of a cave and seeing, in tongues of leaping light, the forms of a lion and lioness appar-

ently walking, can only have been an experience of profound awe for early humans – the feared beast that stalks the darkness, made visible, close enough to touch, made by touch, made present. It is difficult to reconstruct this impact in its full context.

There is a residual sense of the ambiguous and at times interchangeable relationship between the actual and the painted. This could mark an emerging separation between an idea of the painted image as an illusion, whose value lies in its mimetic potential, and a more iconographic strand of image making that reconstructs the real in a formalized pictorial way. For the illusion to be sustained, at its extreme, the image must not be recognized as a painting. Conversely, in the second form of construction, for the painting to be legible, the marks and colours depend on being understood as being equivalents for the real, even when the image makes considerable departure from the appearance of the actual. The reality of the painting is constructed and defined on its own terms.

Early Egyptian portraits made to cover coffins in places such

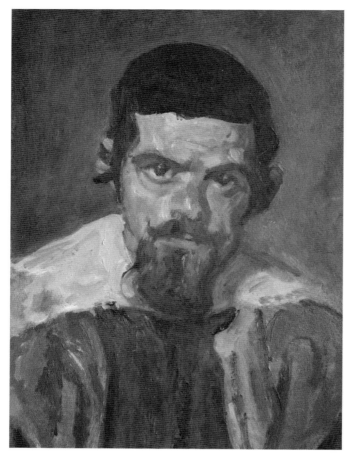

David Caldwell, Detail from *Sebastian de Morra*, after Diego Vélasquez, 1643–44. This is a compassionate and empathetic painting of a particular person.

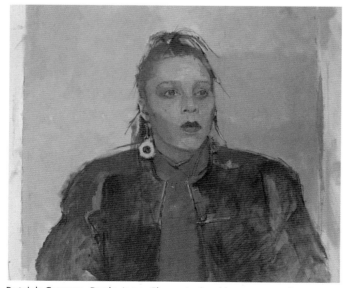

Patrick George, *Darla Jane*. Characterized by a sense of restraint, the head in the painting is carved in colour.

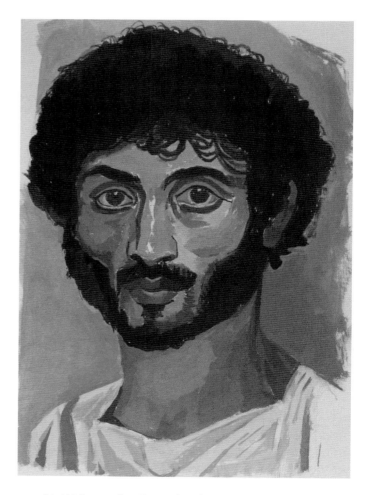

Atul Vohora, after Fayum head, c.100BCE. Painted after the death of the subject, the head remains resonant.

as Fayum are realistic and highly individuated paintings. Made after death, they have a charged relationship to memory, acting as a record of the appearance of a person. They were intended to be buried and have a function as a part of beliefs and rituals that mark the death of a person. The survival and re-emergence of these paintings, in some instances after 2,000 years, is in part due to the climate. That they have survived presents a curious confrontation across an almost impossible span of time. As paintings they vary greatly in the quality of their representation, some tend to be more stylized and generalized, yet it is possible to experience a kind of uncanny encounter with the unmistakeable presence of a person staring back. As the visible world continues to change the paintings are islands looking back at us unchanged. In this way, seeing is a layered experience of which the purely retinal is only a small part.

Fluidity and Order

The chances of a painting surviving great lengths of time are very small and relatively few of all the paintings ever made still exist. Of those that remain, the deterioration of the image over time, in many instances, has been compounded by well meaning but insensitive restoration, that makes it very difficult to form a clear idea of the original appearance of the painting.

When looked at in comparison to each other, modes of painting, which are often quite distant geographically and temporally, start to reveal ideas about the nature of painting and the richness of visual possibility and image making.

Egyptian wall painting from the fourteenth century BCE has a particularly characteristic linear emphasis. A clear, unbroken line surrounds and defines the form. The line has a sinuous, undulating grace and a steady authority that does not change in density or emphasis. Unmodulated colours fill the areas enclosed by the line. The paintings coexist on the wall with bands of hieroglyphs and are often surrounded by complex verbal structures, yet each wall presents an integrated and unified field. The paintings may have developed from an alphabet of visual iconography and retain something of a commonality with the construction of the hieroglyphs themselves. The similarity between the visual construction of the paintings and the hieroglyphs helps sustain the organizational unity of the walls.

Paintings of kings and gods with human attributes are marked by a strongly formalized depiction of the head in profile, a frontal torso and the legs returning to profile. There is an echo in this of the hieratic nature of sculpture of the same period, where the rectangular frontality of the block from which the sculpture is carved remains visible in the final shape of the figure. The connection is even fuller with contemporary shallow relief from the Tomb of Seti 1, the idea of the linear grace of the

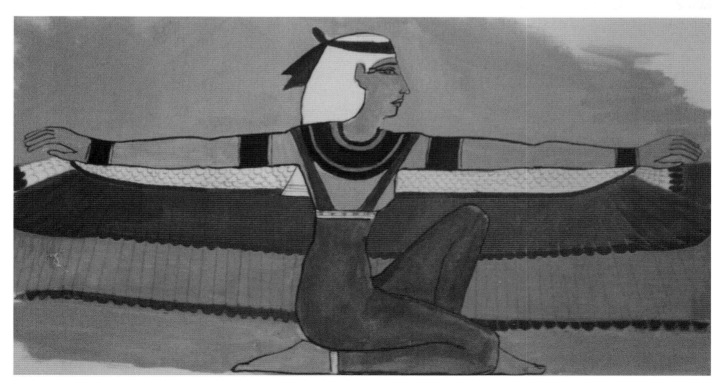

Atul Vohora, *Isis*, from the tomb of Seti I, Valley of the Kings, 1360BCE. The winged Goddess perches as though on a narrow shelf, her body defined by a slow, burning line.

painted line as an incision has a direct parallel in the drawn and cut shapes of the carved relief. The statuesque, monumental figures are tempered by the graceful tapering of each limb.

The figures exist in a space, albeit not a very deep space, rather like a narrow shelf. Parts of the body are hidden behind the nearer forms, implying, through the overlapping of form, an understanding of recessional depth. Conceptually, the space the figures inhabit is understood in a pre-Euclidian sense. The idea of an integrated and inhabitable three-dimensional space has yet to be fully theoretically formed.

The pyramids themselves point to a conceptual separation between the ideas of plan and elevation. If the length of the base is considered as the roll of a large drum, the height can be calculated in terms of a number of diameters of the same drum stacked on top of each other. Distances across the surface of the earth are conceived of as multiples of the circumference, whereas height is measured in terms of the diameter. The two measurements are related by the constant Pi, so the shape of the pyramid is a beautiful expression of the relationship between a square and a circle, the base and the height.

In paintings of people, rather than kings or gods, the figures are comparatively animated and move freely. They are less con-strained by the ossifying need to continue to exist in an immutable eternity. So servants, slaves and dancers punctuate the formal stasis of the regal mode, twisting their lithe limbs in ways that are suggestive both of an easy sensuality and a considerable understanding of form. The figures interact openly with each other, uncontained by the formal conventions that govern depictions of more reverential subjects. Musicians are presented facing forward, this frontal aspect a substantial departure from the convention of heads painted in profile.

Little of Ancient Greek painting survives. It is from painted ceramics that it is possible to infer something of the vitality of Greek painting. Individual painters can be identified within the continually evolving development of painted ceramics, with works often signed by the painter. Where a painting is unsigned, recurring elements within the paintings are used to identify the work of an individual, even if the name of the person making the work is unknown.

An amphora painted in 530BCE by the Euphiletos painter and now held in the Metropolitan museum in New York, bears a painting of five men sprinting. The amphora was decorated with a slip, which turned to a rich black on firing. The figures are what remain of the black, the rest has been scraped away from the surrounding surface to reveal the red colour of the amphora itself. Fine lines cut through the larger areas of black, to both delineate in parts and articulate the forms of the body. The thinness of the line cutting through the richness of the black leads to a heightened contrast so the line appears brighter than the surrounding red ground of the amphora.

The men are muscular and athletic and the painting in part is a celebration of a kind of masculine virility. The same pose is repeated five times as the figures move together as a group, although there is some differentiation in the painting of the heads. A second colour is used for the hair, which breaks the uniformity of the black. The runners are in mid leap, on the toe of the trailing leg, the leading leg lifted and contrasting with the long line from the ankle to the front of the hip. The torso continues the dynamic forward momentum of the pose and is turned to face outward, in part a concession to the swing of the runner's arms. The head is nestled above the dipping left shoulder and turns to the profile once again. The succession of thighs forms a central band across the horizontal of the composition, a robust axis above which the arms and shoulders read as racing waves, while below, the blades of the shins carve out a series of shapes of red. A delightful variation in the interval between each figure suggests a sense of acceleration. The play of overlapping forms lends a sense of depth to the composition, in fact the middle of the five runners leads, while the unchanging scale and flat line of the ground resist any reading of space and emphasize the musical interaction of line and shape.

Two soldiers face each other in a second painted amphora from 530BCE also now in New York. The symmetry of the com-

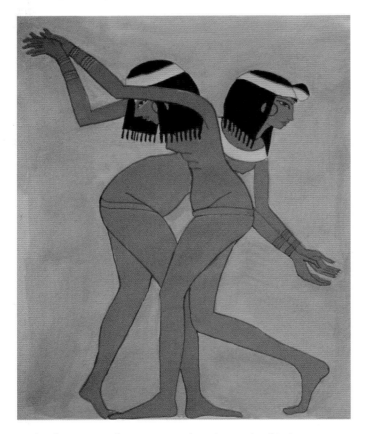

Atul Vohora, *Egyptian Dancers*, after the tomb of Nebamun, c.1350BCE. The dancers writhe freely as they dance, unhindered by formal restriction.

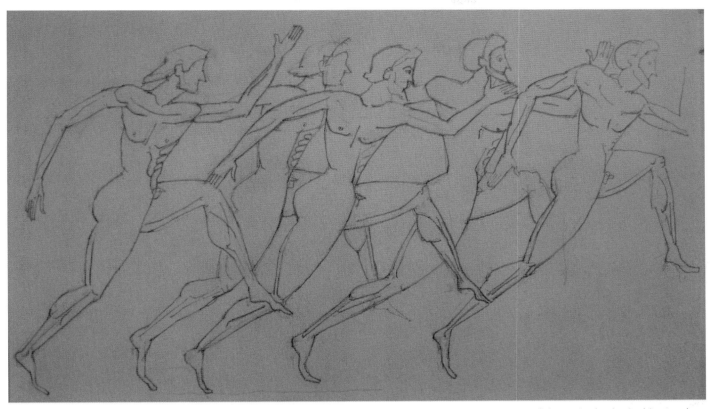

Atul Vohora, *Sprinters*, after Euphiletos, 530BCE. The repeated shapes of the bodies create a series of dynamic rhythmical intervals.

position is broken by the full circle of the near shield. This serves to conceal the intimate space of the confrontation, fighting hand to hand. A second colour in the plume of the helmet echoes the red band around the shield, the trailing tail of the plume paints a kind of counterpoint to dropping diagonals of the spears. The band of spiralling decoration registers as an inversion of the pattern inscribed across the chest-plate.

KORDAX DANCERS, FIFTH CENTURY BCE

Although the surface swells with the shape of the vase, the figures occupy a dark band between lines of decoration, standing in a relatively shallow, frieze-like space. The black glaze is painted onto the surface of the vase, leaving the red of the terracotta exposed. The transition from black figure painting to red figure painting was in part enabled by a technological advance in the process of painting and firing clay. Whereas black figure painting required line to be carved or scratched out of the paint, in red figure painting, fine brushes allowed greater sensitivity and expression. The black colour acts as a contrast with the warm red of the figures while remaining slightly ambiguous or purely ground.

The figures are sharply drawn against the black and form a lively grouping of comically animated dancers. The shapes are

seen as uninflected areas of red with wonderfully incisive painted lines cutting through the unglazed red. The line is directly drawn with confidence, and yet loaded with information. Folds of cloth swing as they hang, legs overlap, the eye of the figure

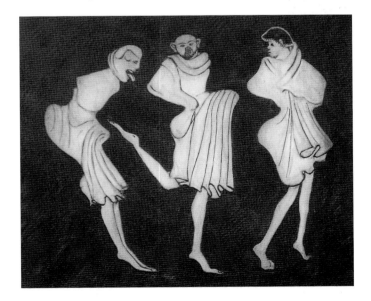

Coll McDonnell, *Kordax Dancers*, after fifth century BCE vase. The playful, animated figures spring from a linear construction.

on the left of the frieze is painted as seen in profile. This naturalism is something of a departure from the more stylized convention of a frontal eye on a face seen in profile. Accents of line indicate the pressure of bone under skin and give volume to the pointedly raised ankle.

In a second departure from conventional depiction, the head of the central figure is turned to face forward, eyes crossed and ears enlarged for comic effect. More than just a mask, the head has weight and depth, and it is painted as part of the same agile, arcing turn that sweeps from toe to crown, and echoing the distended shape of the vase itself. The wit and innuendo of the ensemble finds a counterpart in the liveliness of the line and the rhythmical exuberance of the shape making.

The artist who has come to be called the Berlin painter was active in the early fifth century BCE. The iconic work, or name vase that identifies this painter's work in the Staatliche Museum in Berlin, demonstrates a characteristic organizational clarity. The group of figures is framed between two horizontal patterned bands, a floral motif above the figures, which circles the neck of the vessel, and the shorter band upon which the overlapping figures of Hermes and a Satyr stand.

The body of a deer separates the two figures, its neck elegantly outstretched and its head lifted. The long slender arms of the figures gracefully enclose the forms in their arch. The tender rise along the neck and throat of the deer completes the circular shape.

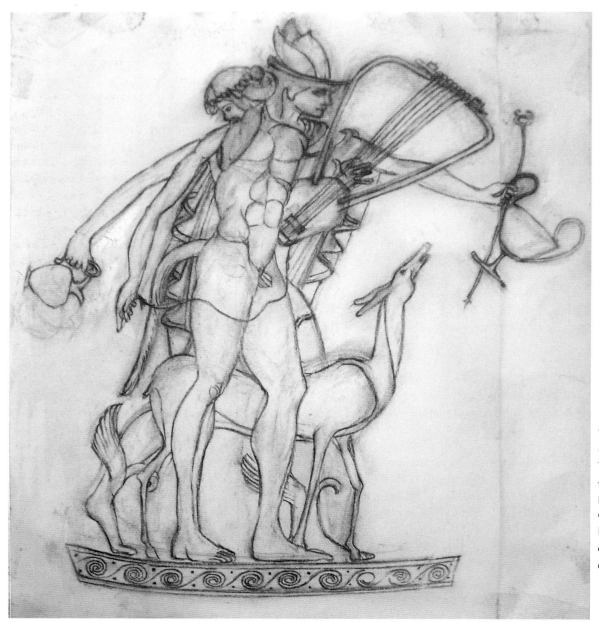

Coll McDonnell, *Hermes and Satyr*, from an amphora after the Berlin painter, fifth century BCE. The layered rhythms create a beautiful design.

The interplay of the legs of the figures with the much narrower shapes of the legs of the deer creates a series of musical intervals. Trapped shapes of the black ground are interspersed between the plunging tapering descents of the figures' legs;

Coll McDonnell, *Achilles*, after the Achilles painter, fifth century BCE. The single figure holds a commanding presence. The line encompasses an extraordinary range of forms.

one foot is turned forward and foreshortened.

A gently insistent line carves out the long forms of the limbs. The muscular definition of the torso is restrained and understated, painted with lines of varying colour and thickness. Closely packed lines form the strings of the lyre, resonating with the drawing of the folds in the fabric and the feathers adorning Hermes' body. The painter invents a second range of lines to describe the hair of the two figures. The patterns created by the hair have an abstract quality at something of a remove from the naturalism of the drawing elsewhere. The bolder pattern on the red deer creates a strong visual contrast with the clear unvarying colour of the body of the Satyr. The superimposed figures form a single unit of powerful integrity set against the gleaming black ground.

The name vase of the Achilles painter is held in the Vatican collection. A student of the Berlin painter, it was painted in the mid-fifth century BCE, and consolidates some of the concerns found in the work described previously. The composition is more severely pared down, so the single figure of Achilles stands alone on a truncated band of pattern, the only decoration on this side of the amphora. The contrapposto pose is supported by the unbroken diagonal of the spear, running from the neck of the amphora to the base Achilles stands on. Achilles is muscular and heroic, the structure and drawing of the legs and head draws comparison with the Munich sculpture of Doryphorus by Polykleitos, made at a similar time. Acutely observed moments, a hand curving around the hip, the eye seen turning in profile, punctuate areas defined with a more formalized type of drawing.

Painted line transforms the red terracotta into volume. Around the dark mass of curling hair, a thin line of unpainted red separates the skull from the black ground surrounding the figure.

The almost cylindrical cuirass conceals the form of the torso, its bulk slightly incongruous with the slender arm emerging at the shoulder. Scales painted with thin glaze form the flank of the cuirass and a gorgon's head forms the centrepiece of the chest. Variation in the weight of the line renders the skirt transparent.

Later paintings take up the dramatic potential of multiple figures with specific narrative reference. Odysseus sits, overcome by remorse on encountering Elpenor in the Underworld. Both figures are drawn with a penetrating line, the definition of musculature in the torso of Elpenor reminiscent of sculpture in the emphasis and selection particularly of the separation between pelvis and stomach. There are also more elaborate spatial indicators; reeds and rocks, and in the case of the Niobid crater now in the Louvre, trees and mountains give context to the narrative.

Regal paintings of monarchs in profile recur through many cultures, up to and including the head of the Queen on current postage stamps and coins. In the paintings of Mughal India, from the sixteenth century line again surrounds shapes of clear

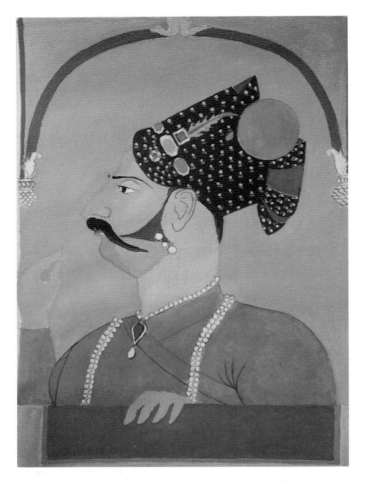

Atul Vohora, *Maharajah Bakhat Singh, Nagaur*, c.1740 (National Gallery of Canada). The Maharajah's powerful frame is suggested by the line surrounding the field of red.

He became excited by the spatial possibilities he intuited these paintings seemed to afford, following his visit to the 1903 exhibition of Islamic art in Paris, and reinforced in Munich in 1910. Both versions of *The Dancers* from 1909 and 1910 resonate with the language and construction of Egyptian, Greek and later Indo-Iranian painting. The areas of colour are simplified and without modelling, the line is vigorous and bold and absolutely part of the language and structure of the image.

The dancers are painted in motion. Their bodies arc and turn across the surface of the painting. Their linked hands form a delightfully leaping rhythm that embraces almost the entire canvas. The shapes of blue and blue green, caught between the inter-weaving limbs of the dancers become an essential part of the whole music of the picture.

The figures move in an apparently shallow space, with little concession to perspectival constraints. The dancers push on the edges of the painting with a barely containable energy. The highly saturated colours are pitched at a celebratory fullness; the red-orange makes a searing contrast with the blue and blue green. The paint is applied with slight variations of thickness, so the colours appear to pulsate within each shape. The naked figures become a source of intense luminosity.

The later cut-outs revisit the idea of the relationship between figure and ground. The *Blue Nude IV* of 1952 is an assembly of separate pieces of coloured paper, reorganized to make the form of a seated woman. Matisse uses the scissors to draw, cutting into the painted paper to make shape. The coloured paper is laid onto a larger sheet of white paper, over repeatedly re worked under-drawing and revisions. While the erased charcoal lines soften the contrast of the paper and the blue, by breaking the fields of white, there are no significant spatial references, placing considerable emphasis on the interaction of shapes on the surface of the paper.

The larger blue shapes fragment internally in variations of hue. The effect is to disrupt the dominance of the outer edge. The intervals of white paper between the blue shapes become an active part of the composition and are as positively considered as the blue surrounding them.

There is a strong directional reciprocality between the elements of the painting. The raised arm in parallel with the folded leg and the raised knee have a similar relationship with the extended left arm. Intervals of white paper, cutting through the blue, articulate the form of the body in a way that is highly reminiscent of the incised line in Greek black figure paintings. The scale and shape of the pose is held in an intensely charged relationship to the shape of the rectangle and the surface of the page.

undivided colour. The line has a quality that recalls the bold rhythms of early Egyptian painting. There is an interplay between exuberant patterning of fabric and bordering and the delineation of form, which serves to create a tension between an emphasis on the flat design of the painting and sense of pictorial depth. The portraits are part of a convention that depicts the ruler, Emperor or Maharajah in profile, often framed by a device rather like a window, one hand resting on a ledge, the other holding a flower. Equestrian and full-length portraits also employ the severe profile as the preferred aspect.

Matisse felt great affinity for miniature painting of this sort.

Atul Vohora, *The Dancers*, after Henri Matisse, 1909. The rhythm leaping from hand to hand breaks at the centre of the painting.

Light, Cylinder and Form

MODELLING THE SHAPE OF THE BODY THROUGH THE FALL OF LIGHT ACROSS THE FORM

Thought to be a Roman copy of a painting made in Pergamum in the second half of the second century BCE, this fresco was painted in Herculaneum in the first century CE. The mudslides that destroyed the city following the eruption of Vesuvius have ensured the survival of the paintings.

Hercules stands naked before Arcadia, his dark, knotted muscular body a powerful vertical presence at the right of the composition. His head is turned, his gaze held by the tender sight of a doe suckling a child. The doe itself turns to lick the child. With a mingling of surprise and concern, Hercules recognizes his own son Telephus. The child leaning to reach its milk and the turned neck of the deer creates a wonderfully intimate vignette within the larger composition.

Strident diagonals bind the image. The downward turn of Hercules' head leads into the diagonal formed by the outstretched arm of the winged figure, which extends into the tilt of the infant's body and finally culminates in the meeting of the legs of the doe and child.

The abundant ripples and cascades of Arcadia's robes tumble over her lap, plunging diagonally to meet the dropped knee and bending leg of Hercules. The draped cloth is carefully modelled to reveal the presence of the full forms beneath. Arcadia's left hand is raised above her head, holding the vertical of her staff with an air of imperial authority, the repeated verticals contrasting with the fluid curves of her body swathed in cloth. Her semi-recumbent pose and flowing robes recall the figures from the Parthenon frieze.

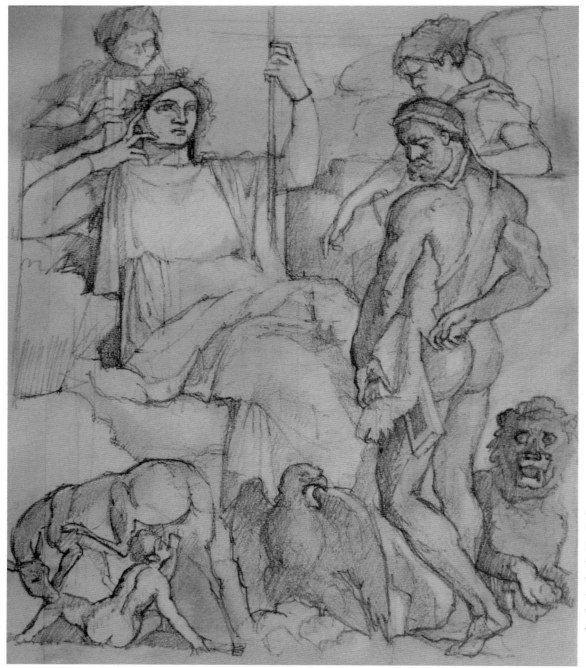

Atul Vohora, *Arcadia*, Roman copy of painting, second century BCE. The cylindrical presence of each form resonates within the composition.

There is a symmetry to the organization of the figures in the painting, heightened by the opposition of the diagonals. Arcadia sits, lulled by the music of Pan, in the top left corner of the painting. The pair of heads at the top right of the picture echo the two wreathed heads of Pan and Arcadia and a rather startled Nemean lion becomes a pendant to the child and deer. Within the painting, the colour of the figures creates a series of reversals, so the lighter female figures are placed opposite the darker figures of Pan and Hercules, while the pale infant Telephus contrasts with the darker shape of the lion. The eagle,

symbol of Jupiter, perched astride the rocks at base of the painting occupies the centre.

The figures are painted with a vivid concern for volume. Light floods the painting from the top right of the composition. As the light passes across the figures, it reveals each form, with a deeply felt sculptural physicality. The figures cast shadows in the space emphasizing a sense of their physical presence in the painting, while also forming a part of the underlying geometric structure of the composition. The consistency of this light serves to unify the surface of painting. Each limb claims a cylin-

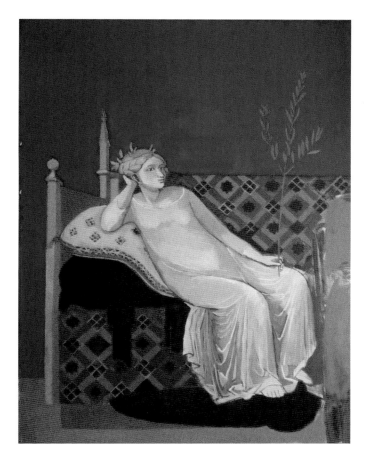

Atul Vohora, *Pax*, after Ambrogio Lorenzetti, 1338–40. Peace is graceful and languid; her gently modelled form is draped over discarded armour.

drical fullness, the turning forms are gently but insistently modelled. Arcadia's neck becomes a column bearing her majestic head, lightly brushed by the tips of her two fingers.

Ambrogio Lorenzetti painted the *Allegory of Good Government* in the Palazzo Pubblico, in Siena in the late 1330s. Three walls of the chamber are covered by this elaborate decorative scheme. A panoramic description of the well-governed city and countryside faces the badly governed city and countryside on opposite walls of the chamber. Between them, the *Allegory of Good Government* occupies a wall facing a large window that looks out onto the surrounding fields. The painting is constructed as a series of visual metaphors for the mechanisms of delivering justice and the elevation of the idea of the Common Good in the affairs of the city. The iconographic programme of the frescoes is resolutely secular and enshrines the political ideals of the Commune.

To the left of the wall, the first grouping of figures aligns Wisdom, Justice and Concordia vertically, above the door through which the governing Nine would have entered. Justice is open-handed and looks up to Wisdom. From the scales of Justice, reward and punishment are distributed evenly. Two cords pass down to Concordia, who binds them together and hands them on to the first man in a line of pairs, the twenty four.

These figures link to the enthroned, male personification of Siena, in Italian, Ben Commune, who sits raised on a platform, flanked by six female virtues indispensible to the activity of the Commune: Fortitude, Prudence, Magnanimity, Temperance, Justice and Peace. At his feet, the infants and she-wolf allude to the founding myth of the city, while in the bottom right corner, armed soldiers surround a group of chained prisoners. Hope, Faith and Charity hover above. In this way Ben Commune is explicitly tied to Justice.

Peace, effectively seated between the two groupings, is at the centre of the whole composition. She is radiant in her glowing white robes and clearly visible against the dramatic, diagonal pattern covering the entire left wing of the seat, and the band of blue above. A small shift in the scale of the pattern gives a sense of the depth of the bench. She leans on a cushion covering a redundant suit of armour, looking out into the distance. The rather languid turn of her body further marks Peace as the focus of the statement that Lorenzetti seeks to construct. She strikes a resounding note as the fruit of good government, the flowing, rounded softness of her diagonal body contrasting with the more rectilinear and chaste figures in the rest of the picture.

Lorenzetti invokes a visual language of desire as the means to describe the desirable abundance and grace a state of peace brings.

She is considerably less formal and statuesque than Arcadia, yet the connection remains strong. Arcadia's rigid staff is here replaced with a slender olive branch lightly held in her fingertips. The fingers of the right hand tease at the thick braid of hair and the flowing lines of her dress sweep delicately against the richly patterned covering of her throne. Lit as though from the window in front of the painting, Lorenzetti builds a clear sense of the modelling of her head, its weight supported by the right arm. Emphatically delineated, the rounded volumes of her body push at the fabric of the dress with the gentle fullness of her breast, stomach and knee. The suit of armour is a dark mass, whose shape and volume is revealed by the fine line etched through it.

Keenly aware of the radical inventions of Giotto, Lorenzetti finds a lasting sense of solidity and presence in these figures, perhaps equally informed by an earlier Roman sources. With a sensuality that is entirely his own, however, the figure of Peace escapes being rendered an elevated and idealized abstraction. Instead she is fully human and retains an earthly approachability.

Madame Moitessier was painted over a period of almost twelve years before it was finally completed in 1856. Ingres was,

Atul Vohora, *Madame Moitessier,* after Jean-Auguste-Dominique Ingres, 1856. The rich construction of the painting centres on the abundant volumes of Madame and her remarkable white dress.

in his own words, taken by the 'terrible beauty' of her head. Although the commission was accepted in 1844, events such as the death of Ingres' wife and later Madame Moitessier's pregnancy interrupted the progress of the picture. During the same period Ingres also produced a standing portrait of Madame.

The painting is highly rendered and there is an immaculate clarity to the surface, undisturbed by visible touches of the brush or any indication of the substance of the oil paint. Madame sits, turned slightly, to face outward, leaning on the stuffed back of the chaise. In the large mirror, which fills most of the upper half of the canvas behind her, the head is caught a second time, now in profile. Light spills across the painting from the front right, gently disclosing the cylindrical, alabaster fullness of her body.

The picture is a celebration of the extraordinary floral extravagance of the patterned dress. The dress rises from the base of the composition in a dazzling pyramid of light, which culminates in the gentle peak of her highly burnished forehead. The

white cloth is drizzled with touches of yellow, red and blue-green in the flowers and leaves of the pattern. These touches recombine optically, in a dizzying demonstration of pattern and form that seems to anticipate the later developments of impressionism and divisionism. The intensity of this light is set against the rising darkness of the upper part of the room reflected in the mirror.

Several existing drawings show the evolution of the idea for the painting. The drawings demonstrate a particular concern with the scale and position of the arms. In pursuit of a monumental solidity, the arms become fuller, and the reflection in the mirror is gradually modified. The resulting profile holds an imposing remoteness and is perspectivally at odds with the rest of the painting. There is then a tension between the apparent naturalism of the observed portrait and the idea of the painting as a constructed world, governed by the demands of its internal relationships.

The mirror divides the painting into two distinct spaces, the illusory space of the mirror and the apparently real space of the room. A pronounced shift in the quality of light further emphasizes the separation of the two spaces. This separation enforces a sense of the painting as a continuous part of the real world of the spectator. Within the mirror, the sense of illusion is compounded by the inclusion of infinite recession caused by two mirrors facing each other.

Ingres follows the model of Arcadia closely. The braceleted right arm held to the temple, the idealized head and even hairline come directly from the Roman model, with refinements to the set of the shoulders and the drape of the fingers of the right hand. The left arm is closer to the shape made by that of Peace in Siena; a closed fan turns down under the weight of the left hand. Arcadia's floral wreath is echoed here in the unbridled exuberance of the patterned dress.

Madame Moitessier's neckline is displaced to the right, initiating a series of cascading diagonal rhythms through the body and dress, leading to the outstretched hand. The neckline itself sweeps beyond the left shoulder and begins to rise instead as the hairline of the head in reflection. To the bottom left of the painting, the dress begins to fracture into triangular shards. Densely patterned areas fill the painting and become a source of contrast to the unblemished gleaming ivory of the bare arms and shoulders. The luminous areas of pale skin become the focus of the painting through an absence of adornment and inflection. The modelling of the forms of the body and the cast shadows equally generate the volume of the forms. The tightly pulled pink fabric of the chair also helps to sustain an idea of volume in the painting. The construction of the body is then liberated from a more descriptive mode, without a loss of fullness.

Ingres maintains something of the hieratic vertical and horizontal structure of the Herculaneum composition, with the mirror frame and the several vertical architectural elements seen in

reflection. In a similar way the organic rhythms and the dynamic diagonals of the composition are held in tension by this structure.

The jewellery that Madame Moitissier wears has been scrutinized with a miniaturists' zeal, the deep ovoid stones of the brooch and bracelet resonating with the dark eyes. The vividness of each form expresses the artist's urge to identify, inhabit, to touch, the looking seems hungry, suffused with desire and yet the touch is absolutely restrained, the surface of the painting like the unbroken skin of an onion.

Madame Moitessier was actively engaged in negotiating the realization of her self-image. Ingres was aware of the tensions involved in creating the portrait and was to a degree, ambivalent about the process. Keen to avoid what he perceived as some of the limiting implications of a purely mimetic kind of painting, Ingres arrives at a synthesis of seemingly opposed possibilities, that of an unmediated naturalism with a highly considered construction. Through this process, the identity of Madame Moitessier becomes fused with the timeless ideal of Arcadia in a space reconfigured by the demands of the internal dynamics of the painting.

Fractured Surface: Carving Form through Colour and Shape

YOUNG WOMAN WITH A WATER PITCHER, JOHANNES VERMEER, 1662

Light tumbles through the open window, spilling into the corner of the room. The blue glow of the slightly opaque glass is cut through by the delicate tracery of the veins of lead. The elliptical shapes formed by the lead work become containers of cells of light, which are in turn held by the dark rectilinear shape of the window frame. The painting itself is built in a similar way, in that each shape across the surface of the composition is entirely self-contained, defined as a discreet entity, and possessed of clear limits. Light seems to emerge from the painting as though the canvas is a source of internal light in a way that goes beyond a purely descriptive rendering of a scene.

The brilliant-white folded fabric of the young woman's bonnet appears to fragment against the broad expanse of the wall. The starched fabric hangs either side of the face, slightly transparent against the right cheek. Vermeer rejects any sense of continuous modelling or gradual transition. The fabric envelops the head and clearly defined shapes, each of a slightly different colour, articulate its turning surface. Distinct colours again reveal the faceted turn of the cloth draped over the shoulders, the pale shape dramatically penetrated by the dark triangle of

Atul Vohora, *Young Woman with a Water Pitcher*, after Johannes Vermeer, 1662. In the stillness of the corner of the room, the young woman bridges the expanse of the space in the painting. The bonnet is carved in colour.

the bodice. The yellow and blue of her clothing vibrate against the muted colour of the wall. The bonnet is transformed into a crystalline structure held in space.

This faceting and fracturing underscores the tension between shape making pattern and the possibility of shape making form without recourse to the gradual transitions of continuous modelling. Each of the forms possesses a material density that that speaks of an unambiguous physical presence There is no organisational hierarchy as such. Each area of the composition functions as a considered and vital part of the whole, as demonstrated by the small shape trapped between the arm, pitcher and body

The wall, by the sheer fact of its mute immensity, creates a feeling of space and air in the painting, through the unassuming consistency of its surface. The neutral colour of the wall becomes a continuous solid field against which the multiple dramas of light, colour and space unfold.

Both the map hanging on the wall and the rich patterning of the tablecloth are a play on the relationship between shape and surface. Here the shapes within the map, and of the patterned

cloth, read as variations on an unbroken surface. They are contrasted with the picture surface, on which closely juxtaposed shapes create space, form and light. The shapes interact freely without the intervention of line, so that colour meets colour directly. In this sense the surface of the painting also remains unbroken, as a continuous field of shape against shape.

The red tablecloth reflected in the gleaming saucer forms a pronounced horizontal base. It is presented frontally in a way that serves to diminish perspectival convergence. The rich patterning of the fabric changes colour to describe the structure of the table, so the sliver of bright red, suggesting a relatively low viewpoint, makes the surface of the top of the table. The rectangular shape of the table is painted in a way that to a degree resists reading as depth, while simultaneously creating a physical presence at the front of the pictorial space.

The edge of the map hanging on the wall repeats the horizontal emphasis of the table, and frames the objects on the table. The vertical edge of the map calls out to the gently staggered vertical descent along the left of the painting, as it drops

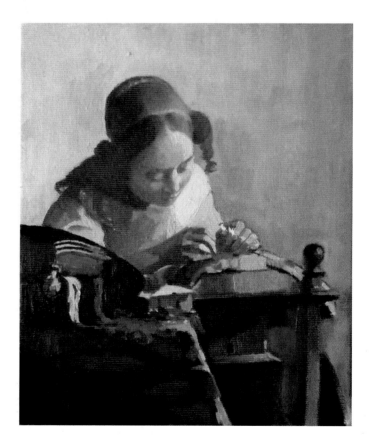

Hero Johnson, *The Lacemaker* after Johannes Vermeer, 1670. Delicate planes of colour describe the facets of the head.

into the corner of the room. The proportions of the map are close to that of the whole rectangle, while the projected horizontal of the leading edge of the table meets the base of the wall in a square.

The arms of the young woman bridge the severity of the architectonic elements of the painting, a series of dancing shapes, set at a tilt, leap between the left and right edges of the composition. She is surrounded by three large rectangular areas of colour; the yellow of the map, the horizontal red tablecloth and the vertical blue of the window. The poise, stillness and clarity of the painting are the direct result of Vermeer's organizational integrity and compositional rigour.

The Lacemaker, painted in 1670, and now in Paris, shares many similar qualities. Again the painting focuses on a young woman. She is bathed in a gentle light from the right of the composition, a direction relatively unusual in the paintings of Vermeer. Behind her, the expanse of the pale wall makes something of a contrast to the finely drawn hands that form the focus of the painting.

She is deeply absorbed in her work and brings her head close to her hands as she concentrates. Her eyes are dropped and she remains unaware of being seen. This unselfconscious focus, combined with the small scale of the painting, suggests an intimacy. The table and cushion at the front of the painting intervene physically, creating a mass of form between the woman and the viewer.

The rising top of the cushion becomes a ridge behind which she is partially hidden. The table on which she works emphasizes this separation further. The layering of the spaces in front of the wall reads as a series of horizons, travelling back through the space.

A thick braid wraps tightly around the back of the girl's head, which, in its shape, offers an echo to the rounded finial on the post of the table. An escaped tendril hangs playfully above her left shoulder, a note of release from the intense scrutiny and closely bound order of the composition. Its innocent charm lends an air of vulnerability to the image.

The rich, deep blue of the cushion dominates the front of the composition, contrasting with the yellow of the blouse. From within the cushion, vibrantly coloured thread spills luxuriously onto the tabletop, providing an almost pure note of red. The fluidity and abandon of the unused and discarded thread, is set against the image of the thread transformed in the young girl's hands, pulled taut, as it becomes a part of the fabric of the lace.

Clear ridges mark the transition around the shape of the girl's head. The middle of the brow, the bridge of the nose and the middle of the chin are defined by distinctly painted planes of colour, which reveal the shape and orientation of the head. These planes are seemingly the mark of a volume carved by a chisel, rather than moulded in a malleable substance such as clay. The fracturing of surface is mirrored in the construction of

the hands. At each joint, the surface turns and Vermeer introduces a new colour, to define the structure of the hand. The connection between head and hands is very close, each painted with a marvellously faceted economy.

The base of the cushion initiates an almost horizontal line across the painting; the post registers as a clear vertical and the diagonal leading edge of the tablecloth burns brightly through the bottom of the composition. This diagonal is very close to that of the tilted head, and leads into the top half of the painting.

Through the unhurried organization of the painting courses a scintillating feeling for edge and shape making. The clarity and lucidity of the painting is deeply charged. In spite of the diminutive scale of the picture, the image resonates across time and space. In this, Vermeer's painting is very close to the idea of a stillness that is eternally moving.

MINERVA PROTECTS PAX FROM MARS ('PEACE AND WAR') PETER PAUL RUBENS, 1629–30

This allegorical painting by Rubens appears in some ways as the antithesis of the purity and restraint that characterizes the paintings of Vermeer. Rubens revels in a conspicuous sumptuosity that floods the picture. Compositionally abundant, the whole surface of the canvas is filled with barely containable forms. This expansive energy finds expression in dynamic rhythms sweeping from top to bottom, traversing the painting in a heightened state of movement only just held by the edges. The constant motion of these rhythms condenses to reveal the swelling volumes of each figure, emphatically celebrated in colour and light. In this painting Rubens orchestrates something of the swirling interdependence of energy as rhythm, and animated mass defined by light.

To the left of the painting, the figure of a woman strides into the scene, wrapped in a tumble of richly embroidered silk. Under her arm, a golden bowl overflows with cups and jewels;

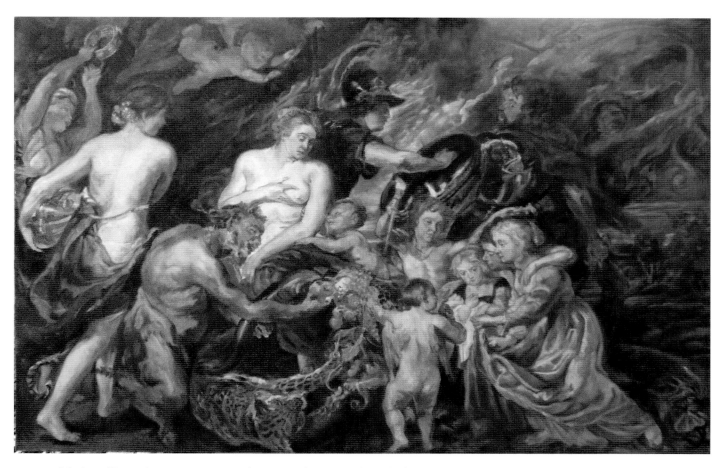

Nichola Collins, *Minerva Protects Pax from Mars ('Peace and War')* after Peter Paul Rubens, 1629–30. The luminous back of the woman on the left reads as a series of vertical planes.

the pale skin, almost translucent, radiates light. Evoking the desirable state of peace, the painting is suffused with a palpably eroticized visceral desire.

The woman's body is physical and substantial; the construction of each volume of her torso and limbs is clearly and fully expressed. Rubens' delight in making each form is evident in the exclamatory way areas of brilliant, layered colour are placed against each other, revealing the structure of the body. As the hip twists, becoming the back, large areas of colour define the planes of the torso, the depression of the spine and the turn of the rib cage to the front of the chest. Each plane is painted a distinct colour; any change in the orientation of the surface of the back is described by an equivalent change in the colour. The nearest, most prominent part of the volume seems to be painted in a way that is more definite than the register of its edge.

The shoulders and back of the kneeling Satyr yield a similar sense of urgent making. So the plane between the raised ridge of the shoulder blades, the shoulder blade itself and the subsequent shapes of the back and arm are built as large shapes of clear distinct colour. Again, the physical tactile surface of the shoulder reads as closer and more formed than the colour at the edge of the body.

In spite of the apparent differences in temperament between the two artists and the diverging range of their subject matter, these paintings demonstrate a surprising affinity in their construction. A shared rejection of seamless continuous modelling of form, in favour of discretely separated passages of colour to define changes in surface and volume, forges an unlikely connection between the worlds of the two artists.

Daniel Shadbolt, *Self Portrait*, after Paul Cézanne, 1880–81. The great domed skull looms in the centre of the painting.

SELF PORTRAIT, PAUL CÉZANNE, 1880-81

Cézanne turns to face himself, light falling over his left shoulder. Behind him in the mirror, a pale wall and a patterned screen meet to form a vertical line to the left of the head in the painting. A glimpse of his white shirt and dark tie are visible between the collars of the jacket he wears. The silhouette of the upturned collar echoes the diagonal pattern on the wall.

The pattern surrounds the head and creates a scaffold for the bare dome of the skull. Cézanne looks at himself with both eyes open. The nature of binocular vision and the irreconcilable disjuncture caused by the distance between the two eyes, results in the vertical displacements and misalignments of the pattern. The vital sculptural presence of the head radiates into the space, so that the diagonals of the pattern are obscured close to the profile. The head is framed by the diagonals yet retains a separation from them. While a powerful diagonal leads down from the ear, through the beard and collar, to the tie, completing the large diamond around the head, it is only at the far collar that figure and ground fuse. The vertical diamond of the pattern becomes a motif that is repeated through the shapes in the painting.

The painting, and in particular the head, is built out of small areas of closely laid parallel brush marks. The marks form a unit of structure that lends unity to the surface of the painting. The patch of marks are placed against each other, each area a slight variation in colour from the adjacent. Cézanne's term for these close variations was 'modulations of colour', each patch a record of a distinct sensation of colour and light. The closely placed touches remain visible as paint and so resist a direct transformation into illusion. The emphasis on mark and touch foregrounds the close relationship between looking and making in Cézanne's painting. The patch as a unit of construction was integral to his painting, effectively the building blocks of his stated aim, to make something durable of Impressionism. The pieces of colour are not intended as an imitation of the appearance. They represent an equivalent to a particular sensation and, taken together, constitute a reimagining of the head in paint.

The mixtures of colour, ranging from yellow to red-orange, blue-violet, green and so on, do not display a marked difference in tone. The tonal range across the head is compressed; instead,

Atul Vohora, *Bathers* (*Les Grandes Baigneuses*) after Paul Cézanne, c. 1894–1905. The mysterious and monumental figures inhabit Cézanne's densely constructed world.

it is the contrast of hue and saturation that reveal the changes in the orientation of each facet of the form.

The smooth dome of the skull is fractured into fragments, each piece defining a particular plane and orientation on the surface of the head as it turns away from the light. This reconstruction in paint is not purely optical. The visible touch of the brush is accompanied by a forcefully tactile sensation of form. The eye socket, nose and eye itself are painted with a density and physicality that would seemingly respond to the touch of a hand. Cézanne reinvents the way in which paint is harnessed in making form. The nature of his reinvention is radical, and represents a departure that is close to the idea of seeing for the first time.

Les Grandes Baigneuses is one of three similar paintings found in his studio at the end of Cézanne's life. While it is possible that all three paintings were worked on simultaneously, it remains unclear whether Cézanne considered them completed. They were part of a wider project to integrate the figure into the landscape. *The Bathers* paintings are not made from direct observation and, as such, stand apart from the body of Cézanne's mature work. He may have made reference to reproduced images of sculptures and paintings as well as photographs. The three paintings are much larger than any of the previous Bathers paintings by Cézanne. The scale of these pictures is in itself a declaration of ambition; the dimensions are close to the Poussin *The Golden Calf* and the Rubens *Minerva Protects Pax from Mars*. Although there is no evidence of a direct literary reference for this painting, there is arguably a narrative framework to the figures.

As in the painting by Rubens, a female figure strides into the composition from the left of the image. The set of her body signals an intention that is quite distinct from the atmosphere of intimate repose permeating the rest of the picture. The tilted trees above and behind her accentuate the diagonal charge of her entrance. A ripple passes through the group as the disruption is registered. It is the dejection of a distant figure at the far right of the composition that seems an answer to this dramatic tension. The story of Diane and Callisto has been suggested as a reading of the painting.

A shallow area of deliberately painted ground separates the group of figures from the front of the composition, creating a short pause before the main movement of the picture. The figures function as structural, architectonic elements in the composition. The unforced symmetry of the two seated figures contains the force of the diagonal momentum of the central figure, lying with outstretched arm, picked up by the limbs and bodies either side of her. The heads of the figures read as a series of warm notes against the landscape, the rhythm of which is mirrored by the billowing shape of clouds in the distance.

Again, the painting is built from patches of colour, which are themselves parallel brush marks placed close to each other. The direction of the touch in each patch varies although there is a consistency to the scale, which acts to unify the surface of the painting. A spatial consideration is central to the construction of the whole image, so the patches of colour explore relative possibilities of near and far. A consequence of the rigour of Cézanne's language is that the surface begins to have something of the appearance of beaten tin, a shallow relief of lumps

and hollows.

The bodies and limbs are painted to a bursting fullness. Cézanne carves the cylindrical forms from the highest point of the relief, each area of colour cutting back around the body. The volume is the result of the juxtaposition of coloured patches, which retain a distinct identity as mixtures, and stand as equivalents for the changing planes across the form. The result of this consideration is a kind of abstraction. The coloured patches interact with the line to make an image that possesses a compelling pictorial reality without seeking overtly to mimic appearances. The brush marks and the patches of colour function as independently unifying structures. When placed in the context of its immediate forebear, Gustave Courbet's *La Source*, 1862, the painting represents a polemical shift in the possibilities of the language.

Matisse and Picasso were both immediately sensitive to the potential of Cézanne's departures. The fractured surfaces that generate bold, immense volumes are crucial in the gestation and realization of the splintering of Cubism. Matisse grapples with the idea most fully in the four back sculptures, which demonstrate an engagement with carved form, fracture and monumentality through their development. The density and raw physicality of the sculpture resonates with the construction of Cézanne's bathers and to an extent, frees Matisse's painting

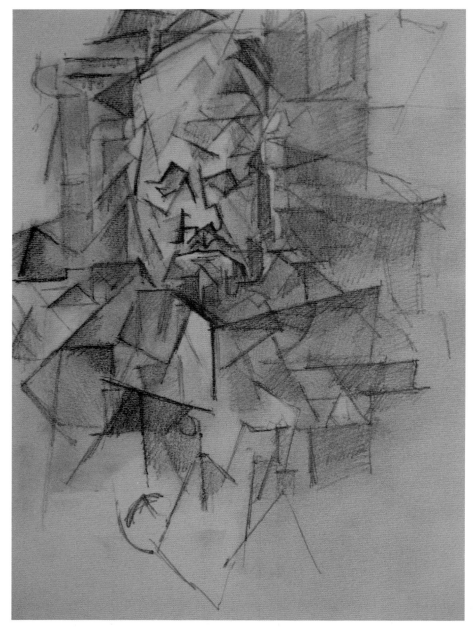

Atul Vohora, *Ambroise Vollard*, after Pablo Picasso, 1910. The surface fragments dissolving the form.

from primarily plastic constraints.

Picasso's painting of Ambroise Vollard was made in 1910 and is now held in Moscow. The hulking figure of Vollard is subjected to a deliberate strategy of fragmentation. The angular prism of intersecting shape at once reveals and disrupts the image. Shards of muted colour interact tectonically, generating autonomous structures that push and slide under and against each other. Heightened tonal contrasts create a sense of compressed relief across the surface of the painting. The image of the head is fugitive, crystallizing and becoming legible, only to dissolve and disintegrate and in this way mirrors an inherent instability in the experience of looking. The head, as a centrifugal presence, dominates the centre of the painting. The half closed downturned eyes are a reference to the painting of Vollard by Cezanne. The fracturing of the surface is focused on the area of the head and dissipates to the far bottom edges. The angular shapes of each facet of the splintered form remain firmly on the flat surface of the painting, although, at times, the shapes perform a dual function, in also becoming convenient signs for the features of the face.

To Space

Beyond the purely iconic depiction of a figure, the question of context arises. Supplementary to the construction of the figure, is the necessity of placing it in relation to a place or thing. The inclusion of an external reference within an image, either an object or a spatial signifier, immediately redefines the initial figure. Often the ability to recognize a person is tied to an idea of place; seeing a familiar face in an unfamiliar environment can lead to a momentary confusion.

The act of locating a figure spatially, and by extension temporally, in a painting, inevitably reflects both the beliefs and understanding of the artist. Encoded within an attempt to answer the question 'Where?' are a set of physical and metaphysical beliefs about the world, which may lie buried in accepted visual conventions for depicting real space. Any attempt to create a painting that, as an image, includes depth, encounters the unavoidable and ultimately irreconcilable problem of the gulf that exists between the flat picture surface and the depth of the world. The tangible, physical world cannot exist on a flat surface; through a mixture of shared signs, and to an extent, illusion, it may be possible to recreate the appearance of the world very convincingly. But the gap remains unbridgeable, the surface will always remain just that, a flat surface covered with marks.

Over time, formal conventions for the construction of pictorial space have emerged. Continually refined, these conventions become embedded in visual culture, to be either followed or subverted. The most recognizable of these is the construction

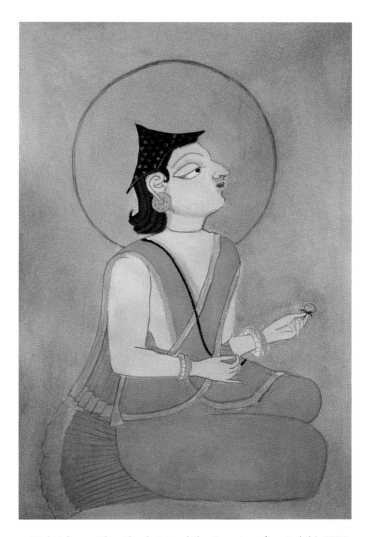

Atul Vohora, *The Absolute and the Cosmos*, after Bulaki, 1823. The series of squares depict three aspects of the Absolute. Defined as in terms of negation, without form, without origin, without colour and so on, a field of gold represents the self-luminous Absolute. Here in the second panel, a seated Siddha, set against an expanse of gold, represents the first manifestation of the Cosmos in subtle form.

of space defined by monocular systems of perspective. A manifestation of rational empirical enquiry, this system of construction mimics appearance closely within a small angle of vision. As the angle of vision broadens, the image begins to suffer distortions and the relationship to appearance breaks down.

Alternative constructions of pictorial space hold diverse relationships to appearance. The idea of what defines 'real space' in a painting is broad and fluid. Images can attempt to express an experience of the relationship between a figure and space,

Atul Vohora, *Skeleton Blue*. Painted from within arm's reach of the skeleton, the visual field in the painting extends over a wide angle of vision. The vertical axis ranges from above the head down to the feet and horizontally, the painting spans both the skeleton and the reflection in the mirror. Measured from two suspended verticals, one running through the centre of the skeleton and the second through the centre of the mirror, the pictorial space arcs over the wide angle, with the result that the base of the mirror is seen twice. The mirror enables the skeleton to be seen from two aspects simultaneously.

that is, to reconstruct visually the experience of seeing. Architectural elements can be used to punctuate the pictorial surface, dividing the field visually as a way of organizing the image. This chapter explores a range of pictorial possibilities, which engage with the idea of locating a figure in space.

THE MASSACRE OF THE INNOCENTS, AFTER DUCCIO DI BUONINSEGNA, 1308–11

Almost a square with truncated corners, the four quadrants of the composition of The Massacre of the Innocents, by Duccio carry distinct emotional resonances. The king, seated in an elevated gallery, gestures at the group of women pressed into the bottom left corner. This huddled group of grieving figures tries desperately to resist the inevitable end. The soldiers, with a marked absence of enthusiasm, are poised to run their swords through the helpless bodies of the naked children they hold. At their feet, the lifeless corpses gather in a mound. Diagonally opposite them, the painting is empty. The horror and inhumanity of this episode taken from the biblical narrative, is conceived of, contained by and expressed in relation to the idea of the square.

THE GAME OF DICE; THE DISROBING OF DRAUPADI, ATTRIBUTED TO NAINSUKH C.1765

The Game of Dice describes the events following Yudishthira's catastrophic game of dice. Bound by a code of honour to accept the challenge laid down by the Kaurav prince Duryodhana, Yudishthira agrees to gamble. Having lost everything, including his own freedom as well as that of his five brothers, he wagers his wife, Draupadi. Inevitably, he loses again. Urged on by Durydhana, Dushasana attempts to remove the clothes she is wearing. The five Pandava brothers watch impotently from the front right. Divine intervention prevents further humiliation. As they are removed, her clothes miraculously multiply; she escapes being seen naked and the discarded fabric piles up

Atul Vohora, *The Game of Dice*, Transcription. Draupadi's garments multiply miraculously, while the five brothers watch in a dejected heap. The Kauravs sit in the pillared gallery above.

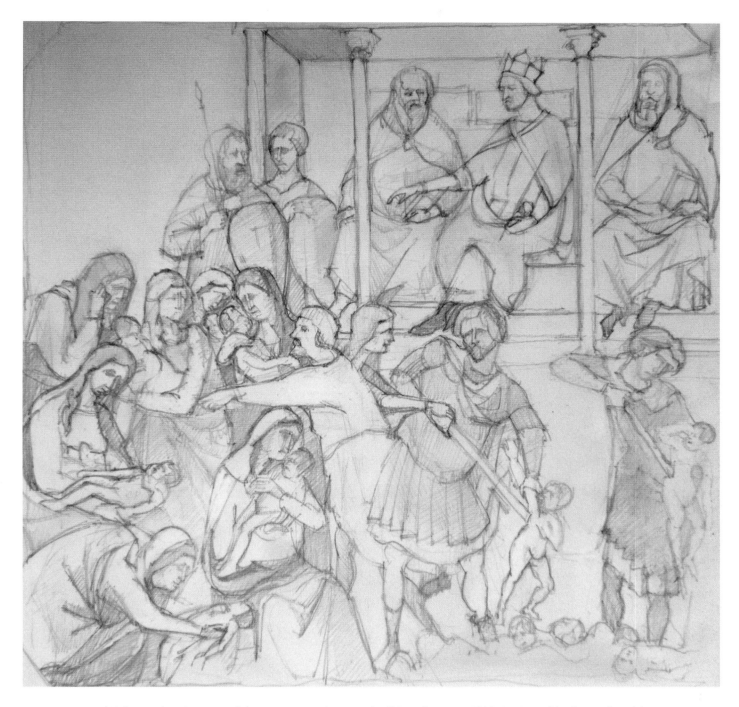

Atul Vohora, *The Massacre of the Innocents*, after Duccio di Buoninsegna, 1308–11. From his elevated position
in the pillared gallery, Herod orchestrates the massacre below.

around her feet. The result of this episode, taken from the
Mahabharat, is that the two families are plunged into a devas-
tating war.

The blind King Dhritarashtra, father of Duryodhana, is
perched in a gallery very similar to that in which Herod is paint-
ed. Flanked by two pillars, he is set back from dramatically
unfolding narrative. The pillars here divide the upper half of the

composition into three equal portions and separate the paint-
ing spatially into front and back. The figures are organized into
three groups, and the gesture made by the prince Duryodhana
from the gallery, almost identical to that made by Herod,
bridges the separation between the two areas. Again, as in the
Duccio, the figures at the front are divided in space and in their
responses to the unfolding narrative. To the left, Draupadi and

Atul Vohora, *The Denial of St Peter*, after Duccio di Buoninsegna, 1308–11. A complex spatial construction links the two separate episodes of the narrative. Note the stool in the bottom left corner.

her assailant, are surrounded by the growing mound of fabric at their feet. The five Pandava brothers sit in a dejected clump to the right.

In both paintings the space is compressed so that the figures do not appear to diminish with distance, although the diagonal of the wall enclosing Herod's bench does give an indication of depth. The areas of *The Game of Dice* are deliberately flattened, so the carpet under Dhritarashtra reads as a rectangle. The absence of orthogonals places an emphasis on the pattern of the shapes, and the design these make.

THE DENIAL OF ST PETER, AFTER DUCCIO DI BUONINSEGNA, 1308–11

The space Duccio constructs in *The Denial of St Peter* departs further from the expectations raised by a perspectival system of construction. Rising over the heads of the seated figures, a high balcony is painted as though seen from below. A staircase leads up to the balcony; its rising diagonal becomes a metaphor for Peter's mounting denial. The orientation of the stairs is at odds to that of the balcony. This incongruity suggests that the space is not organized within the limits of linear perspective. Rather, the architectural elements function primarily to give structure to the surface of the painting and help to organize the narrative zones of the panel. The continuous space connects the two episodes on the panel. As two distinct moments in the narrative, the episodes occupy separate zones on the surface of the painting, yet visually the staircase makes an uninterrupted connection between them. The space defined by the architecture is constructed experientially; it is the experience of looking up to the balcony and across to the base of the stairs that gives rise to the aperspectival relationship between the two.

The nearest figure on the left of the fire is seated on a circular stool. The low stool, close to the front of the painting, is seen from above and the round seat reads as almost fully circular rather than the expected ellipse. Seemingly tipped forward, the circle resonates with the flat surface of the picture plane, resisting a sense of the depth of the pictorial space.

MAHARAJAH KIRPAL PAL OF BASHOLI SMOKING, C.1690

Poised against a clear field of luminous yellow, Maharajah Singh of Basholi lifts the slender neck of the pipe to his lips with evident relish. His powerful frame is defined by a series of deter-

Atul Vohora, *The Pipe, Transcription*. Shape creates an interaction between pattern and space.

mined linear rhythms incised into the red of his robes. The forceful volume of each limb and the delightfully understood twist of his body are the result of the intensity of the drawing. The overlapping and layering of forms in space are the result of keenly observed natural phenomena.

The Maharajah sits on a brilliant white sheet, which covers the stripes of the rug, and leans against a swollen green bolster. Neither the edges of the white sheet nor the stripes in the rug appear to converge in the painting. Pressed vertically against the picture plane, the rectilinear shapes resist being harnessed in the description of depth. Their clarity and presence in the composition resonate with the edges of the painting and the red painted border surrounding the figures. The border defines the edges of the composition yet remains within the field of the painting. As a limit to the pictorial space, the red border is permeable, demonstrated by the figure on the left breaking the edge.

The rounded belly of the bowl of the pipe nestles on its elliptical base. However the mat beneath it becomes circular. Throughout the painting, there is a strong interplay between constructed volume implying depth, and the idea of the flat surface of the picture. So while the objects and figures are understood as physical forms in space, the floor is painted vertically, parallel to the picture surface.

A similar tension and interplay between surface and space is at the heart of Matisse's *Red Studio*, 1911. Etched into a field of red, the lines of the furniture give some spatial clues. A plate on the table below the belly of the plant pot, tips into a circle. Partly arrived at perceptually, as the result of looking down, the plate echoes visually the circle of the clock on the far wall, collapsing the perceived distance between the two. The consistency of the red field further destabilizes any suggestion of distance.

THE ANNUNCIATION, DUCCIO DI BUONINSEGNA, 1308–11

The winged Archangel striding into the painting gestures to the startled Virgin Mary. Set against a field of gold leaf, the figures are enclosed within the folding planes of the arched structure surrounding this supernatural encounter. The play of light across the shifting surfaces of the architecture reveals the space in which the figures stand. The light is consistent, without having a fixed source or direction, although it does lend physical and spatial credence to the forms.

The arches and the pillars punctuate the painting, creating a musical series of variations in scale and interval. The semicircular arches naturally rhyme with the shapes of the two heads, while the pointed arches and the shift in scale of the large arch separate the two figures, giving emphasis to the Virgin Mary. The upward momentum of the Angel's body is echoed in the

Coll McDonnell, drawing of *The Annunciation*, after Duccio di Buoninsegna, 1308–11. The figures are held in a lyrical tension with the surrounding architectural structures.

Atul Vohora, *The Temple*, after Giotto di Bondone, c 1304–06. Joachim is pushed out of the enclosed space of the temple.

retiring diagonal of the Virgin's flank. The shape created between the bodies of the two figures, the unmodulated expanse of the wall behind them, resonates with an unspoken tension.

The Virgin Mary's red dress burns brightly, caught inside the rich blue of the robe wrapped over her shoulders. Trails of golden threaded border fall to the floor with a ripe trill. Her gesture is one of both modesty and hesitation, revealing something of her shock at the nature of this news. Her doubt and fear of the unknown are manifest in the dark aperture of the open doorway and the heaviness of the ceiling above her.

Rays spill down to her from a curved shape at the top of the picture. The curve is inverted in the open mouth of the plant pot below it. The pot is painted as though tipped slightly outward, allowing a fuller than expected glimpse into its mouth.

The architecture locates the scene. It provides a contrasting geometric clarity against which the organic shapes of the figures move. The shapes created by the interaction between the figures and the structure are charged with expressive potential. Finally, the rhythms of the intervals created by the pillars and arches dividing the surface of the painting are in themselves an integral part of the emotional charge of the image.

The fresco taken from the Arena chapel, by Giotto, is the first in the cycle. The childless Joachim is prevented from entering the temple by a priest, who drives him away. Folded panels define the internal space of the temple without seeking to imitate the appearance of the building. The body of the priest covers and obstructs the entrance, effectively sealing the space.

Within the screened space, a second priest offers instruction to a young boy. The presence of the child within the temple heightens Joachim's sense of exclusion. Raised arches over the altar signify its importance and help identify the site of the events taking place. The rising diagonal of the steps, climbing to the altar, adds a directional momentum to the push, delivered by the priest to Joachim's back. The architecture gives scale to the figures, and it locates the moment of the narrative spatially. The structures inform the visual and emotional register of the image.

THE FLAGELLATION, PIERO DELLA FRANCESCA, C.1454

Approached on foot, the walls of the Duke's Palace in Urbino tower over the surrounding countryside from the top of the hill. *The Flagellation* by Piero della Francesca hangs in the Palace, now the National Museum, in Urbino. The unassuming size of the picture (58.4 × 81.5cm) comes as something of a shock. The depth and scale of the world Piero constructs appears impossible to contain within the limits of this relatively small painting. A single vanishing point defines the system of perspective inherent in the painting.

It is an entirely inhabitable space; it seems possible to move

Atul Vohora, *Three Figures*, after Piero della Francesco. The three enigmatic figures dominate the front of the painting.

freely through the architecture and beyond, as though it is an unbroken extension of the space outside it. The figures are physically present in this space. They populate the painting, suspended and unmoving among the musical intervals of the architecture. A powerful yet undemonstrative compositional framework binds the figures to each other and to the architectural structures in the picture.

Through their scale and position, the figures themselves set up a series of rhythmical divisions across the surface of the painting. These resonate in turn with the patterns and intervals in the space. The painting then is rigorously constructed; the organization of the forms and the surface is pregnant with significance. Two intersecting squares enclose a Golden Section rectangle at the centre of the painting. From this, a series of similar intervals rises up through the horizontal structures of the roof.

The figures stand, held in the stillness of this fully imagined world. Abundant light spills from the infinite clarity of the blue sky, flooding the visual field. The transparent air reveals crystalline shapes, clearly incised against each other. In spite of the intensity of the organization and the clarity of the painting, the underlying meaning remains opaque. Two groups of figures are separated by the insistent vertical presence of the row of columns. Closer to the picture plane, three figures are locked in discussion, at something of a remove from the second more distant group under the arcade. The second group encircle the

diminutive figure of Christ. He is bound to a freestanding column and held, as one of his assailants raises an arm to strike. A barefoot and turbaned figure, standing turned away from the front of the painting, joins Pilate in watching. Behind him, through the doorway, a staircase disappears; the diagonal of the banister echoes the diagonal of the beams in the roof and that of the lintel.

The column to which Christ is bound is topped by a gleaming statue, revealing the classical roots of the contrapposto pose he holds. He is positioned at the centre of a black circle inscribed in the pavement below his feet. The patterned tiles either side are formed of squares, directly related to a decagon nestling inside this circle.

The group is lit by a mysterious light, which is much more than simply reflected light entering the shaded arcade. This divine illumination fills the section of the roof directly above Christ, throwing sharp shadows up into the cavities beyond, reversing the direction of the light found elsewhere in the painting.

Strong resonances between the pose held by Christ and that of the muscular, heroic youth, dressed in red, at the centre of the near group, suggest an intended allegorical association. The groups of figures are divided, occupying two distinct sections of the painting. The near group stands in the natural and contemporary space at the front of the picture. Surrounded by Albertian architecture and defined by the light of the sun, the figures are highly individuated portraits. Behind them, the second group occupies the divine, allegorical space of the colonnaded portico.

Relegating the biblical narrative to the distance is nothing short of radical. This displacement is emphasized by the perspectival structure underpinning the whole painting. Distant and smaller, the group surrounding Christ becomes secondary to the figures at the front. Seen from a low vantage point, the three figures dominate the painting with their monumental presence. The space is continuous and fully understood. It is as though Piero conceived of the structures as real architecture, in which the figures interact. Subject to consistent, rational and natural law, the figures are treated democratically, in so far as their scale is determined by their position in space rather than in relation to their perceived importance. This profoundly enigmatic painting has then, at its core, an unprecedented reordering of both pictorial and social relations.

DIEGO, ALBERTO GIACOMETTI, 1953

Facing each other, the two brothers, Diego and Alberto, engage, visually and psychologically. The painting is the result of this repeated and highly charged encounter. The haunted craggy features of Diego's head emerge from the amorphous grey. Behind him the studio ceiling rises and arcs over both of their heads. The painting is a recreation of the living presence of the figure in the space. Thin lines of paint cut through the rubbed and effaced surface, defining the figure and carving out the depth of the room.

No longer analogous to a window through which a world is presented, the painting encapsulates an immersive experience of lived-in space. Giacometti jettisons the privileged position of a remote observer. The pictorial space begins from the eye of the painter, radiating outward around the room. He is present in the painting, in as much as the painting records the process of seeing with its inherent ambiguities and instabilities.

The volume of air filling the room becomes a tangibly expressed idea. The surfaces of the walls enclose this volume, defining the limits of the space. Diego's head and body, rising up into the room, transform the space. He animates and electrifies the cavernous interior, casting every surface in the room into a charged relationship with his form. With each revision and each restatement, the fractured surfaces of his body emerge, held in the space of the room. As the surfaces accumulate, the structure of the body takes shape, acquiring a physicality born of the resistance of living matter to space and time.

Atul Vohora, *Diego*, after Alberto Giacometti, 1953. Diego, framed by the volume of the studio.

The body disrupts and penetrates the space with its animate presence. The volume of space in the room in turn exerts a pressure on the body. This interaction defines a tension, the coming together of an internally generated force and the external pressure of the space. The compressed forms in the painting are the result of this tension held in equilibrium.

The outer edge of the painting is drawn within the shape of the canvas. It too has emerged as an integrated part of the process of making the painting. Multiple revisions reveal an ongoing re-evaluation of its position. Expanding and contracting as the picture develops, the final shape of the drawn rectangle is inseparable from the marks it contains. In this sense, Diego's head and body cause the scale and shape of the rectangle. His body is similarly created as a consequence of the shape of the rectangle. The relationship between figure and ground, body and edge is fluid and shifting. The search is to find an equivalent to the charge of Diego's presence, distant, isolated and contained within the space of the room.

Space becomes the visible medium of the painting. It is at the limits of this space, meeting the walls, ceiling and body that each form is revealed in turn. The contours that define these limits are to a degree permeable, born of an exploration of the visual field, and represent an elaborate reconstruction, in paint, of the radically transformative effect of the presence of a living being on a space. The form of Diego is condensed to its core. Paring away the excess form leaves only its essential presence. Diego, fully synthesized with the space of the room, comes to inhabit the painting.

PORTRAIT OF GEORGE DYER STARING AT BLIND CORD, FRANCIS BACON, 1966

Emerging from the scattered detritus littering the confined space of Bacon's studio, the painting is of the painter's young lover. The turbulent relationship began in 1963 and ended with George's eventual suicide in 1971.

The large scale of the picture and the curving space it contains invites a sense of participation. It seems possible to step into the painting, which becomes an extension of the space and time from which it is viewed. A harsh, uninflected light fills the space. The merciless glare leaves nothing concealed. The seated figure at the centre of the picture is cruelly exposed, and yet the pared down environment and flattened lighting has something of the stage set in its appearance, as though the figure is playing a part.

The fields of gently contrasting colour fill the rectangle. Pale blue divides the slabs of clear ochre. The rich green of the floor surrounds the almost complete red circle of the empty seat. The space is indicated rather than conventionally defined. The broad, visually calm fields of colour are the site for the painterly convulsions, which erupt in the form of the body. Agitated paint bursts through the surface. Ostensibly sitting, the body resists a single reading. The layered marks fracture and disintegrate into an incandescent explosion of pure sensory abundance. The shape of the body offers taunting glimpses of recognition, in the turn of a shoulder or a snatched profile, only for the image to dissolve and disappear 'up unknown stairs'. The frenzied touches sit over a remorseless field of black, whose ominous undercurrents fill the image with a palpable sense of foreboding. The haunted, wounded presence of the figure stubbornly claims its existence. The watch face on what would be the arm, intractably retains its integrity, in spite of the miasmal paint around it. White paint flung suggestively at the canvas disrupts the potential for illusion further, by sitting obstinately on the picture surface in a violent splash of virile desire.

Painted from memory and with the use of photographs, the painting seeks to reconstruct as fully as possible the living presence of the subject. It is an attempt to encapsulate in paint, on the surface of the picture, the complete reality of the person and the sensation aroused by their appearance. The elastic distortions are that of breathing flesh, in all its materiality, apprehended by the heightened sensitivities of the nervous system of the artist.

The painting is evidence of Bacon's declared intention to escape the formulaic, the habitual, in both looking and representing. In this struggle to see and make the figure, in paint, apparent distortions arise. The painting is an attempt to grasp reality, to make visible with irrefutable lucidity the living presence of the figure. Paint is wrenched into biological viscerality. The physical body, unidealized flesh, pungent with the smell of death, is inseparable from the complexities of being.

Placed centrally, George is enclosed and enshrined within the limits of an inscribed linear framework. The bare outline gives emphasis to the figure, becoming a visual pedestal for the anguished ecstasy of paint at the centre of the painting. The rectangle of a painting on the wall behind encloses the head. The severity and fixity of the rectilinear shapes reveal the organic fluidity of the figure. The cage and rectangle both separate, as well as elevating the figure. The enclosure serves to isolate the figure, to contain the persistent and disturbing charge of its presence. Flesh and life are uncovered; paint reveals flayed reality in all its horror and enchantment.

Atul Vohora, *Portrait of George Dyer Staring at Blind Cord*, after Francis Bacon, 1966. The secondary internal cage-like structure transforms the reading of the space and the register of the figure's presence within the painting.

This is not a Woman

LA GRANDE ODALISQUE, JEAN-AUGUSTE-DOMINIQUE INGRES, 1814

The painting was first shown in 1814 and was painted for the Queen of Naples, Caroline Murat, a sister of Napoleon Bonaparte. The title summons a constructed Orient and locates the nude in a heavily scented environment of decadent sumptuosity. It is an image of tactile sensuality; brilliant silk flows into the gentle feathered caress of a lightly draped fan. The yielding softness of the well-cushioned divan is covered by fur and linen. Heavily jewelled and decorated ornaments lie scattered around the unblemished, gleaming skin of the concubine. The surface of the painting is similarly immaculate and unbroken by the appearance of brush marks.

There remains something implicitly gendered in the highly consumable eroticism of the portrayal of the woman. The image is constructed around the idea of display; the woman is primarily being seen, as both naked and available. The painting does however avoid the limitations often raised by conventional voyeuristic Orientalist fantasy. A series of contradictions in the structure and organisation of the image are the result of the far-reaching pictorial ambitions and inventions within the painting.

As a pupil of Jacques-Louis David, Ingres based his *Odalisque* to an extent on the model of David's portrait of Madame Recamier. Dextrously able to resist the amorous attentions of Napoleon, Madame Recamier eventually found herself exiled from Paris for her impertinence. During this period of exile, she travelled extensively in Italy, including a journey to Naples, where she was well received by Caroline Murat. This was in 1814, the same year in which Ingres painted his *Odalisque*. David's painting *Mars Disarmed by Venus and the Three Graces*, painted in 1824 has strong echoes in turn of the *Odalisque*.

The painting of Madame Recamier by David, now in the Louvre, was commissioned in 1800 and remained unfinished. The figure is modelled in light falling from outside the left of the composition, and the sparse and seemingly unyielding furniture of the room emphasizes the flowing folds of her robe.

While maintaining the idea of the half-turned head, and the outstretched legs and bare feet turned to reveal the soles, Ingres transforms the stately elegance of Madame Recamier into the voluptuous nakedness of his exotic *Odalisque*. The severe profile and the overtly triangular shape of the shoulders identify the woman as an explicitly classicized nude, now transposed to

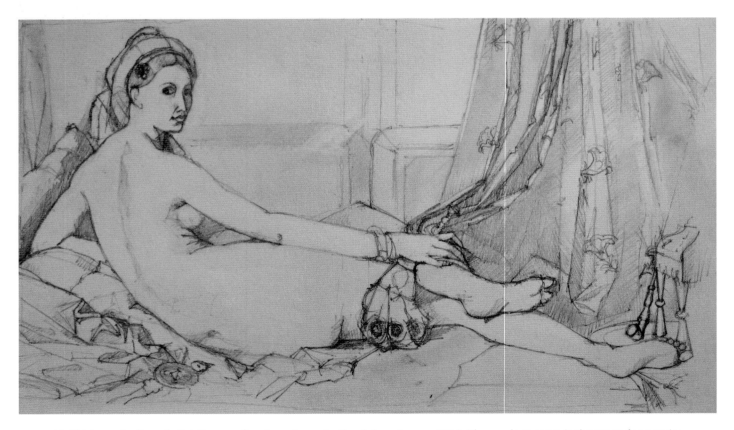

Atul Vohora, *La Grande Odalisque*, after Jean-Auguste-Dominique Ingres, 1814. The opulent room is the stage for a series of unexpected visual departures.

the languor and luxury of a romanticized image of Eastern opulence. The painting summons a canonical classical ideal, which is then subverted with radical departures from accepted proportional ideas. Equally, the austere severity of the candelabra, stool and meridienne in David's painting, is exchanged for an intoxicating abundance of texture and luxury.

The body sweeps diagonally across the painting. The woman leans on the compressed shape of her left arm, while the long right arm extends over her naked thighs, meeting the powerful turn of the right leg, as it arcs down to the corner. She tugs coquettishly at the hanging drape, as though to cover her exposed flesh.

Set against the clear horizontals and verticals in the room, the slow turning curves of the body are amplified. The arabesque of the hip and back dominate the composition. Both the back and the leg depart from a dutiful anatomical correctness. Their lengthened forms turn with a sinuous grace, contrasting with the compressed triangle of the left arm. The hip becomes a monumental presence at the centre of the painting, the skin pulled around its abundant form. The raised left knee seems somehow incongruous with the position of the pelvis. Lifted in

this way, the knee rests at the mid-point of the picture.

Several preparatory drawings exist for the painting in which the shape and position of the right hand is explored and revisited. Ultimately, Ingres settles the hand with its back almost parallel to the picture plane. The long, lingering descent along the arm culminates in the hand and the gently balanced feathered fan, hanging from it. Painted with a reduced inflection, the sense of volume of the limb is inferred from the bracelet encircling the wrist. The extended curve of the arm, mirroring the downward turn of the hip, completes a crescent, as it carries up into the folds of the drape on the right. The hand interrupts the projecting diagonal of the left leg. The effect is to diminish the sense of depth in the painting.

The drawings confirm the intention to increase the length of the figure along the diagonal, although suggesting a much fuller sense of volume. In the drawing, the left leg retains a higher degree of naturalism. In the painting, however, the generous depth of hip and bottom are masked by white fabric and the spatial interplay of wrist, heel and knee is interrupted by the feathered fan. Several clues to the volume of the figure are retained, a cast shadow from the left heel turns over the right

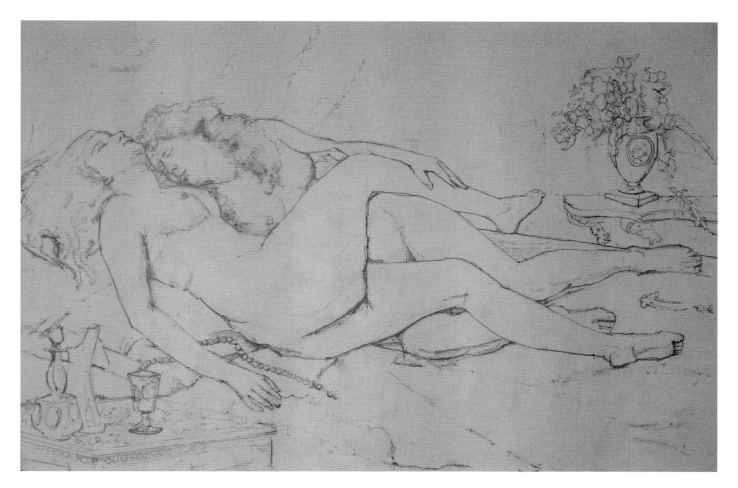

Christopher Dean, *Sleeping Women*, after Gustave Courbet, 1866. The languid twisting figures lie in a deliberately compressed space.

calf, folded skin reveals the turn of the waist and deeper shadows give form to the neck and head. The sense of volume created by the lines of the form is largely negated by suppression of modelling in the figure. The resulting bold shapes contrast strongly with the intense scrutiny Ingres brings to the comparatively fractured and angular construction of fabric and form in the rest of the painting.

The inventions Ingres makes cannot be entirely ascribed to a process of idealization of the female form. It would seem the shapes he arrives at are themselves the result of an engagement with the internal dynamics of the rectangle and the tension between the flat surface of the painting and the constructed pictorial space. The picture alludes to a heightened realism in the language of its construction and yet the figure is arrived at as a result of primarily abstract considerations. The surprising distortions of the body are seemingly unsustainable, the small head and asymmetrically extended limbs exerting considerable tensions on the body, and yet, the integrity of the image remains intact. The terms of the painting's construction are largely independent and maintain their own pictorial reality. The naturalism of the figure masks the radical departure Ingres makes here, as a painter of the human form.

The Sleepers painted by Gustave Courbet in 1866 shares a similarly lucid clarity. Courbet co-opts a mode of high realism as a part of a polemicized stance against his perceptions of contemporary convention and morality. The painting is intended to shock and employs the language of realism to authenticate and accentuate an idealized image of sexual interaction. The woman with lighter hair has been identified as Joanna Hifferman. The presence of an individuated person in the painting can be seen to underline Courbet's determination to subvert the conventions of the female nude as remote and idealized.

The two women lie naked, wrapped in each other's limbs in a state of exhaustion. They appear oblivious to anything outside their self-contained embrace, and yet, the lifted thigh and twisted back puncture the illusion of containment and reveal the

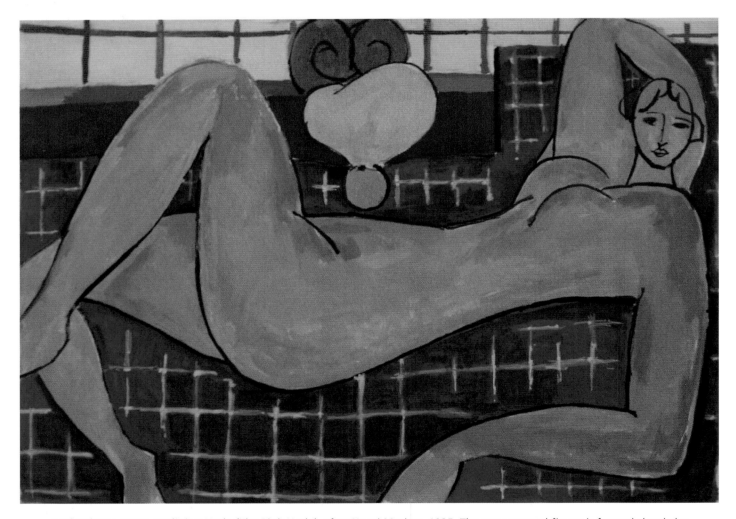

Atul Vohora, *Large Reclining Nude (The Pink Nude)*, after Henri Matisse, 1935. The monumental figure is framed closely by the edges of the rectangle. Filled with light and air, the painting is simultaneously flattened.

image as a construction intended for the viewer.

The pose and mood of abandon of the dark-haired woman recalls Titian's painting of *Danae*, although the twisted back and both the pale tonality with subdued modelling, and the vivid clarity of the painting directly refer to the *Grande Odalisque*.

The figures are seen from close to the bottom of the bed and from a relatively low point of view. They are positioned along the diagonal of the rectangle and two small tables frame the intertwined couple, presenting a contrast of ordered domesticity with sensual physical abandon. A broken strand of pearls and a discarded hair comb allude to passion and freedom from restraint. The trailing right hand of the dark-haired woman parts the white sheet to reveal flesh-coloured fabric in the fold.

The bed appears to tilt upward compared to the plane of the top of the small table at the front of the painting, lending a sense of spatial ambiguity to the image, as though the bed and table are seen from different positions.

The pictorial space becomes discontinuous and the effect of this is to compress or reduce the apparent depth of the picture. The objects on the tables are closely scrutinized and draw the distance across the bed. The vibrant orange on the blue bottle at the front of the space set the key of the painting. The spray of flowers against the blue wall echoes this contrast with an almost identical opposition. However the much larger scale of the flowers again resists the spatial implication of the drawing and flattens the depth of the pictorial space.

Matisse painted *Large Reclining Nude (The Pink Nude)* in 1935. It was bought in 1936 by Etta Cone and is now held in Baltimore. There is some evidence to suggest that Matisse painted the picture with Etta Cone in mind. The evolution of the painting was documented photographically and the surviving photographs demonstrate the often radical ongoing revisions that mark the genesis of the image. Matisse sent copies of these photographs to Ms Cone while the painting was still in progress. Matisse and Etta Cone had been introduced to each other by Gertrude Stein, and there is some suggestion that Etta Cone shared a physical relationship with Gertrude Stein.

Drawings relating to the painting reinforce the idea of Courbet's *Sleepers* as the point of departure for *The Pink Nude*. The pose of the nearer of the two women, in the painting by Courbet, is reversed, and in Matisse's drawings, the forcefully wrought twist of the form is recreated in vigorous and energetic line. The first recorded state of the painting has a bunch of flowers in a vase placed beside a chair in the far corner of the room.

The sequence of photographs indicates that Matisse goes on to substantially remove references to a perspectival space. The corner of the room and the shape of the chair are simplified to a series of frontal, geometric planes. Grids of squares flood the horizontal fields of pure colour, the organic curves of the body contrasting strongly with the vertical and horizontal of the pattern. The scale of the lattice covering the blue zone of the painting, is significantly smaller than the green squares on the white field. The position of these fields in the composition raises an expectation of depth.

By creating a more compact grid at the bottom of the composition, Matisse deliberately destabilizes any illusion of space. Similarly the pattern of the grid eliminates a sense of converging orthogonal lines, so that each field of colour becomes a flat shape pressed parallel to the vertical plane of the canvas. There remains however enough of an indication of spatial recession within the paler red band to sustain the idea of the depth in the painting. This engagement with the, at times, conflicting demands of pictorial space and the integrity of the flat surface of the painting, was informed by Matisse's interest in similar tensions in the construction of Persian miniature paintings.

The horizontal and vertical structures surrounding the pose and the triad of pure yellow, red and blue evoke the abstraction of Mondrian. Here they serve as a foil to the monumental arabesque of the figure. The full limbs expand, extending across the picture surface and ultimately beyond the edges, becoming uncontained by the rectangle. The arms exert a vertical tension on the top and bottom edges of the rectangle, as though to force them apart. Both upper arms resonate with the vertical rungs of the grid formation. An equally pronounced vertical of the back of the raised thigh seems to anchor the structures of the legs within the rectangle.

A sinuous black line, of varying intensity, carves out the long back and full limbs of the reclining giantess. The immense forms of the limbs enclose areas of the blue field between them. The pale pink and orange paint of the body is spread lightly between the sharper, more insistent note of the line. The paint is applied thinly over the surface of the canvas, at times hinting at an explicitly plastic intention, at others simply reverberating as an area of luminous breathing colour, against the density of the unyielding blue.

The raised left knee breaks the edge of the blue field penetrating the red bar and finally turning within the white field. The arresting binary opposition of checked blue against veiled orange is disrupted. The leg now devoid of line, pulls the red and white fields back into the composition. The dramatically simplified vase of flowers and chair nestle in the tender enclosure made by the arm, breast, stomach and leg.

The scale of the head seems understated, underlining the extraordinary presence of the rest of the body. The painting does not attempt to describe the appearance of a particular individual. The features of the face are drawn with an economy and directness that reclaims an anonymous neutrality. They are rendered as signs that function as a part of the rhythmic dynamism of the painting, affirming the position that this is a painting not a woman.

THE FROZEN MOMENT

Since its inception, the relationship between photography and painting has been complex and shifting. Indeed the implications of new technologies on questions of visual experience remain urgent and profound. A photograph in its purest sense as light indexed on a surface, carries an apparent authority in its ability to denote and imitate appearance.

The photograph is a record of both the physical trace of light and in the image, a resemblance to the object photographed. In spite of the many challenges that exist, this idea of the photograph as an unmediated record of reality remains persistent. It can be shown that in some ways the syntax of photography is related in origin to the close scrutiny of highly rendered naturalism in painting. Emerging from the technology of the camera obscura, the production of an analogue photograph requires a section of film to be exposed to light, processed and the negative reprinted. All of these processes provide opportunity for intervention in the formation of the image. The mechanical process by which the real is apparently imprinted in the image cannot account for the possibility for meaning to be internally generated and organized within the image. Negatives can be spliced, prints burned out or exposed twice, images cropped. The result of these textual disruptions is a dislocation of unmediated meaning. Early photographs frequently included painted backdrops and props, intended to convey social and cultural ideas; at times the print itself was modified with touches of a brush used to add colour.

The photograph renders space in a coherent perspectival mode. Based on light passing through a lens or aperture, the image mimics the monocular seeing upon which perspectival pictorial space is constructed. By remaining adhered to this convention, the photograph is unreconciled with a fuller, binocular human experience of existing in space.

The image is contained by the limits of the frame, so formed by an inevitable selection and its unshakeable shadow, omission. The ability to isolate an area of the visual field is then to remove context and to re-present the image. This manipulation confers a kind of power, related to the idea of truth, which depends on the mimetic ability of the photograph for its authority.

In its documentary mode the photograph leans toward neutral observation, while masking rhetorical or political intentions. The ability of the photograph to function as a report produces a shift in the conception of looking itself. It is a seeing as if one were there, made possible by a disembodied and almost universal eye. This extension of the limits of the seen has implications for being seen, manifest in the growth of surveillance, of unknowingly being recorded.

Developments in the technology enabled the thresholds of visual experience to be rolled outward, particularly in relation to movement. Precisely by its ability to arrest movement, photography revealed to the eyes aspects of movement which had previously remained unseeable. More than simply an aid to looking, the photograph began to displace the eye in its role as seeker of truth.

With its immediacy and widespread availability the photograph facilitated a kind of democratization of the self-image, or photographic portrait. The image of the head, severed from the body and invested with all the authority of the photograph,

LEFT: Atul Vohora, *Blue Tie*.

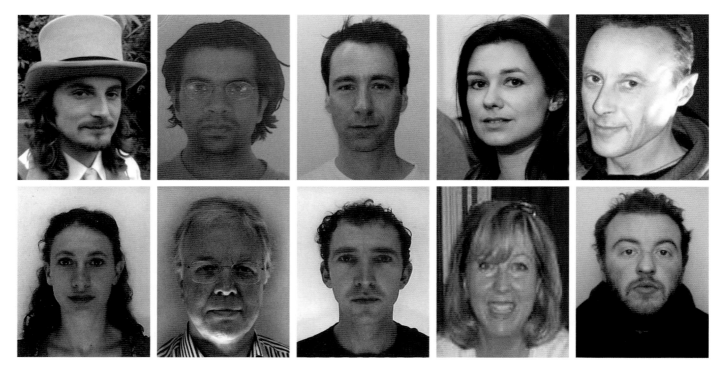

Ten Heads.

came to be co-opted as a record of identity. More recently the evolution and propagation of the digital image has increased the potential for reworking photographic imagery. Bodies can be reshaped, adjusted, aged, made younger or even entirely constructed, within the linguistic framework of the photograph. The repeated use of refashioned self-image as a means of social exchange makes the medium of the screen into something of a hall of mirrors, while seemingly reinforcing the idea of the photograph as a site of truth.

The evolution of the photograph cannot be entirely separated from the act of painting. The multiple dialogues between these modes of representing the human form have proved immensely fertile. Certainly many painters have seized upon photographic imagery with considerable excitement as a source for paintings. This includes not only images of figures both stationary and in motion, but also photographic reproductions of works of art. Photographic documentation significantly facilitated the possibility of inter-cultural appropriation. Perhaps most significantly, the mimetic imperative of the photograph challenged the purely mimetic conception and functions of painting. The ready realism of the black and white photograph may indeed have provoked crisis in a certain kind of painting. Equally the photograph had some bearing in the explosive experiments in colour and form emerging at the end of the nineteenth century. Here the indexed photographic image is experienced and reflected in dramatic departures, a

kind of liberation, in painting and the possibilities of painting itself.

SELF-PORTRAIT, CHUCK CLOSE, 2007

The colossal scale of the painting is transformative; the looming head fills the visual field inducing a sense of unease and instability. The overwhelming size of the picture demands a certain distance for the image to be readable. Based on a section of a comparatively small photograph, the painting is of the artist's own head, cropped very closely.

The photograph, importantly, makes it possible for Close to hold a stable, fixed image in his hand. As a part of his painting process, he is crucially able to repeatedly check the emerging painting against the unchanging photograph. This limiting of the contingencies of visual experience releases for Close the possibility of building the painting gradually and incrementally, over a long period of time. The photograph represents a particular section of the visual field, which here has been cropped a second time. It is fixed both in scale, as the dimensions of the print held in his hand do not alter, as well as in relation to time, as it represents a frozen moment. The static nature of the image is the result of the process of light imprinting on film. What remains is a record of the moment, isolated within the flux of time. Within the frame of the photograph, there can be no movement, it is as though the passage of the sun itself through

the sky has been arrested, so that the recorded event is fixed. As an image of a past moment, the relationship between the photograph and memory seems inevitable. It is a past without movement, a splinter of time stilled and in this unmoving state heralds permanent absence and death. The context within which the photograph is seen can redefine the image, but cannot alter the inscribed relationships. The mythology surrounding the emergence of these paintings within Close's oeuvre points to the painting of photographs as a strategic attempt to counter prosopagnosia, an inability to remember faces. Constructing the paintings became a way of remembering, through the recreation of the image as a flat painted surface.

Similarly the photograph is constructed from shapes and signs alluding to the continuous visual field within which it exists. The social, cultural and visual apparatus surrounding photographic imagery allow the analogous nature of the image to be sustained. Turning the photograph over, to look at the blank back of the print, collapses this illusion of continuity.

Like a mirror, the photograph here reveals an image of the self and yet remains resolutely a flat surface, in this case, held in the hand. To sustain the illusion of a three-dimensional space reconfigured on a two-dimensional surface, inevitably distortions particular to a photograph arise. Close accepts and transfers these adjustments into the painting, so variations in focus arising from shifts in the depth of field and distensions of the form produced by the lens are retained. Both the sensitivities of photographic film and the process of printing the image from a negative lend a bias to the colour that reoccurs in the painting. The intention, however is not to reproduce a facsimile of the photograph, or to achieve a likeness of himself. The photograph becomes a vehicle for the painting process, invoking a site for work, which particularly emphasizes the flat surface and the distribution of marks across it.

The initial photograph of the head frames the face; Close then crops the image again, framing the head more severely, so that part of the head is lost. The original image is redefined before the painting begins, through a process of removal. A grid imposed over the remaining portion of the photograph forms the basis of the painting.

While placing an intense focus on the image of the face, cropping the picture in this way is an intervention that raises the sense of exclusion, with what is left out of the painting lingering as a trace in the final image. The result of this multiple reframing is to remove anything recognizable from the image apart from the face. The head fills the rectangle and is at the same time uncontained by the limits of the canvas.

The painting is divided into a diagonal grid of squares, so that the entire surface of the canvas is assembled from cells of colour. There is some resemblance to the construction of a mosaic, with each cell behaving as the tesserae of the mosaic. Equally the formation of the image using a repeated unit has echoes of printed reproductions in newspapers. The highly economical process allowing multiple prints to be reproduced almost identically is reversed in the painting, becoming instead a labour intensive, incremental process producing a singular idiosyncratic image.

The cells can vary dramatically in their internal composition, with adjacent cells built from widely diverging touches and bands. Each cell has an analogous relationship to the idea of a musical chord, and only functions fully when understood as a part of the whole surface. When seen at a distance the bands of colour within each cell begin to recombine optically to read as an equivalent colour. The effect of distance is to reduce the separation and autonomy of each unit and to encourage a reconfiguration of the image of the head. The sensual exuberance of reading the cells individually and the delight in their individual inventiveness is deferred to regain a sense of wholeness. The cells are however, large enough to remain visible as the structure of the surface of the painting, even from a distance, and offer a resistance to the reading of the image.

On returning to view the painting in close proximity, the cells once again reclaim an increasingly autonomous individual identity. The modular structure of the painting intervenes in dispersing the image – the image fragments and wholeness is lost, mimicking the non-recognition of prosopagnosia. Yet, once the reconstituted image has been activated, it remains unconsciously present, so that even when the proximity to the surface of the painting makes an impossibility of seeing the whole, the head lingers in the mind like a visible spectre. The earlier inability to see the image is replaced by the insistence of the recognized head. To a degree, the image of the head becomes independent of the very marks it depends upon for its legibility. To look at the painting is to participate actively in the formation of the image, insofar as the image reforms in the mind of the viewer.

The grid implies a detached neutrality that renders the treatment of the whole surface full and equal. While the scale and orientation of each cell is constant, the cells are not applied rigidly, occasionally eliding to form longer runs of colour. This liberation from the imposed structure of the diagonal square introduces rhythmical shifts in the rows of cells, creating natural pauses or accents. The diagonal structure is mostly sympathetic to the shapes in the photograph so elements of the face run parallel to the rows of cells.

Shapes running against the diagonal are either softened, for example the mouth, or create a saw-toothed dissonance, as in the arm of the glasses. The cells themselves are able to switch function from notational parts within the larger pattern, to become more direct descriptive marks. In this way the dark aperture of the nostril retains its status as a conjoined cell yet also reads as the self-contained sign for the nostril. The apparent neutrality and non-hierarchical structure of the surface grid is destabilized by this ambiguous dual possibility in the function

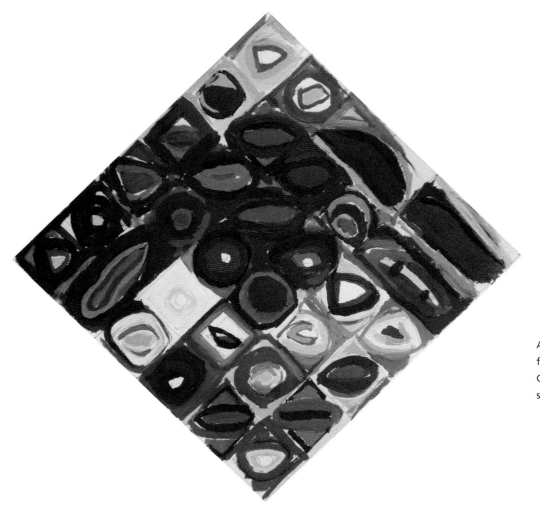

Atul Vohora, *Chuck's Eye*, from *Self-portrait*, 2007 after Chuck Close. A detail showing his left eye.

of the cells. The apparent self-abnegation in the process of painting, implied in the modular construction of the grid, is equally destabilized by the sensual abundance of colour and touch in each cell.

At the limits of the head, in place of what might be an outline, the fractured armature becomes vibratingly visible. It is the illusion of the image that fragments, leaving only paint and surface.

In spite of a repeated insistence, in interviews and texts, on the primacy of the formal properties in his work, this painting is one in a long series of pictures by Chuck Close, of himself. As a result of a double editing of the image, the photograph, which forms the basis of the painting, is forced to abandon claims to unmediated neutrality.

It is an image of self, deliberately presented to be seen. As one in a series, the painting becomes included in a multipart portrait, in which evolving claims to identity are staked. Compared to the defiant posturing found in the early self-portraits, this painting alludes to a more contemplative self, perhaps mirror-ing a process of aging and maturity. The trajectory seemingly defined by the paintings contradicts the emergence of the comparatively expansive and exuberant colour and touch in the later painting, where the radical, destabilising incoherence of the cellular structure hinges on abstraction.

The self-portrait is then, part of an ongoing dialogue concerning the self-expression of identity. The museum or billboard scale of the paintings places them in multiple relations to contextual imagery as well as spatial sites. The painted self-portrait can also be positioned in relation to existing paintings by other artists as a part of the same process. This painting invites particular comparison with the Self-portrait by Cézanne in the National Gallery, London. In both paintings, the artist is turned at a three-quarter angle; the bearded and balding Close, although sixteen years older at this point, bears some resemblance to Cézanne in appearance. Both artists are represented as contemplative, alert and restrained. The surface of each of the paintings is defined by the diagonal structure of the marks, which remain a visible part of the painting; the marks are con-

tained in units of modulation repeated across the whole surface. In the two paintings, variations in hue and saturation, rather than purely tone, are employed to make light.

The modulations in the painting by Cézanne, the patches of parallel brush marks laid adjacent to each other on the picture surface, have something of a duality in their function. In one sense the visible touch of the brush emphasizes the unbroken flat surface of the canvas, while at the same time, the patches of colour are the building blocks of the constructed spatial physicality of the painting. The urgency of Cézanne's haptic looking generates the structures of mark on the surface, which are the result of a fully engaged sensual imagination.

The diagonal grid of the Chuck Close self-portrait is imposed first on the surface of a modified photograph and repeated across the surface of the painting. The grid creates units of construction that refer to the process of making the picture. The units combine to generate the image, while retaining an autonomous decorative possibility. The interaction of touch and grid refers directly to surface, in the first instance the surface of the canvas, and by implication, the surface and reality of the photograph. It is to the compressed shapes of the photographic surface, rather than a physical experience of space that the painting is indebted.

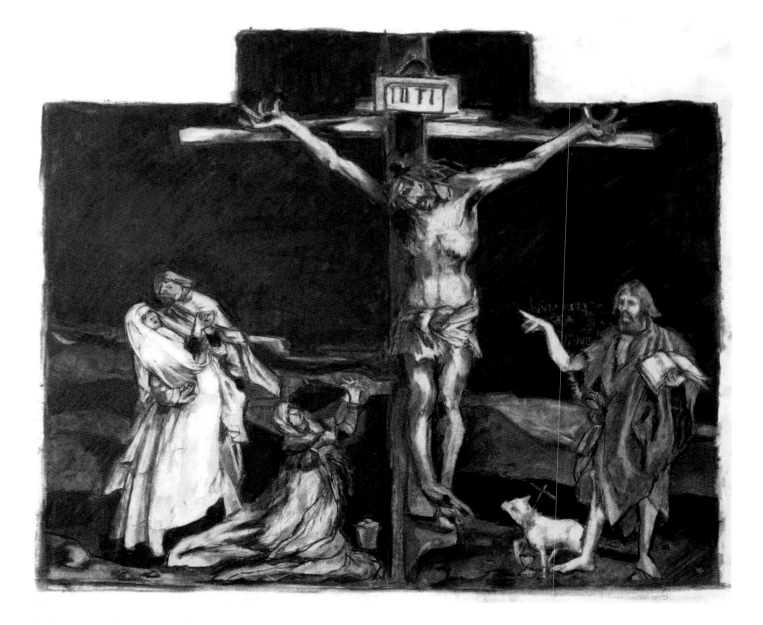

MARK, TOUCH AND FORM

At its most purely mimetic, the act of making images of people shares close ties to the ideas of appearance and illusion. The ability to recognise human form is, in fact, considerably elastic and accommodating of apparent distortion. Even extreme anatomical or proportional departures rarely inhibit the inherent, vigorous desire to identify shape as a person. The human form is adopted as a part of the visual expressive language of the image, with the body subjected to deliberate manipulation rather than simply the result of close description. The nature of these manipulations can be extreme and goes beyond the idea of employing gesture to convey emotional states.

In distancing the process of image making from the twin pole of appearance-illusion, the means of construction, which is the physical material from which the image is created, can also assert its presence. Mark implies touch and in a very direct form, registers the presence and physical bodily action of the artist. The substance and handling of the paint becomes as much a part of the expressive content of the image as the human figure to which it gives form. This chapter explores some of these possibilities in relation to specific paintings.

Matthias Grünewald was commissioned by the Antonine monks of Isenheim to paint an altarpiece for the chapel of their monastery. The monks took their name as followers of Saint Antony, a pioneer of Christian monasticism. The monastery functioned as a kind of hospital offering treatment and relief to those suffering the agonies of ergotism, or Saint Antony's Fire, a condition that resulted in gangrenous boils, open sores, and the death and loss of the affected limbs. Convulsions, spasms and psychotic hallucinations accompanied the wasting.

The folding altarpiece could be adjusted to display the paintings in various ways, depending on the configuration of the winged panels. Grünewald, a contemporary of Dürer, painted the altarpiece between 1512 and 1516. The crucifixion is unprecedented in its depiction of suffering and deliberately echoes the sufferings of ergotism in its grotesque misery.

Set to one side of the central division, the corpse hangs, drained of blood and twisted. The beam of the cross is bowed by its weight. Splinters and sores cover the skin and the arms writhe, drawn and extended. Open, upturned hands claw at the empty darkness. The head lolls, slack above the emaciated torso.

In the twilight a black stream flows behind the figures, separating them from the landscape. The space at the front of the painting becomes fluid, ambiguous and visionary. The huge figure of Christ looms above the figures either side, spread arms raking the night sky, dwarfing the kneeling Mary Magdalene, far below. Dressed in the white Cistercian habit, a shock of light in the darkened landscape, the Virgin collapses in grief. She is caught in the tender, muscular arms of Saint John, who, swathed in red, stands immediately behind her.

On the other side of the cross, the incongruously resurrected John the Baptist holds an open book, his other hand pointing to the cross. An inscription refers to the relationship between Christ and John the Baptist. The white pages of the book set in front of his red cloak are a neat reversal of the red and white of the figures opposite, the arcing body of the Virgin, mirrored by the curve of his hanging robe. The pale lamb at his feet is equally answered by the paler red of Mary Magdalene's robes, flow-

LEFT: Georgina Read, *Drawing of Crucifixion,* after Matthias Grünewald, 1512–16. Christ's looming body dominates the centre of the picture.

ing in disarray.

Light rakes across the shallow relief of the figures, picking out Christ's ribs, visible below taut skin. Entering the painting from the right, the light throws deep shadows over the stony earth. A painting of Saint Antony would have stood in a winged panel to the right of the crucifixion, bathed in a similar, if slightly softer, directional light.

The violent, twisted forms in the painting mark a dramatic departure from any conventional forms of picture making. The horror and agonized suffering in the painting are altogether human and imagined in all their fullness, in a profoundly mov-

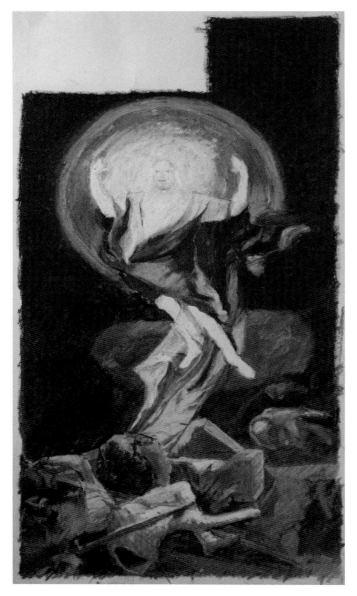

Georgina Read, Drawing of Resurrection after Matthias Grünewald, 1512 – 16. The spirit, freed of its body, ascends, surrounded by a ball of light.

ing image.

A Resurrection painted on the other side of one of the wings then offers an image of release and salvation to the sufferers hospitalised at Isenheim. The broken and disfigured body of the crucifixion is transformed, now luminous and whole, unblemished as it rises, becoming pure light.

The altarpiece has had a lasting importance for many painters, and prefigures an emergence of paintings that sought to dismantle a pure rational order. The halo of light that surrounds the resurrected Christ seems a direct precedent to the burning red disc in William Blake's *The Ancient of Days* of 1794. The apparent weightlessness of many of Blake's figures seem equally indebted to Grünewald's image of the resurrected figure shedding its material burden as it ascends.

It was as a result of the intervention of the painter, Max Beckmann, that the altarpiece was removed to Munich for safety during the war of 1914-18. Beckmann's painting of the crucifixion from 1917 is closely related to the Grünewald altarpiece from Isenheim.

Painted during the war, Beckmann's painting of the deposition brims with a fresh horror at the inexplicable possibilities of human violence. The broken and starved body is lowered to the ground. Blackened and twisted feet rest amid the thorns and rock of the bare earth. Heavy in death, the body is stiffened and unyielding. Covered in scars and unhealed sores, the frail form carves an emphatic pale diagonal against the dark vertical of the cross behind. The arms extend from crushed hand to crushed hand in a movement, counter to the diagonal of the body. The raised arms enclose and shelter the figures below. Christ's head is raised and curiously alert, as though unblinking in death. Coupled with the upturned hands, the direct gaze takes on a questioning look of helpless accusation and disbelief. The figure is large, pushed right up to the surface of the painting, arms and legs spread across the composition, its scale incongruous in relation to the surrounding people. The skin is mottled and bruised, swabs of violet mingled with green are contained by a continuous dark line.

Two men, straining as they embrace the body, slowly bring Christ down from the cross, their heads dropped with the solemnity of the work. To the right of the composition, two women kneel in grief upon the stony ground. Mary Magdalene's hand is raised in anguish as the Virgin comforts her. The dark tunic of the man on the left, cut through by the sharply contrasting knotted muscle of the arm, registers as a reversal of white robes and dark hood of the kneeling Virgin. She looks out of the painting with a gesture of intimate complicity, while the massive profile of a helmeted soldier looks out to the left, beyond the frame of the painting.

A molten, black sun burns into the emptiness of the grey sky. It casts no shadows as a symbol of absence and darkness. The dark orb ringed by red and yellow bands is prefigured by the

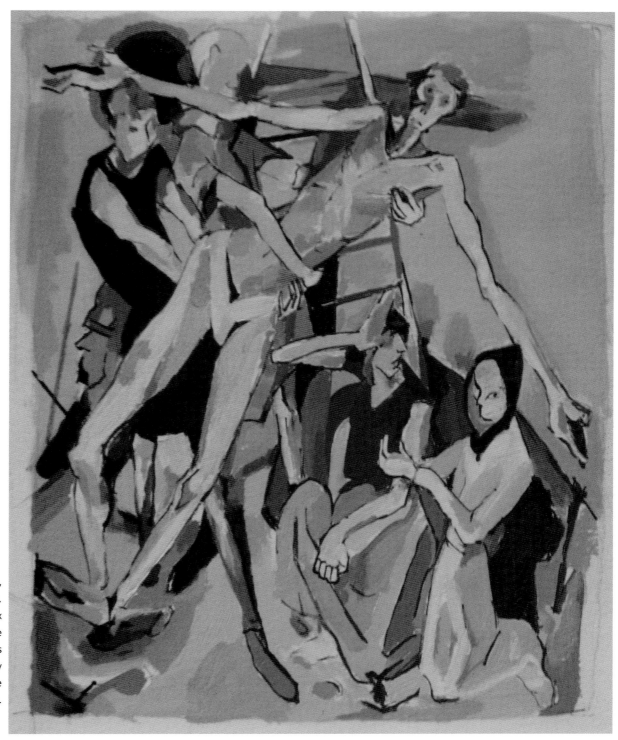

Atul Vohora, *Crucifixion*, after Max Beckmann. The rigid diagonals of Christ's body fill the composition.

brilliant halo of light that surrounds the resurrected Christ in the Isenheim altarpiece. The promise of redemption is simultaneously invoked and denied as a possibility in this context. Indeed the painting reads as a closely considered response to Grünewald's crucifixion from the same altarpiece, with structural and thematic affinities to the earlier picture. The outstretched, elongated arms with clawing fingers and the dominant scale of the central figure are almost a direct quote from Grünewald. The light in Beckmann's painting is set at a significantly higher key, the bleached earth and the washed-out sky

become a foil to pools of black that punctuate the composition. The sun itself seems an echo to the empty eyes set deep in Christ's head.

It is primarily in the expressive distortions of the anatomy and in the fluid experience of space that the two paintings resonate most clearly. Dramatic shifts in scale and emphasis generate an atmosphere of heightened emotional turbulence and structural dynamism.

THE FLAYING OF MARSYAS, TITIAN (TIZIANO VECELLI), 1575–76

The bound figure of Marsyas hangs inverted, each leg crudely tied to the branches of a tree. The weight of his body pulls heavily through the centre of the picture, with the immensity of a column, dwarfing the surrounding figures with its oppressive presence. The torso stretches, as it hangs; his tied wrists scrape at the ground. The folded arms frame the head in their embrace. There is a sense of resignation in the face of the satyr,

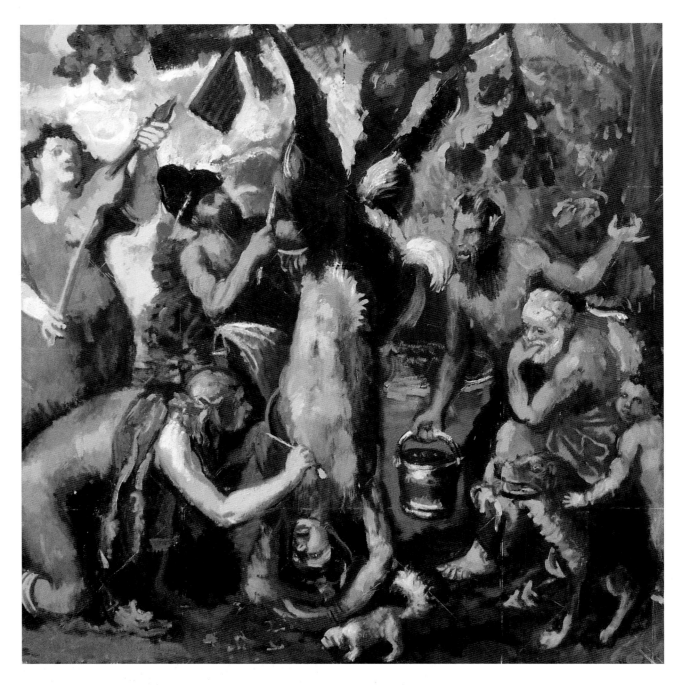

Alex Cree, *The Flaying of Marsyas*, after Titian (Tiziano Vecelli) 1575–76. A young man patiently peels the skin from Marsyas' body.

fallen foul of Apollo's wrath.

The canvas is densely filled: six figures and two dogs witness and inflict punishment on the helpless, unresisting body of Marsyas, creating a web of closely packed form, across the surface. The powerful cruciform of the suspended body divides the painting at the centre. The figures surrounding Marsyas are pushed to the front of the picture, occupying the compressed space at the front of the painting. The figures are modelled in shallow relief; the interplay of their limbs locks the forms to each other.

A kneeling golden youth tenderly pares the skin away from the still living chest. He leans in, head close to the blade in his hand, concentrating on his work, his face lit by reflected light from the exposed flesh. As the knife separates the skin from the body, the hungry eyes of a large dog follow his movements attentively. Blood, running freely from the body, collects in a pool below the head. A small dog laps at the congealing puddle, bushy tail raised with frisky anticipation.

Light enters the painting from the left of the canvas, and it is here that the two figures with Apollonian attributes are placed. Above the luminous arm and back of the young man, a musician accompanies the flayers on a viol. The knife points forcefully to the hand of the musician, a bow resting lightly on the fingers. A second, more muscular, figure attends to removing skin from the legs.

The light spills over and beyond these figures, catching Pan as he strides into the composition from the right, bearing a bucket for the blood. His raised arm is a direct echo of the arm of the young man holding the knife. The open hand, a gesture of shock and disbelief, registers as a reaction to the cold violence of the knife.

Midas sits transfixed by the unspeakable horror and his complicity in the situation. The direction of his eyes is emphasized by the diagonal of his arm and leg. The three arms of the figures on the right converge at the head of Marsyas, which becomes the dramatic focus of the painting.

The figures are painted from a low level, sharing something of Marsyas' viewpoint. There is a sense of looking up at the splayed legs and into the tree, at the branches against the bright sky. The musician's eyes are transfixed by the stark, angular shape of the offending flute, hanging from a high branch.

The colour in the painting is subdued compared to Titian's earlier painting. Flashes of red flare among the dense field of marks, which swing between oranges and greens. An accumulation of visible touches covers the canvas, building the volume of the thick muscular body, stripped bare of its skin. It is almost as though the touch of the brush is transformed, becoming a hand touching flesh.

LAOCOÖN, EL GRECO (DOMENIKOS THEOTOKOPOULOS) C 1610–14

The subject of the painting is taken from the Iliad. Apollo punished Laocoön for urging the people of Troy to reject the Greek gift of a horse. Sea serpents seize and kill Laocoön and his two sons. The naked, sprawling figure of Laocoön, at the centre of the painting, wrestles fervently with a snake that has coiled around his body. He stares at the head of the snake, only inch-

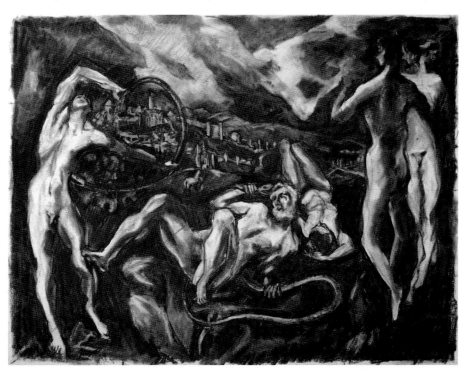

Georgina Read, Drawing of Laocoön, after El Greco (Domenikos Theotokopoulos), c 1610–14. Laocoön and his two sons meet their grisly end.

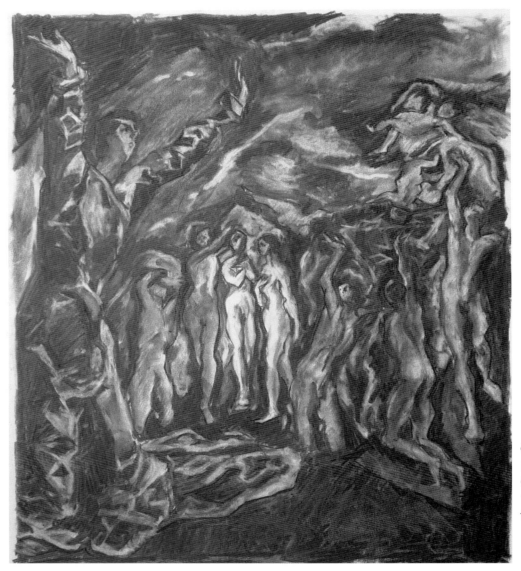

Georgina Read, *Drawing of The Vision of Saint John*, after El Greco (Domenikos Theotokopoulos), 1608–14. Ecstatic rhythms define the picture.

es from his face. One of his sons lies unmoving behind him. Twisted with fear, Laocoön sees the imminence of his own death. The pallid body of the second son arcs across the left edge of the painting, taut as a snake strikes at his flank. The struggles of Laocoön and his sons are watched by a second group of three figures standing at the right edge of the composition. The slender figures are similarly pale with tapering limbs that seem almost weightless and immaterial, compared to the heavy rocks on the ground. The elegance of their presence contrasts with the tortured writhing of Laocoön.

The bare earth and sharp boulders at the front of the picture give way to a rising hillside and the distant city of Toledo. A horse, a reference to the horse of Troy, seems to run toward the city gate. Turbulent, laden skies mirror the diagonal rhythms of the figures below. The limbs of their bodies form pronounced pictorial structures that carry emphatic directional momentum.

The curled body of the snake at the centre of the composition echoes and magnifies the turned arm of Laocoön's dead son. The figures at the front of the painting divide into two groups that share a somewhat ambiguous relationship to the landscape. The mythological subject is relocated to contemporary Toledo, although by placing the figures at a distance from the city, the painting takes on an allegorical quality, mirrored in the abrupt transition from the heightened emotional world of the narrative, to the more descriptive world of the far city.

The figures are painted in an almost achromatic palette and, while there is some modelling of the bodies, with light spreading from the left of the painting, the pale forms seem to possess an interior iridescence that shines against the dark rocky earth. The undulating vertical rhythms of the bodies accentuate the shimmering ethereal nature of the figures.

Laocoön's leg, lifted as he tumbles in a terrifying mortal

struggle, links the two sons with its forceful triangular shape. A turn in the leg of the closest standing figure at the right hand edge of the painting, meets the shoulder and side of the fallen son. The same movement extends into the diagonal made by the cloud, linking the two groups with the top of the painting.

The language of the painting shifts radically in register and scale in the construction of the buildings. Finely drawn shapes of the far city contrast strongly with the dynamic energy of the near figures. Observed closely, vertical towers and turrets punctuate the hillside. Richly coloured fields surround the city, again a considerable departure from the starker register at the front of the painting. The city acts as visual relief from the loaded intensity of the figures, taking on the appearance of a vision. The painting as a whole has a dreamlike quality, filled with a strange light, the figures no longer subject to the constraints of gravity.

It is possible that El Greco may have encountered firsthand the classical sculpture of Laocoon now held in the Vatican. The sculpture had been unearthed in 1506 and El Greco visited Rome in 1570. However the painting breaks away from the muscular forms of the classical sculpture. El Greco reinvents the idea, the feverish flame-like figures a very personal response to the emotional charge of the narrative.

There is some evidence to show the painting was made using wax models for the figures. A large number of wax models were found in the studio after his death.

Painted during the same period of El Greco's life, *The Vision of Saint John*, also known as *The Opening of the Fifth Seal*, now housed in New York, shares elements of its composition with the Laocoön. The painting has been significantly cut down in size, with a large part of the upper section having been removed. The narrative structure of the painting has been partly dismantled as a result, with the kneeling figure of an ecstatic Saint John looking diagonally out of the painting.

His blue robe fractures into triangles of light that ripple over the front of his body with a calligraphic vehemence, his arms are thrown upward, spreading in reverential abandon. The diagonal of the left arm extends into the rush of cloud across the sky. El Greco dispenses almost entirely with any reference to the natural world. Behind the towering figure of Saint John, richly hued fabric shields a line of naked souls. The pale forms are vigorously outlined with a dark line. Several kneeling figures reach up forming a beseeching chorus around the Saint, and white cloths of salvation fall in answer.

The final standing figure, at the far right of the composition, is very close to a complete repetition of the standing son of Laocoön. The body curves, with a bend in the left leg, although the arm now extends outward to receive the white cloth. Similarly, the kneeling figures, either side of the group of three standing figures, are very like the horizontal son of Laocoön, now turned to the vertical, which suggests the re-use of existing wax models with slight alterations in the subsequent painting.

A gentle cool light plays across the figures revealing their form with an absence of harsh contrasts of light and dark. Saint John himself is set apart, his body almost ablaze as his arms reach up to receive a shaft of shattering, brilliant light.

Picasso's *Les Demoiselles d'Avignon* takes up the idea of a group of figures standing in a line. Structurally, the painting shares similar forms with the El Greco, most notably the inverted triangles of the raised arms and a splintering of the pictorial surface.

PORTRAIT OF JOSEPH ROULIN, VINCENT VAN GOGH, 1889

The heightened sense of alienation that van Gogh felt during his stay in Arles was, in part, relieved by the attachment he formed to the Roulin family and, in particular, the head of the family, Joseph. All members of the family became subjects for portraits, which record the emerging relationship between the marginal figure of van Gogh and the nuclear stability and intimacy of the Roulin family. In his letters, van Gogh makes a direct comparison between the relationship of his own parents to that of Joseph Roulin and his wife. It was Roulin who visited and attended to van Gogh in hospital, following the severing of his own ear. Eventually, he helped the recuperating Van Gogh to return

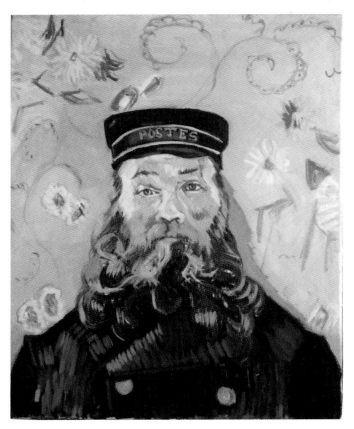

Gabriella Marchini, *Joseph Roulin*, after
Vincent van Gogh (Barnes Collection), 1889

home, spending entire days during this transitional period as a companion to him. Roulin also communicated with various members of the Van Gogh family, informing them of Vincent's state of mind; in this role he acts as both mediator and provider of reassurance.

In a series of portraits that date from this period, Roulin emerges as an unshakeable bulwark against the disintegration of van Gogh's internal world. Roulin was due to take up a new job in Marseille and the departure of the family from Arles was imminent. Van Gogh was in a state of turbulent dependence on Joseph and his family. The approaching isolation, brought on by their departure, provided the psychological and emotional context for the three portraits.

The painting now held in the Barnes Collection, of Joseph Roulin, dates from 1889. The shoulders are framed closely by the rectangle and richly decorated wallpaper fills the field behind the head. Roulin stares directly out of the picture, dressed in the rich blue postal uniform. He becomes a towering presence, the shapes of his body and head are stacked to form a solid pyramid crowned by the lettering inscribed between the golden bands of the braided hat. This immutable tree trunk of a man is alert and present, commanding the centre of the picture. The abundant and impressive Socratic beard swirls thickly over his chest. Van Gogh's deep concern for people is reflected in what is primarily a compassionate depiction of the man. Roulin looks back with a steady gaze that carries what can be read as sympathy and understanding for both the painter and the project in which he is immersed.

The head is lit from the left. The light catches Roulin's temple and glances across the side of his nose. The head throws a vibrant blue shadow on the wall, to the right. A second, less intense source of light is reflected in the side of the nose and in the sheen of Roulin's left temple. The keenly felt drawing of the head does not depend on tonal modelling for form. It is with a combination of line and densely packed variations of colour that van Gogh builds the great mass of the skull. The drawing is concise without drifting into the mode of caricature. A slight inclination of the head and the gently tilted eyes find an echo in the drop between the two gleaming buttons of the coat.

The range of touches demonstrates a coming together of the manual dexterity particular to van Gogh, with a depth of creative invention. The marks are defined by a pronounced directional emphasis, which generates a structure in the painting comparable to that of the ink drawings. Closely packed interwoven hatchings of colour change direction to sculpt the dense form of Roulin's head. The hatchings are punctuated by a more linear mark, employed to outline the fully lidded eyes and the clear shape of the nostrils.

There is a dramatic shift in register as the beard spurts out over the shoulders, with tumbling exuberance, evoking the forms of clouds in its riotous curling growth. The marks them-

selves seem to possess a leaping energy. The hatched structure becomes more open and visible, and the oscillating contrasts of the interspersed colours are at a higher pitch.

The scale of the marks increases, in the painting of the thick cloth of the overcoat. A dense wall of broad strokes fills the front of the torso with an insistent vertical. A heavy line underscores the fold of the collar and a sharper band of pale blue separates the light of the top edge from the collar below. The yellow buttons glow from deep within the blue coat, to form an inverted visual rhyme with the pale grey eyes embedded in the colour of the face.

Behind the rooted bulk of the shoulders and head, the wall is painted with a series of less visible, liquid, horizontal touches. A lyrical, floral motif fills the field around the head, picking up and accentuating the curves and curls of the nostrils and beard. The pale reds and pinks of the flowers play on the rosy bloom in the face, the dark rings at their centre mirroring the lucid circles of the irises. A diagonal rhythm links the stem, emerging from the flowers at the top left of the painting to Roulin's shoulder at the bottom left. The urgent and manifest delight with which the flowers of the wallpaper are painted pluck them from a secondary role. The playful shapes define the surface of the wall and create the space behind the figure. They provide the field against which the thickly packed brush marks erupt into the form of the head. Finally, the immediacy with which the pattern is painted emphasizes the surface of the painting and throws into sharp relief the extraordinary range of inventive touch.

A second painting, now in the Kröller-Müller Museum, retains the same compositional structure, the head and shoulders are similarly framed by the rectangle and again, the uniformed and heavily bearded Roulin looks directly out of the painting. The patterned wallpaper is, however, distinctly different. The long flowing rhythms of the Barnes painting give way to a new pattern of bunched groupings, with bursts of rich colour set amidst a cool blue green. Three bursts of the strong red in the form of poppies surround the head. It is the same red that reappears as the colour of the pressed lips.

The light on the head is less clearly directional, the drawing and hatching is less deliberately structural and the deep blue of the uniform is modified to a lighter, more even colour. The beard becomes the focus of the painting, its layered volume of curls cascading from the face. The head is less forcefully constructed, instead the accumulation of vigorous and energetic marks in the beard, dominate the composition. The radiating swirls of touch of each flower resonate with the pattern of marks surrounding each eye. The beard disrupts the surface of the picture, with its energetic insistence on volume and form.

The third painting in this series, now in New York, reprises the motif of Roulin in uniform against a patterned wall. This third pattern is recognizable from paintings of other members of the

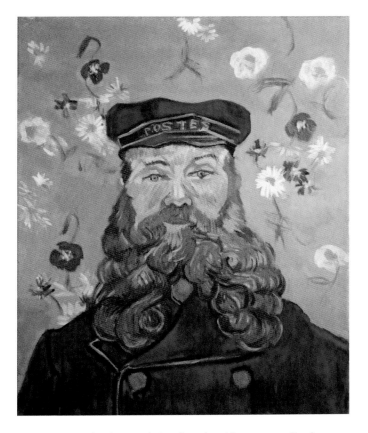

Gabriella Marchini, *Joseph Roulin*, after Vincent van Gogh (Kröller-Müller), 1889.

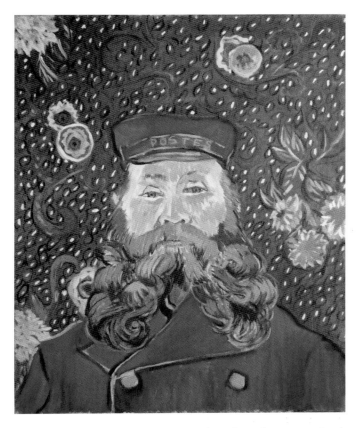

Gabriella Marchini, *Joseph Roulin*, after Vincent van Gogh (MoMA), 1889.

Roulin family and is characterized by the appearance of individually defined cells that swarm in the area of the pattern between the shapes of the flowers. The cells themselves are similar to the shape and scale of the eyes.

Rhythm and pattern now flood the painting. Structural concerns are swept aside by the urgent interactions of mark and shape. The separation of figure and ground begins to dissolve in the fluid density of the highly decorated surface. The head now becomes a source of light in the painting, a calm presence in the pressing mass of the pattern.

Painted in a short period of time, the three paintings move towards an encompassing celebration of mark and surface. The shifting responses chart this trajectory, demonstrating van Gogh's emotional range and the particular nature of his poetic vision.

PORTRAIT OF A MAN, CHAIM SOUTINE, 1921

Soutine's painting of fellow artist Emile Lejeune is in the Musée de L'Orangerie in Paris. Both artists reciprocated in sitting for each other. This portrait was painted in 1923, the year of a dra-

matic reversal of Soutine's financial status following his meeting with the collector Alfred Barnes in 1922.

There is a formal frontality to the painting; Lejeune stares directly back at the painter with a frankness that implies no hierarchy in the dynamics of their relationship. He is sombrely dressed in a black jacket and tie. The white shirt strikes a clear note against the weight of the surrounding colour, and the pale wall behind him accentuates the stark unembellished nature of the encounter. The head and shoulders are closely framed by the edges of the rectangle. A tapering slender neck spurts from the dark mass of the body. The shoulders rise steeply, to support the full head, topped by a playful thatch of black hair. A triangular wedge of thinly painted canvas fills the top right corner. Over the top of this layer, the paint thickens and accumulates; the surface of the painting becomes deeply covered with a web of pulsating, agitated touches.

The fluid paint is applied freely, and often disturbs and mixes with the wet paint of a previous touch. The warm, saturated colour of the head is embedded in a field of modulated cool greys that swing from violet to green. A more subdued grey to the left of the picture suggests a shadow cast on the wall by the

Atul Vohora, *Portrait of a Man*, after Chaim Soutine, 1921.
Portrait of the artist's friend.

head and shoulders.

The angular drawing of the collar cuts into the dark shape of the shoulder with an urgent impasto, framing the narrow knot of the tie. The shoulders, similarly triangular, give way to fleshy rhythms of the head. The stability and presence of the sitter begin to subside with an unsteadiness in the structure of the head. The face seems to collapse, as the eyes sink toward each other under the burden of the turbulent paint and an anguished redrawing. It is Soutine's violent hunger to remake reality that gives rise to the unexpected forms of the head. His sensations resist a conventional schematization with their intensity and desperation. The raw convulsions of the face are the result of an unremitting determination to penetrate appearance mingling with a sensual engagement with the physical substance of paint.

There is equally something almost joyful in the play of forms of the head. The quizzically arched eyebrow instigates an asymmetry, which is taken up, in turn, by the diagonal of the displaced nose. The full end of the nose hovers above the thinly hanging moustache. The proximity of the two eyes echoes the parted halves of the moustache.

Protruding ears sit either side of the head and stabilize the form with their strong shape and pigmentation. Both ears are fully drawn, resisting the sense of a turn of the head. The intense red of the left ear begins to dissolve into the colour of the wall. There are a certain amount of similarities between this painting and the Cézanne portrait of his uncle in the Musée d'Orsay. However Soutine's frenzied search for veracity diverges from the sense of solidity and permanence of the painting by Cézanne.

NANCY CUNARD, OSCAR KOKOSCHKA, 1924

Kokoschka travelled to Paris from Vienna, where he painted this picture of Nancy Cunard, a descendant of the American founder of the shipping line of the same name. She was a poet who held radical political views and had come to live in Paris. In parts, the unpainted ground remains visibly part of the fabric of the composition. Thinly applied blue paint, ribbed with the trace of the brush, breaks up as the turpentine begins to run. The surface of the painting is layered with energetic, broad strokes. There is a dynamic vigour to the scale of the brush marks, almost as though the sound of the painting grows in volume with each subsequent layer. The thin washes that form the bottom layer of the painting mount to the resounding diagonals of mark and paint that bracket and inhabit the shape of the torso. In doing so the tentative suggestions of colour are transformed into dense paint and the strident register of pure pigment.

Fine black lines that curl around an elegant ankle are evidence of incisive drawing. These specific moments sit ambivalently with the anarchic calligraphy of marks that surround the figure. At times, the colour spreads openly through the body, as though dissolving distinction between figure and ground, only for the shape of the arm or the articulation of the torso to be reinforced with a thick line of black. Freely applied colour cuts through these lines in turn, so that the form appears to vibrate, optically. The touches, at times, are close to serving no strict descriptive function. In retaining an element of autonomy, they reassert the presence of the painter. The painting then becomes a field of encounter between the two people, painter and sitter, that radiates with the urgency of looking.

Muted greys, ochre and greens are a foil for searing marks of bright red, vibrating purple and the flowing clear blue of a loosely tied scarf. The colour of the face is reminiscent of the etiolated pallor of El Greco's figures. Large eyes stare fixedly out of an angular elongated head. An anguished, slightly haunted set to the head contrasts with the almost studied languor of the draped body.

Bracelets jangle along the seemingly endless narrow wrist, raised to take the weight of the head. The right arm tapers to the bottom left corner of the painting. Kokoschka is content to leave the hand largely unworked; the open lattice of marks is crowned with an emphatic touch of red at the wrist. The long

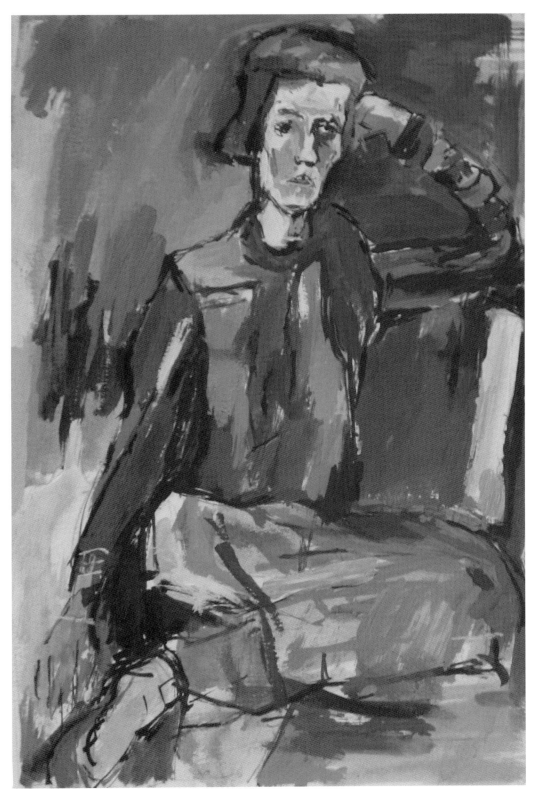

Atul Vohora, *Nancy Cunard*,
after Oscar Kokoschka, 1924.
The paint is vigorously handled
and layered.

limbs and body divide the canvas into large shapes held by the framework of dark line, closely bound by the rectangle. The attenuated shapes of the figure are absolutely locked into the fields of colour in a way that is both restless and without compromise.

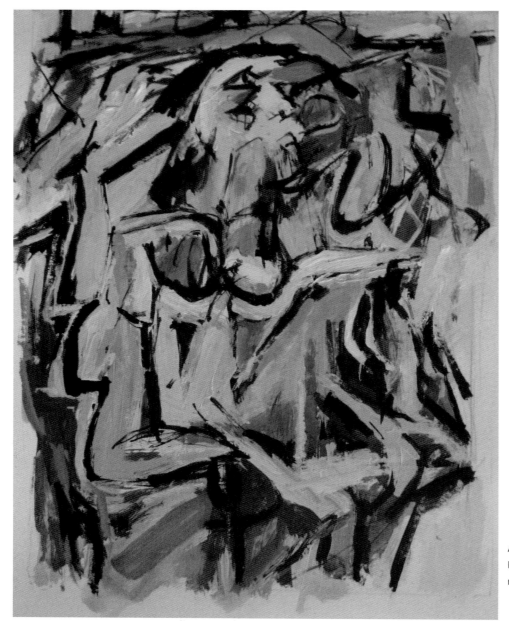

Atul Vohora, *Woman*, after Willem de Kooning, 1949-50. Gestural, dramatic marks sear across the picture surface.

WOMAN, WILLEM DE KOONING, 1949-50

De Kooning was an immigrant of Dutch extraction, arriving in New York in 1926. His paintings of women, made in the late 1940s and early 1950s, elicited a mixed reaction, particularly following the exhibition in 1953 at the Sidney Janis Gallery. *Woman* 1949–1950, now held at the Weatherspoon Art Museum, is a large painting, just over 150cm tall and almost 120cm wide. The surface of the painting is densely filled with angular loaded brushmarks, retaining something of the impact and scale of each touch.

Rich colours, submerged beneath a crust of white paint,

erupt, pushing through the obscuring paint. Searing black marks cut through the pale field of the painting, forming a dissolving lattice across the picture surface. In parts, charged with an angular autonomy, the marks shift to a more explicit and voluptuous register in the description of mouth, breasts and hip. Material and subject elide with ambiguity as the marks vibrate with the pronounced contrast of light and dark, fracturing and fragmenting the woman's body. Moments of recognition dissolve into the calligraphic flux of paint, resisting a full separation of figure and ground. The assertive presence of paint and touch withholds any possibility of illusion; the spatial depth

of the painting is at most very shallow. The woman reads as though positioned closely against the surface of the painting. De Kooning, in the face of acute and sustained challenges, remained resolute in his desire to reference the human figure; he explained that it seemed absurd not to.

Woman 1, housed in the Museum of Modern Art in New York, was begun in 1950. The evolution and genesis of the painting was fraught with uncertainty and tension. Completed in 1952, it was exhibited as one of a series of six canvases. The painting is larger again at more than 182cm tall by 152cm across. The woman is painted with an immensity approaching the presence of a great rock. She is rectilinear and frontal and compared to the previous painting, her body retains an integrity and wholeness. The broad areas of light colour, of the arms and breasts emerge from the agitated, smeared surface behind her. The evo-

lution of the painting remains a visible part of the final structure of the image. Areas of scraped paint sit against fluid stains that have run. These are in turn buried by thick paint forcefully painted over and through wet pigment below. The canvas becomes a field of resolution for a kind of intuitive process defined by accretion and negation. The dense web of dark marks now gives way to areas of undivided colour, incised by the gestural presence of black lines. De Kooning's conscious desire to escape established formulations leads to a riotous surface, in which he seeks to celebrate the affinities of paint and flesh. In doing so, the result places De Kooning's picture close to the idea that first and foremost this is a painting. In a specific sense the painting becomes a site of turbulent confrontation and the image of the body functions as a vehicle through which conflict can be expressed.

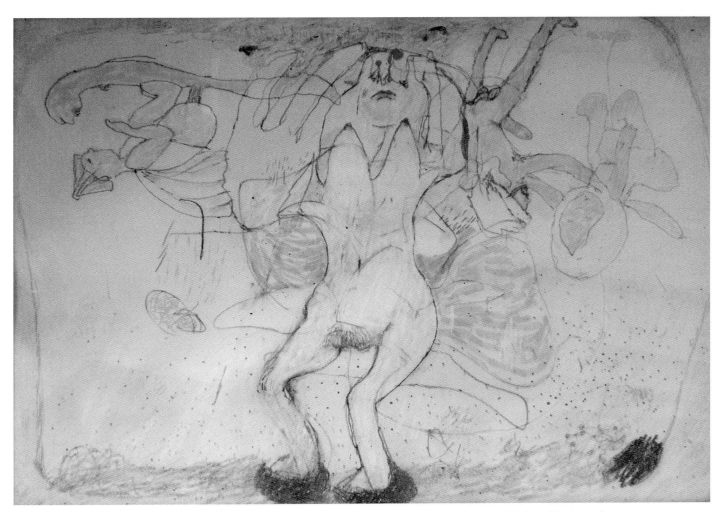

Karl-Peter Penke, *The Birth of Venus, The Death of Venus*. The sparse colour and incisive line reverberate through the emotionally charged composition.

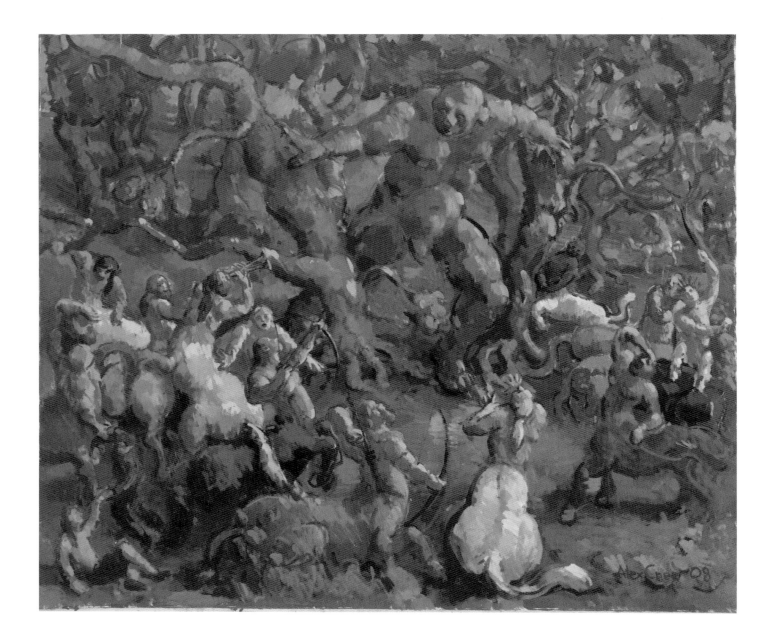

CHAPTER 6

ON NARRATIVE

Combinations of visual forms can express a particular idea or emotion. These ideas, taken together, can create readily intelligible structures, structures that can be read and transmitted repeatedly. Language, and the ability to construct and exchange stories, facilitates the ability of any group of people to form an identity and to develop systems of belief, a vital part of the continued existence of the group. The story contains both the history of the group and its future.

The role of storytelling in identity formation operates equally at an individual level. Single members of the group accumulate and structure memories, ideas and beliefs in the construction of a self-narrative, presented both internally, to oneself, or externally, to others. Although not always at the level of conscious thought, these narratives depend for their meaning on the possibility of being decoded. Pattern and symbol are closely tied to meaning and intelligibility.

The shared story reinforces the common identity of the group and permits individual members to form personal inter relations within the group. Non-members of the group do not share the same relationship to the shared narrative strands that bind the individuals within the group. Attitudes and behaviours encoded in stories reflect and, at times, govern the personal, social, cultural and biological spheres of being. Knowledge transmitted through the medium of the story, itself an evolutionary phenomenon, is key to the ongoing biological imperative for adaptation and survival.

The oral transmission of the story shares roots with song and finds its rhythms in a lived bodily experience of the world. The storyteller is an incarnation of the story to the extent that the existence of the narrative is in its re-telling. The story then has multiple claims to a living state, in the body and voice of the teller as well as in its elastic, amorphous ability to absorb, appropriate and reshape in each incarnation. Objects of a symbolic, totemic nature often accompany the dramatic re-enactment of narratives. These include visual images, whose function is either as an icon; to denote, or, as the backdrop or scene: to locate. Later image objects are adapted to signify status within narratives of social position and cultural aspiration.

The relationship between oral narrative and visual image is fluid and yielding. Stories told in relation to portable images reveal latent meaning in the image, the image provides the frame for the story, although depends upon the verbal retelling of the narrative for its ability to generate meaning. While the visual image is less sensitive to distortions implied by language and translation than the spoken word, in this context it becomes dependent on the reinforcing function of the told narrative. Without the story, layers of the image are rendered opaque and unreadable.

Multiple readings of a single picture foreground the inherent ambiguity in any figural image. Interpretation of the image can generate new narratives or discover latent or unconscious meaning. In this way, the fixed image becomes a hinge for a re-evaluation of belief and an attendant sense of identity.

The desire to construct readings of an image, to create a story in relation to an image is demonstrably a powerful one. By placing a title, which deliberately implied an ambiguity, beside a painting with high narrative and emotional content, Victorian so-called 'problem paintings' harness this need. Highly dis-

LEFT: Alex Cree, *Grawp and the Centaurs* (photograph by Hugh Gilbert).
Encircled, the giant lumbers through the trees.

Bin City, Page 1, Michael Dowling. Streetlights bleach an anonymous urban street. The cityscape situates the cinematic series of over-laid images.

cussed by the public rather than the critic, the 'problem paint-ing' initiated discussions of a social, moral dimension. In this instance, the gallery is transformed into a site for the presentation and formation of interpersonal identity. This was reinforced in subsequent written evaluations of the 'problem painting', which appeared in print, with the newspaper as the second site for this kind of transaction.

The links between identity and place exist both in the form of the story and the place name. Often tied to the particular spatial geography of a place, stories in this mode reveal a meta-

Kate Lyddon, *Suddenly I'm Flying*. Everything appears to permanently teeter on the edge of a nervous breakdown.

physical dimension of identity. Indigenous Australian painting is layered with meaning relating to self, group and place. In the absence of any knowledge of orally transmitted narratives surrounding a given painting, the dazzling surface remains unyielding to anything more than a superficial reading.

The dismantling of both the metaphysical narratives and the powerful correlations between identity and place present in them, frequently takes prominence in colonial projects. This severing is framed in moral language, as one of 'civilizing' the occasionally unwilling, rather than in the dynamics of power

exploitation and control. The decentred subject has proved much easier to govern, hence the necessity of erasing narratives, of renaming and replacing with new histories that the process of religious and educational conversion enact. The price is an almost permanent dislocation of identity and a denial of the subjects' right to self-representation. The trajectory of this process is contained within the framework of unfolding narratives of post-colonial and international capitalist identity.

The process of erasure sets up the later possibility of objects

Gregory Ward, *Love Alters Not*. A distant horizon defines the expanse of water far below as the couple edge unknowingly closer to the drop.

and images, now neutralized, labelled as primitive, and therefore non threatening, being adopted as part of the modernist project. Placed in a museum, potent and formative image objects are recast as distant, other, as curiosities intended to be observed as forms, in a disinterested rational manner. The so-called rational observer engages visually with the unfamiliar object, now reframed as exhibit, frozen, silent and without life.

The transition from oral to written narratives is linked to a desire for stability and permanence. The inscribed word becomes a form of fixing narrative; text adopts the authority of law. Once written, the text is independent of its author. Disembodied and static, the ideas, narrators and narration inherent in the text are available for interpretation. The written text permits repeated exchange, multiplication and translation. The dynamics of the relationship between word and visual image are altered by the shift from oral to written modes and the accompanying, imposed separation between text and visual image. The living re-enactment of narrative by the storyteller, through word, bodily action and image becomes instead, in the written mode, a series of sequential encounters between inscribed text and accompanying image. The integration of the two in each reincarnation of the orally recreated narrative gives way to a relationship governed by hierarchy. Either the text is illustrated with images playing a subsidiary role, or the image is subject to interpretation and criticism. This remains the case even when the image has no explicit figural function. The written title forces a further relationship between image, word and meaning. Magritte was quick to explore the ambiguities and dissonance in this relationship either employing the structure of negation, as in 'this is not a pipe', or by the deliberate mislabelling of a pictorial image. The incongruities arising from these juxtapositions of word and image reveal a gap, which on probing opens up to become a gulf between picture, word and meaning. Much less frequently, narratives are written in response to an image, with the image as the source.

Encoded within each permutation of word and picture are the implications of the social, cultural and political context of their creation. In a very real sense, the context informs and defines the image.

Visual imagery has a long relationship with the construction and evolution of narrative. An array of forms make the expression and transmission of complex and layered narratives possible. These include the single image, the sequential image and the continuous image, where the field of the picture is unbroken as the narrative progresses. A single image may represent a single scene. It can also represent multiple strands of the story simultaneously, or temporally sequential episodes, where the same figure reoccurs several times within the frame. The language, form and structure of the image are directly related to the nature of the narrative in question. This chapter explores some of these possibilities.

The Grand Narrative Engine

FRESCO CYCLE, GIOTTO DI BONDONE, C 1305, THE SCROVEGNI CHAPEL

The chapel was commissioned by Enrico Scrovegni and is a surviving part of a much larger complex of Palace buildings. The site was close to that of the former Roman Arena at Padua and to the space where the Feast of the Annunciation was routinely celebrated. The land was purchased in the year of the jubilee in 1300 and the Chapel was consecrated shortly after, in 1303. The interior of the chapel provides, in its architectural simplicity, an ideal platform for the integrated programme of decoration. The broad ranging and imaginatively inventive decoration raises and sustains several narrative arcs simultaneously. The most immediate reading of the frescoed walls is related to the multiple textual sources of the New Testament. A part of the function of the images, as a visual recreation of the texts, was to disseminate doctrinal ideas, which hitherto remained inaccessibly bound to an ability to read Latin. The adoption of vernacular, incidental modes and idioms by Giotto in the frescoes is mirrored by a similar transition to contemporary Italian in the writings of Dante.

Inevitably, the biblical text retains a position of authority in relation to the images, although the fresco cycle does have some claim to autonomy, through the selection, structuring and the invention of a particular iconographic form. The organization of the paintings in the chapel allows the possibility of multiple or layered readings. The design of the images relates in part to the mosaics of the Baptistery in Florence, of which it seems likely Giotto was aware.

The elaborate cycles spiral around the walls of the chapel completing the continuous narratives of the lives of the parents of the Virgin, Joachim and Anna, the life of the Virgin and finally the life of Christ. The West wall of the chapel, facing the setting sun, and through which people would enter and leave, is entirely given to the depiction of the End of Days or The Last Judgement. A multi-hued halo surrounds the body of Christ; below, to either side the wall cleaves into a vision of the Blessed and the Damned. Enrico is found within the iconography of the saved. He is painted kneeling, as he presents a model of the chapel to the trinity of Marys.

The iconography bracketing the spiralling central narrative can be read as a series of oppositions. Christ sits above Satan, the blessed contrasting with the damned, and a row of vices painted as grisaille statues face a row of virtues. Exploiting the symmetrical and oppositional scheme of the West wall and arguably the whole decoration, a hanged and eviscerated Judas is positioned across from Enrico as a pendant to his act of charity, generosity and penitence.

The commissioning of a project on this scale was unusual for

Atul Vohora, *Enrico Kneeling*, after Giotto di Bondone, c 1305. Presenting a model of the chapel to the assembled three Marys. The model differs slightly from the final design.

a private individual. The richly decorated chapel served as a vicarious symbol of the wealth of the Scrovegni family, and aroused outraged complaint from the nearby Eremitani monks, who found its immodesty difficult to countenance. It had found approval at the highest level however, confirmed in a Papal Bull conferring indulgences upon pilgrims who visited the chapel. Although the construction and authorship of the entire scheme is likely to have been collaborative, a guiding sensibility is discernible in the unity of style found in the cycles.

The minimal architectural interventions in the interior of the chapel allow the images to integrate fully with the building. The frescoes are conceived of, designed and painted to the particular shape and scale of the building. The scale of the paintings reflects a sensitivity to the enclosed space and its functions as a devotional space. The legibility of each image is defined by its distance and position in the space of the chapel. In this way the building acts as a frame, containing and defining the limits of the pictorial scheme and the imaginative world it contains, and as a support, so that the images are physically painted and organized on the walls of the building. The effect of the paintings is not neutral; they function as more than simply decoration. The paintings generate meaning that relates to the textual narrative on which the cycles are based. The interior is transformed and reordered by the paintings. They participate actively in defining the internal orientation to the building, which is itself, a response to the architectural construction and its functions as a family chapel.

The types of representation within the whole decorative scheme are layered. The barrel vault of the roof is filled with a transcendent blue covered with a spread of stars. This blue or

Atul Vohora, *Left Niche*, after Giotto di Bondone, c 1305. One of the pair of painted niches, containing a window and suspended chandelier seen perspectivally from below.

variations of its hue fill the upper portion of most of the individual sections of each cycle. The blue provides a continuity between the sections and unifies the cycles. It simultaneously conflates the interior of the chapel as a sacred and devotional physical space, with the supernatural, sacred, imagined space of the paintings.

The sections within each cycle are separated and framed by an intricate, painted geometric border. The patterned border punctuates the narrative and creates a structure to contain the painted sections. The border provides a bridge between the paintings and unifies the cycles with the building.

The three tiers of narrative cycles are placed above a horizontal band, which contains the opposed grisaille figures of the vices facing the virtues across the chapel. The individual figures are separated by panels of marble, which are in fact painted. The illusion here is of surface, texture and material.

The final order of representation occurs on the chancery arch of the chapel. On either side of the arch, two painted niches recede to a window, with chandeliers suspended from the vaulted ceiling. These deliberate spatial illusions are primarily architectural, and help to destabilize the distinctions between real and imaginary. The inert stone of the building is then co-opted into the fluid and shifting world of representation. By making the separations between physical and imagined more permeable, the paintings are able extend their claim to something of the lived bodily experience of the architectural space.

Atul Vohora, *Joachim and Priest*, after Giotto di Bondone, c 1305. Roughly excluded from the temple, Joachim holds onto his lamb. For the lamb this is a temporary reprieve.

These illusory and mimetic devices invest the whole scheme with a reality, where the paintings become a continuum of the reality of the viewer.

Three generations of biblical stories read around the interior of the chapel. The first begins on the upper tier in the southeast corner, running from Joachim's expulsion from the temple, to the meeting of Joachim and Anna and concludes with their conception of Mary, mother of Jesus.

The first image on the upper tier of the opposite wall describes the birth of Mary, and the tier concludes with her and Joseph's wedding procession. The narrative transfers to the transept arch on the East wall, with the annunciation and, below it, Mary visiting Sarah, mother-to-be of John the Baptist. The spiralling extends to the second tier, back on the south wall, where the narrative continues with the birth of Christ and, punctuated by four slender windows, to the Massacre of the Innocents. Across the chapel, the second tier on the North wall runs from Christ teaching in the temple as a young boy, to his expulsion of merchants and moneylenders. The final spiral begins with the Last Supper, runs through to the flagellation, picks up again with the road to Calvary, and the whole cycle concludes with the Ascension followed with the celebration of the Pentecost. Below the interstitial patterns, which divide the individual frames of the cycle, a row of figures representing seven Vices face seven Virtues on the opposite wall. Among the Vices, envy takes the place of avarice, which may reflect some of the concerns of powerful and wealthy Scrovegni family. The iconography of the vices and virtues underpins the narrative cycle and creates a commentary on the unfolding events in the story. Similarities in the poses, between the iconographic figures and the characters in the narrative, accentuate the moral dimension to the story.

Within each scene, the figures stand in shallow but clearly articulated spaces. They relate to each other physically and spatially, framed either by elements in the barren landscape, or by architectural motifs. The scale of the figures remains constant throughout the cycle; there is no adjustment of scale to reflect prominence or importance.

This rational, democratic rendering of the figures requires considerable invention to sustain the narrative force and a believable experience of the relationship of the figures to the space. The landscape and architecture are painted with a wide angled perspective and reinforce the rhythmical groupings of figures. The repetition of particular architectural motifs raises the possibility of more than one event occurring at the same site, which provides continuity in the narrative. Compositionally, the landscape and architecture in each scene lend force and emphasis to the dramatic focus of the image, while also connecting scenes across the wall of the chapel.

The framed scene carries some trace of a physical enacted oral narrative – the figures are seen in consistently frontal format of the stage-like setting. As actors, the figures are empathetically recreating the story, and in so doing, invite an equal empathetic participation from the viewer. The immersive, non-verbal nature of this involvement facilitates the recreation of the emotional, physical and temporal world of the narrative in the mind of the viewer. The closely observed naturalism of the paintings is central to the process, investing the images with a heightened reality.

The figures display a rich internal life, in that they respond to each other emotionally and empathetically through gesture and a rich reservoir of facial expression. The enactment of the narrative is characterized by a sense of restraint; individual actions are understated and the coherence of the whole narrative takes precedence over individual moments or local events. The progression of the characters through the narrative cycle is both spatial and temporal. The narrative unfolds sequentially, read from left to right and progresses chronologically from one to the next. Figures are framed close to or cut through by the edge of the painting. This kind of contingent cropping lends momentum to the story, with figures either moving out of the frame or caught in the act of arrival. Although unusual, there are instances where the narrative progresses within a single

Atul Vohora, *The Shepherds*, after Giotto di Bondone, c 1305.
The shepherds exchange a momentary glance.

scene, so that characters appear twice in one painting. The characters themselves are subject to the passage of time. The aging of even marginal individuals in the narrative scheme, as the story continues, is conveyed with subtlety and nuance, as figures grow old and hair greys and recedes.

The temporal continuity of the cycle is disrupted by the transference to the east wall around the transept arch. The arch frames the altar behind which Enrico was ultimately buried. At the top of the arch, God, surrounded by angels, looks down on the chapel. This painting, unlike elsewhere in the chapel, is painted on a wooden panel. Presumably detachable and mobile, iconographically this implies a separation between the physically conflated spaces of the chapel and paintings, to the

divine and intangible space of God. Not of the world, and here, separated physically from the wall, God is mounted above the Annunciation. Gabriel kneels facing the arch, which is both a bridge and a cavity. On the opposite pillar, the Virgin Mary kneels, facing back.

On the same wall below Gabriel, Judas, clutched at by a demonic shadow, is caught at his moment of deep transgression. He meets with a group of priests, in fact the same group found earlier, standing in the background when Christ expels moneychangers from the temple compound. In exchange for a sack of money he agrees to betray Christ.

Across the arch, facing this betrayal, is a painting of the now-pregnant Virgin visiting the no-less-pregnant Sarah. It is an act

Atul Vohora, *Satan, the Last Judgement*, after Giotto di Bondone, c 1305. Bloated, hairy and horned, Satan perches on the backs of a pair of dragons.

of compassion and charity deliberately set opposite the scene of greed and betrayal. The choice to extract, isolate and oppose these two arguably infrequently depicted scenes from the narrative cycle suggests a deliberate juxtaposition. From a position of prominence on either side of the arch, the opposition of the two images initiates a sub textual reading of the programme. The reference is specifically to Enrico Scrovegni and his intentions in commissioning the chapel and decorations.

A convergence of events surrounds the commissioning of the chapel. The turn of the century brought widespread celebration to mark the birth of Christ, followed soon after by the portentous appearance of Halley's Comet in 1301, no doubt a cause of considerable concern for triskaidekaphobics. Enrico's first son was born at this time and, perhaps prompted in part by each of these events, he sought to build a chapel. As a banker and the son of a banker, Enrico had access to sufficient money to do this. It was precisely this that may have lent urgency to the project, as money lending or, more specifically, usury was held to be sinful.

The charging of interest on sums of money was taken as making inert metal multiply or breed. As a distortion of the natural and divine process of procreation, the making of money out of money carried connotations of sexual perversion and was condemned as morally indefensible. Enrico's father, Reginaldo, was to appear as a usurer trapped in Dante's seventh circle of Hell, with a bag of money tied around his neck. In the context of the climate of widespread opprobrium toward both his family and occupation, it may well have been expedient for Enrico to seek appeasement and reconciliation within the Church. The resulting magnificence of the chapel reflects a desire to position himself socially, financially and morally.

The elision of the symbol of bags of money with the idea of sin, as opposed to charity, is reinforced through the narrative of Judas, who is finally found hanged in hell alongside the usurers. The usurers hang naked from ropes tied to bags of money; Judas has been disembowelled and his entrails spill from his stomach, in an inversion of childbirth. Satan, here related very closely to the Baptistery Satan in Florence, devours and gives birth to suffering figures.

The sinful and unnatural equated with money and usury is set against the idea of supernatural intervention in procreation. It is through the sacrifice and prayer that Joachim and Anna give birth to Mary. The miraculous hand of God helps Joseph's rod to flower and the Virgin gives birth. Sterility, sacred virginity and fertility take on a symbolic importance. The chapel was originally consecrated to the Virgin of Charity; the Virgin offers herself as the bearer of the Son of God in an act of giving. So charity becomes the model for a path to redemption, epitomized in the charitable actions painted on the arch, in the Annunciation and the Visitation.

Among the Vices, flames at her feet consume Envy and she has a large sack of money tied to her waist. In contrast, Charity, who offers her heart to the hand of God, and fruit to her neighbours, stands on sacks of money with apparent indifference.

Destabilizing the chronology of the narrative cycle opens the possibility of reading the paintings in terms of their spatial position. The frescoes were painted vertically due to the technical demands of the process. At the centre of the long north wall a series of miraculous events are grouped vertically. Descending from the miracle of the flowering rod, to the turning of water into wine, placed besides the raising of Lazarus from the dead, the vertical concludes with the lamentation and the resurrection of Christ.

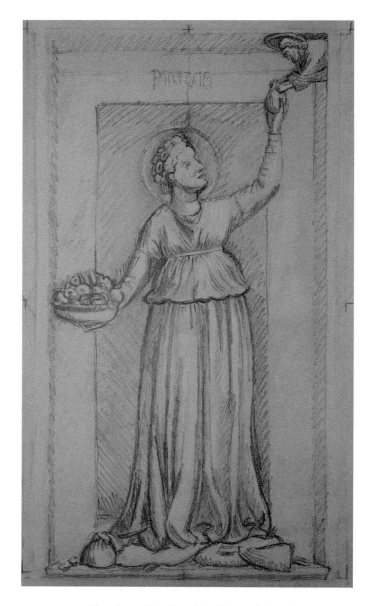

Alex Cree, *Charity*, after Giotto di Bondone, c 1305. Charity offers her fruits heavenward apparently indifferent to the sacks of money beneath her feet.

Across the chapel at the centre of the south wall, the Arrest in the garden faces this grouping of images. The scene of the enactment of betrayal for financial gain is opposite the repeated motif of miraculous return to life. The hope of redemption, or rebirth is then central to the structure of the space, the narrative cycles and the project itself. Enrico imitates the kneeling Virgin of the Annunciation, in kneeling before her to present the chapel, in the hope of eliciting her intervention in his own redemption.

The Kisses

The narrative bands span three generations between their three tiers and the trajectory that they define is closely aligned with the biblical textual source. The content then is in a Christian sense, sacred. One of the most profound achievements of the fresco cycle is to re-imagine the narrative, visually, in deeply human terms. The experiences described in the images go far beyond the symbolic or iconic. The figures have rich internal lives, which become manifest in the interactions between characters. The first tier begins with the expulsion of Joachim from the temple, his vulnerability mirrored by the fragility of the lamb in his arms. In his subsequent encounter with the two shep-

herds, he seems almost oblivious to their presence; the glance exchanged between the two shepherds articulates a shared concern for his wellbeing. In their exchanged look is the resonantly expressive, wordless communication of people accustomed to living remotely, surrounded by animals. Their gestures are compassionate and invite empathetic identification. The role allocated to ordinary people becomes more than the peripheral presence of an anonymous and stylized face. The shepherds are the same scale as the haloed Joachim, they inhabit the same space with an equal physicality, and it is their reaction that gives meaning to the episode.

From a traumatic experience of enforced exile at its beginning, the tier concludes with the meeting of Joachim and Anna outside the Golden Gate. Two imposing, square towers flank the arch, and while marking the boundary of the city, together they frame the small crowd, gathered to witness this meeting. One of the shepherds is partly obscured by the edge of the composition as he walks into the painting.

Between the two groups, standing on an arched bridge, Joachim and Anna kiss. The rich sheen of her embroidered robe conceals her already swelling body and Joachim leans stiffly in to embrace her. His earlier sterility has been miraculously reversed, and the embrace is one of celebration. She holds his head with a moving tenderness, the curls of his beard escaping

Atul Vohora, *Joachim and Anna*, after Giotto di Bondone, c 1305. The couple kiss passionately. The strength of their feeling for each other is manifest in the tenderness of the image.

Atul Vohora, *Judas Kisses Christ*, after Giotto di Bondone, c 1305. Judas, now without a halo, identifies Christ.

between the parted fingers of her delicately placed hand. The proximity and inclination of the two heads speaks of intimacy and regard, reinforced by the two haloes intersecting. As the two heads come together, the profiles overlap and lips touch in a gesture that is deeply moving. The proximity of the heads in profile creates a mingling of identities, almost reading as a new composite face looking into itself, of ambivalent gender, part man part woman. The synthesis of the two heads creates an instability, that of the non-seeing, which intimacy and proximity can induce. Behind them, a figure, hooded and cloaked in black, introduces a malevolent note to the scene.

Lower on the same wall of the chapel, the second kiss and second embrace inverts the loving intention found in the embrace in front of the Golden Gate. Now shorn of his halo, Judas and Christ confront each other at the moment of betrayal. Surrounded by a scowling crowd, Christ looks down at Judas

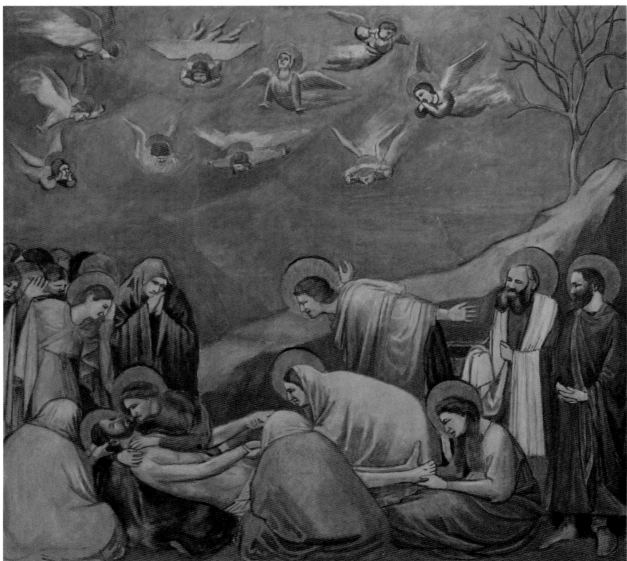

David Caldwell, *The Lamentation*, after Giotto di Bondone, c 1305. Mary's loss is profoundly human and deeply moving.

with hostile reproach; heedless, Judas plunges guiltily on. The raised staves, held aloft by the seething crowd of helmeted heads, converge on the embracing figures, heightening the dramatic tension of the encounter.

A comparable reversal can be found in two embraces between the Virgin Mary and her son. At the nativity she delicately handles the tightly wrapped bundle with a look of maternal joy. This is far from a knowing homunculus – the child is vulnerable and altogether human, reaching desperately for its mother when presented to the priest for circumcision.

The second embrace between the Virgin and Child takes place following the Crucifixion. The pale and lifeless body is supported by the hands of the women at the bottom of the painting. The rocky diagonal of the barren landscape leads down from the dead tree at the top right corner, to the agonized embrace at the bottom left. The backs of two shrouded women are like two pillars surrounding the emotional and dramatic core of the painting, as the two heads come together. Christ's eyes are sightless, his mouth parted, while Mary's face is crumpled in grief at her loss. It is the altogether human grief of a mother for her son, her anguish accentuated by the broken and lifeless body she cradles for a final time. The rejoicing angels of the Nativity now writhe and sear across the sky in despair.

The range and intensity of depicted emotion in the paintings can only be the result of a profound insight into human experience. A highly nuanced ability to describe facial expression combined with a sensitive understanding of gesture gives the figures their extraordinary expressive range. A lyrical sense of human interaction imbedded in the structure of each image creates the emotional landscape of the narrative.

Sign and Iconography

The fresco cycle is defined by closely observed natural and human phenomena. The figures are physically present in space, and among each other. They possess fully articulated and densely formed bodies. The gestures and interactions between the figures are located in highly specified environments, which the figures are able to fully inhabit.

The site of each scene is fully integrated into the dramatic thrust of the narrative, while also providing compositional resonance and emphasis to the internal rhythms and structures of the episodes. The central narrative strands are surrounded by a rich vocabulary of incidental and anecdotal events. Figures arrive and depart at the edges of the frame. Children punctuate the crowds, fitting in a chapel dedicated to family worship. Animals frame the human drama, occasionally attended to by their keepers.

In finding a visual equivalent for the supernatural basis of events in the narrative, the representational mode shifts accordingly. Within the framework of the closely observed world of the fresco cycle, a distinct iconography registers the physical and visible presence of the supernatural. The narrative, at certain moments, hinges on these supernatural interventions. The appearance of the hand of God at the sacrifice Joachim makes in the wilderness, signals an acceptance of the sacrifice. The hand penetrates the field of blue from the top edge of the frame. The hand is disembodied and non-terrestrial, although it shares attributes with the depicted forms of the figures. Similar in scale to the hands of the figures below, the hand seems as physically present, to the extent that it is noticed by the shepherd on the left. The hand reappears in similar circumstances at the miracle of the flowering rod. Just discernible within the blue of the cusped arch, the hand points to the chosen suitor, who, fortunately for all concerned, is Joseph.

Angels appear to both Joachim and Anna. Having found shelter with the shepherds, Joachim collapses into sleep, his head held in his folded arms. The empty blackness of the shelter behind him becomes a metaphor for his internal state. While dreaming, a winged angel appears to him. Again the angel shares a comparable scale to the figures below, although as a creature of the infinite blue sphere above, the angel has no legs. In spite of appearing to Joachim in a dream, the angel is also present to the shepherds who look up from the delightful bucolic vignette of their grazing herd.

Anna, meanwhile, kneels inside her house. Here a section of the house is cut away to reveal the austere interior. The private, secluded nature of her supplication is reinforced by the separation between the interior and exterior spaces of the house. Outside the door, below the stairs, a woman, not dissimilar to the figure of Justice, sits weaving. The angel appears only to Anna, entering the house through the window. At the Nativity of Christ, mother and infant shelter beneath a simple wooden structure, which simultaneously describes their resting place and defines the focus of the scene, in the tender gaze between Mary and Christ. Joseph, asleep among the livestock, anchors the composition, while above the shelter a group of angels soar upward in thanks. Again, the shepherds notice this constellation of winged figures, and are in turn acknowledged by one of the angels. Although diminutive, the angels appear as three-dimensional forms moving through the volume of the air. There is a marked similarity between the trailing tails left by the legless angels and the comet that appears at the Adoration. Based on a probable sighting of Halley's Comet in 1301, the physical properties of the comet are transferred to the flying angels. A more robust winged angel stands in attendance.

Later in the cycle, at the Lamentation, the sky is once again filled with angels, now plunging and arcing in despair. Their reactions and gestures are more overt than those of the figures below. In both this and the scene described above, the angels function almost in the way of a chorus, providing commentary

and reaction to the events of the narrative and in part instructing the viewer in how to react.

The angels then are either terrestrially involved in the events of the narrative or engaged in celestial responses. The oppositional structure of the fresco cycle invokes the corollary intervention of devilish ghouls. It is at the critical moment of betrayal that the naked black silhouette of the hoofed figure seizes Judas from behind. Judas, clutching at a sack of money, seems eager to please, yet oblivious to the figure behind him. The creature is able to physically take hold of his shoulder, yet remains shadowy and indistinct. This invocation of absence, of the fugitive and sinister, exists to a degree, outside of the world of the narrative.

The language in the construction and material presence of the frieze of figures at the front of the painting remains distinct from that of the demon. It lunges into the frame, partially obscured by the edge, and stands outside the physical space of the composition. The demon is present within the composition but occupies a metaphysical space. The dark shape of the demon becomes a representation of the internal state of Judas' mind. As a denotative symbol, the demon in part also signals the now inevitable end for Judas. Amongst the iconographic grisaille depictions of the Vices, despair is envisaged as a woman similarly hanging by a rope attached to a sack of money. She too is plagued by an attendant demon, albeit much smaller.

At the conclusion of the scheme, Judas, having hanged himself, is trapped in hell, at the mercy of hordes of demons overseen by Satan himself. The reciprocity between the scene surrounding the betrayal by Judas, and the depicted Vice creates a frame of reference for the narrative, where the idea of sin is reinforced through a series of visual similarities and elisions.

Here at the Last Judgement, the narrative surrenders its temporal imperative, for the unending expanse of infinite time. The images are untethered from the material limitations of terrestrial space. In its place, the final painting of the scheme is cleaved between visions of heaven, and rivers of blood flowing through the dark recesses of hell. Christ sits in judgement, above the depictions of paradise and damnation, surrounded by angels and apostles.

Above him is a triple-arched window, through which the setting sun would illuminate the space. Either side of the window, angels roll back the very fabric and surface of the image. Here, it is a depiction of the firmament that is removed, to reveal the golden city behind. The image then is layered, with the visible surface concealing a second order of reality. In a similar way, the windows puncture the wall, to allow the light of the evening sun into the chapel. This light resonates with both the luminous, coloured halo defining light emitted by Christ and the light of the golden city behind the painted surface. The window disrupts the picture surface, so the angels peer from behind the moulding at its edge.

While retaining something of a sense of depth, the groups are in fact stacked in vertical bands, either side of Christ, with the scale of the figures determined by their importance within the schematic structure of the wall.

The fresco cycle employs non-corporeal signs that inform a reading of the images. The most significant of these is the use of the halo around the heads of figures in the narrative. The halo, as a sign, exists in relation to a broad and already established pictorial convention for signifying importance within an image. They are used selectively and reflect the doctrinal significance of the haloed character. While having no physical properties, in that the haloes are weightless and inanimate, they reflect the spatial position and orientation of the head of the wearer. They inevitably obscure parts of the painting and are entirely opaque. The halo is then, not a neutral sign, imposed onto the image, but becomes attached to the head it surrounds in a specific way. It seeks to be an integrated part of the painting, while retaining an autonomous ability to denote status. The haloes are gilded, so distinct from the pigment of the frescoes, and ornately decorated, giving an iridescence to the surface.

The circular shapes of the haloes punctuate the cycle with their presence. It is however the absence of the halo around the head of Judas, as he kisses Christ, which resonates most strongly in the narrative. His betrayal is inescapably linked to exclusion and damnation, the force of which is revealed in his dispossession and loss, here symbolized by the loss of his halo.

On the North wall, following the miracle of the flowering rod, Mary is now betrothed and walks in procession, accompanied by the joyful music of raised trumpets and strings. The fresco is considerably damaged, although still visible above them, a large frond emerges from the open balcony window. Like a leaf in shape, the scale of the frond is prodigious, dwarfing the figures below. Here an ostensibly natural form is recast as a symbol of her imminent pregnancy and the coming of her child, and signals the divine nature of the event. The supernatural is given various visible forms that allow a visual integration into the tangible, terrestrial world of the cycle.

Of Vice and Virtue

INJUSTICE

Injustice here is a male figure seated beneath a semi-circular arch. The arch encloses the head and the darkened shapes either side of the body intensify the gleaming robes he wears. The head is rendered in profile, with the projection of the full beard countered by the pronounced shape of the headdress extending behind the head. In his hands he holds a long pike and a sword; battlements above the arch enforce the violence hinted at in the severity of the profile. The rule of Injustice then is coercively arrived at through the unyielding, long shaft of the pike and the blade of the sword resting on its point.

A screen of trees forms a barrier between the viewer and the seated figure. The trees are painted to the scale of the figures of the frieze below the main figure, and simultaneously position Injustice as inaccessible and remote, as well as imprisoned by their slender natural forms.

A group of smaller figures enact scenes of this misrule. The frieze depicts several acts of brigandry. The landscape is harsh and unforgiving. A figure seizes the bridle of a fallen traveller, while at the centre of the frieze, a group of men surround the prone and vulnerable figure of a woman. Her clothes are pulled roughly from her body, and the implication is clear. At the feet of Injustice, lawlessness and violence abound, specifically towards women.

JUSTICE

Justice is personified as a woman. She sits crowned in front of a field of grey blue. A cusped arch rises above her, its gentle curves echoing the shape of her head and shoulders. The arch supports an embellished triangle, which soars to a point above the seated figure and is mirrored by the flaring shape of her parted mantle. Surrounded by a triple cusped arch and the low panelled wall, Justice appears magnificently enthroned; she dispenses both punishment and reward from each hand respectively. Her head inclines towards her right and the idea of reward. This favourable disposition implies a looking away, almost an avoidance of the somewhat harsh figure, whip in hand, who metes out due punishment. At her feet, a frieze depicts the rewards of justice, with, at its centre the idea of celebration in the form of a joyous dance and song.

The structure of the seated figure with the reduced scale frieze at the base connects the two ideas of justice and injustice and defines them in oppositional terms. The opposition is conceived of within a gendered framework, with a pejorative emphasis on violent masculinity. In the context of the decoration of the chapel, the icons representing vices and virtues function as a template for reading the narratives above. Direct similarities underline this connection. Here the icons and their attendant friezes perform a didactic function with regard to civic conduct and governance, so extending the commentary on codes of behaviour from the personal, to the wider social domain.

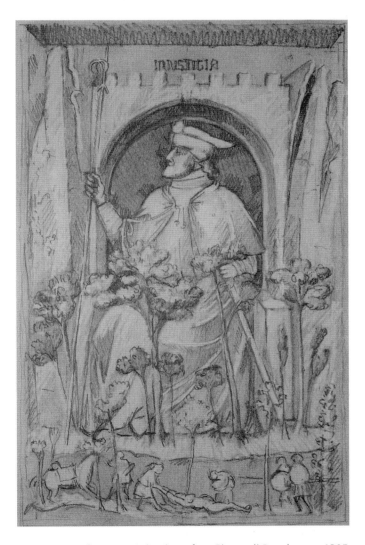

Alex Cree, *Injustice*, after Giotto di Bondone, c 1305.

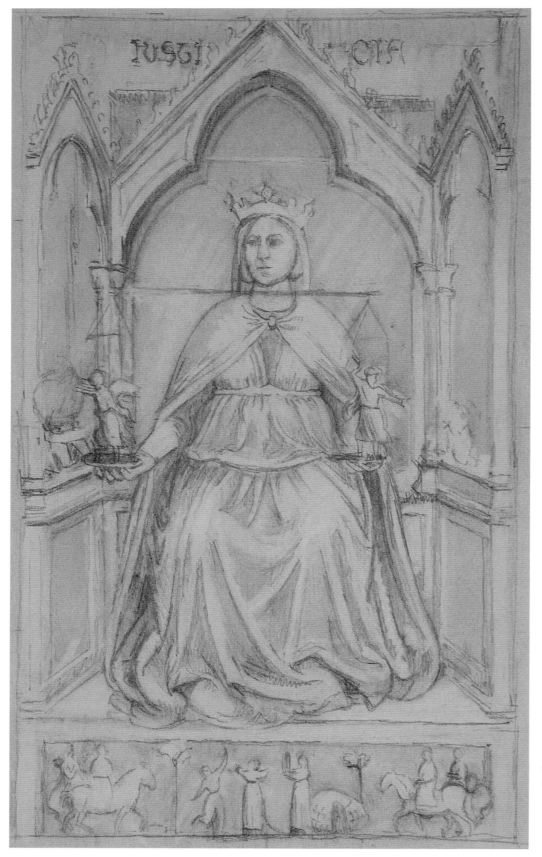

Alex Cree, *Justice*, after Giotto di Bondone, c 1305.

Alex Cree, *Folly*, after Giotto di Bondone, c 1305. Folly is cast as a rotund figure of bumbling avian stupidity. With a crown of feathers and a trailing train sweeping the floor behind him, the threat posed by his raised wooden club seems likely to be directed towards his own person. His presence strikes a comical note amidst the sobering invocations of the surrounding walls. A popular figure of fun, the fool is both morally instructive and a source of ribald humour.

WORD AND IMAGE

Text and image can hold diverse positions in relation to each other. While texts frequently exist with no relationship to any images, it is much rarer for images to lay claim to a complete autonomy from text. The title of a painting places the image in direct relationship to some form of text and inevitably affects its reading. The following chapter looks at some of the interactions between image, word and narrative.

The Hamzanama

The Hamzanama was commissioned during the reign of the third Mughal Akbar. By all accounts an unusual ruler, Akbar's patronage of the arts initiated an extremely fertile period of painting. The highly illustrated manuscript depicts the many and far-reaching adventures of the eponymous hero, Hamza. The scale and dimensions of this collaborative project suggests that even the royal atelier was stretched. Work began in 1562 and the final folio was completed in 1577, with the paintings overseen by the court artists, Mir Sayyed Ali and Abdu al Samad. The final edition contained close to 1,400 paintings, of which fewer than 200 survive.

The Hamza narrative was primarily performed orally and evolved in retelling over several hundred years. Through each performance or Dastang, often lasting through the night, the narrative absorbed local stories as the popularity of the tales spread, reflected in the many twists, sub-plots and the wide array of characters in *The Hamzanama*. Any factual basis for the stories is inevitably buried in the dense layers of accumulation and exchange.

The paintings were bound adjacent to lines of accompanying text. The relatively large scale of the pictures, 68 × 58cm, suggests they may have been held as a visual accompaniment to the oral performance. The text served as an indication of elements that may have been incorporated into the performance. Each retelling was unique, subject to variation, selection and embellishment, depending on the particular rhythms of the Dastang. Although primarily a synthesis of oral and physical enactment with the presented visual image, the performance of the narrative had then a textual underpinning.

The paintings themselves are the result of a collective act of creation, which brought together artists working in a largely Persian tradition with a more indigenous local strand of painting. The extraordinary and heroic popular stories are reimagined in an Indian context. The world of the Hamzanama paintings is that of eighteenth century Mughal life described with a compelling mixture of rich colour and lyrical drawing.

Drawn in black line, and painted with opaque watercolour, the intensity of the colour remains surprisingly undiminished, due in part to the thickness of the pigment. The visually abundant surfaces of the paintings are filled with pattern, closely observed natural forms and a rich vocabulary of human interactions. The vertical format of each page is repeatedly reinvented to accommodate the wide-ranging events of the narrative. Spatially, the paintings are complex and mostly seen from a panoptic, elevated position. This is the visual equivalent to the position of an omniscient narrator, unfurling worlds in which to immerse an attentive audience. Seen from above, the figures

LEFT: Coll McDonnell, Drawing after William Blake's *Hell* in Dante's *Divine Comedy*. Plunging into a fiery pit as Virgil and Dante look on.

appear to spread vertically down the page rather than overlap in a conventional manner. Taken out of sequence and separated from the accompanying text, the characters and events in the paintings can be difficult to place.

Ajanta

In the state of Maharashtra, the Waghora river drops through the Sahyadri Hills in seven dramatic cascades, called Sat-kund. The site of the Ajanta caves is a deep gorge cut by the river from the basalt and lava hillside. In total, twenty-nine caves were hand hewn into the sheer cliff face. These served as prayer halls and sanctuaries for the monastic Buddhist community. The construction and excavation of the site occurred in two distinct phases, the first in a period beginning in the second century BCE and the second in the fifth and sixth centuries CE.

This particular section of the river afforded seclusion and shelter, particularly during the monsoon, when the cliffs become alive with torrents of streaming water. Steps leading from the entrance of each cave down to the river bank have since been lost although they expressed, architecturally, some-

Atul Vohora, *Bodhisattva Padmapani, Ajanta*. The crowned prince holds an open lotus blossom as a symbol of awakening and grace.

thing of the relationship between the caves and the gorge: 'filled with the chirping of birds and the chattering of monkeys' according to a surviving inscription.

It is clear that the site was eventually abandoned altogether and remained largely unvisited until the interventions of an enthusiastic colonial hunting party, who entered the caves after stumbling into the horseshoe-shaped bend of the river. Their published accounts of the site began to kindle popular interest in the caves. That the site had been abandoned unquestionably ensured the survival of both the caves and their abundant decoration. Subsequent interest has contributed to the disintegration of the paintings in particular.

The scale of the project is staggering. Of the caves, some are as much as thirty metres deep and some twenty metres wide. At least one is double height and the internal surfaces of the caves are filled with carvings and paintings that cover the walls and ceilings. Quarried from the front at ceiling height and cut into the rock, down to the floor, the carvings, sculptures and paintings were part of an integrated decorative project. The carvings reproduce elements of contemporary wooden building construction, even where the excavated nature of the chambers renders some of the structures redundant.

The painted surface of the caves covers almost ten times the area of the interior of the Sistine chapel. An undertaking on this scale drew artists and craftsmen from across the country and the paintings are collaborations between artists working in a multiplicity of idioms.

The first phase of construction began in the second century BCE during the reign of the Satavahana dynasty, who were tolerant of Himayana Buddhism in the region. The earliest caves were either Chaityas, prayer halls or Viharas, monastic sanctuaries. Direct representations of the Buddha were prohibited in the practice of Himayana Buddhism, although it is likely these caves were once decorated and they do still contain some symbols and stupas. Deposits of soot on the walls and ceilings are evidence of the burning of oil lamps and incense and point to the use of the caves for worship.

Political stability encouraged extensive trade, and these and other rock cut sites developed close to routes used by traders. Surviving inscriptions indicate that individual merchants may have contributed to the project in part, as patrons.

A second flourishing at the site is recorded during the fifth century CE, under the rule of the Vakataka kings of the Deccan. The Emperor Harisena inherited a kingdom stretching from coast to coast and channelled some of his energy and wealth into the development of the site. Under the patronage of members of the court, the site expanded dramatically with twenty-six additions begun. Among these are some of the most elaborate and refined caves of the site. Although work in the grander caves appears to have continued unimpeded, there are signs in some of the smaller caves of interruptions, perhaps arising from local

instabilities and disruptions. Once a cycle of decoration was completed and dedicated to the Buddha, the images themselves became inviolable. In caves where work was interrupted or discontinued before dedication, the original images are, at times, covered by later additions.

The paintings are primarily of three sorts. Devotional images depict the Buddha in various Mudras, or attitudes, for example of blessing or teaching.

Long murals recount stories taken from the life of the Buddha as well as the Jataka tales, which are accounts of the previous lives and former births of the Buddha. Taking in elements of traditional folklore as well as drawing on a tradition of Brahmanical story telling, these widely disseminated tales are largely didactic and describe qualities of virtuous living. The anecdotal range of the narratives is reflected in the wide catalogue of forms found in the paintings, which also demonstrate the spiritual, cultural and aesthetic beliefs of the time. Peopled by the everyday inhabitants of towns and villages, the paintings offer considerable insight into contemporary life. The narratives run across the walls and follow independent conventions in the separation of episodes and the chronological ordering of the images. The paintings often contain no strict demarcation between moments of a story, with characters appearing severally within a single frame. The narratives can unfold vertically as well as from both left to right and the reverse.

Finally, surrounding these narrative segments, the surface of the walls are filled with geometrically arranged ornamental images of plants, flowers and animals as well as a cast of often humorous, fantastic, semi-divine creatures.

The wall was prepared with two layers of plaster, the first, a coarse layer, the second, finer layer was smoothed then covered with a lime wash. The pigment was applied to the lime wash with a protein glue-binding medium. The pigments include a white based on gypsum, a black derived from carbon, both yellow and red ochre, glauconite green and later, lapis lazuli as a blue. Unfinished sections of the murals show under drawing in red ochre and the more completed images retain this linear emphasis.

Variations in the colour create a nuanced sense of volume without a deep concern for the depiction of a directional light. Forms overlap and obscure each other spatially although the description of the architectural elements visible in the paintings serves a primarily narrative function, punctuating and structuring the pictorial surface rather than defining a purely spatial illusion. The scale of the figures within the paintings reflects something of their prominence in the narrative.

The paintings reflect a working knowledge of the Chitrasutra, taken from the Vishnudharmottara. This treatise codifies the artistic practices current at this time with instructions governing the best use of materials as well as the appropriate rendering of subject matter.

By any comparison the caves are an extraordinary achievement. At Ajanta, a culture is given a dramatic and full expression resulting in an art that is simultaneously grand and compassionate. The work of a large community of craftsmen, the caves are a forceful demonstration of collective endeavour and represent a coming together of multiple styles of imagery. They offer a glimpse of the depth, vitality and richness of an almost forgotten visual world.

DIANA AND ACTAEON, TITIAN (TIZIANO VECELLI) 1556–59

'It is no crime to lose your way in a dark wood.'

In the depths of the cool shadows of the vaulted arches of a ruined temple and surrounded by a thick growth of trees, naked nymphs wash Diana's pale, gleaming, body. Hunter, killer, Goddess, Diana rests her aching body after the rigours of the morning's chase. A youthful Actaeon, stumbling home in the searing midday sun, himself bloodied from the hunt, is driven by curiosity and thirst into the inviting glade. Closely followed by his hound, the sound of trickling water draws him into his fateful encounter with Diana's rage.

Pushing aside a loosely slung crimson drape, he is struck first by the glistening nymphs, radiant in the dappled light. They too register shock, here mingled too with longing, frozen by his gaze, suspended in fear and desire between the two poles either side of the painting.

Then, too late, he sees Diana, ferocious as she twists her body away, eroticism and imminent violence coiled in her powerful form. Her stare is unambiguous, her eyes as pointed as the glinting crescent of her crown. The empty sockets of the stag's skull, a trophy of a previous hunt, signals Actaeon's fate.

Titian's painting is based on the text of Ovid's *Metamorphoses* and, much like Ovid before him, Titian is capable of omitting or reconfiguring elements of the original story that inhibit or obstruct the dynamic tension of the painting. Titian's categorisation of the painting as a poesia invokes an equivalence to poetry and the ability to express visually, in paint, a full range of human emotion.

It is in the fluid reality of an imagined liminal world that the resolutely human Actaeon encounters and becomes embroiled in the supernatural realm of Diana. Actaeon as a symbol of youthful innocence is the victim of extreme passion. The consequence of this highly combustible emotion is his own death.

The two figures of Diana and Actaeon flare upward either side of the composition, both seen against rich red drapes. The solid column of the distant arch divides the two halves of the picture; Actaeon, separated from the group of women by a sparkling stream, stands on the near bank, Diana seated on the far bank is reflected in the unrippled surface of the water. The viewer

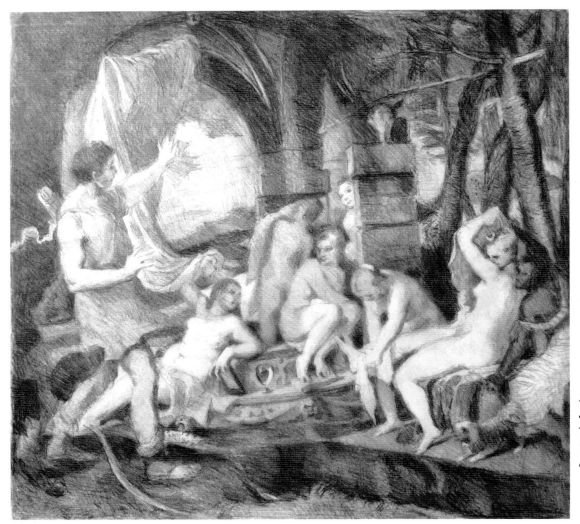

J.H. Woodward, *Diana and Actaeon*, after Titian (Tiziano Vecelli), 1556–59. Actaeon encounters Diana's rage.

becomes complicit in this separation and point of view. The clothed man is the onlooker and the naked women are seen. The accidental nature of the encounter and the violence of its outcome bracket the dynamic of the image.

A golden cone of light, emerging from the left of the painting frames Diana. As the diagonal of the distant hill and the glowing sand of the bank diverge, they become a metaphor for Diana's mounting anger. The open sky caught beneath the arch of the architecture gives way to the broken intervals of blue between the twisting trunks of the trees behind her head. The plunging corner of the vaulted arch is mirrored in the rising curve of Actaeon's fallen bow, and in the tight curl of the crescent moon on Diana's head.

The narrative is poised at the moment of transition between the initial transgression and its disastrous consequences. In the doom-laden, leafy darkness Actaeon, heir to the house of Cadmus and prince of Thebes, is plunged into mortal danger as punishment for seeing Diana naked. The ocular theme recurs

several times in Ovid's *Metamorphoses*. Semele, Actaeon's aunt, demands to see Jupiter in all his magnificence and is destroyed by the sight. Also, Tiresias is blinded by Juno as a punishment and then given second sight by Jupiter.

THE DEATH OF ACTAEON, AFTER TIZIANO VECELLI (TITIAN), C 1556–59

Diana, now clothed, runs, bow in hand, surefooted and powerful. No longer exposed and vulnerable, the goddess is here fully incarnate, mid-hunt, as a muscular Amazonian giant, her red robes trailing in the wind as she runs. In a direct reversal of the earlier painting, she now enters from the left of the composition as the active subject of the picture, framed by a boiling swell of cloud, remorselessly pursuing her rage to its grisly end.

Actaeon, in turn, dressed in red, is now helpless and overwhelmed, as his own hounds claw at his flesh. He is caught between man and stag, an antlered head attached to his still

Jennifer Blake, *The Death of Actaeon*, after Titian (Tiziano Vecelli), c 1556–59. Actaeon,
with the head of a stag, is devoured by his pack of hounds.

human body. Ovid has Actaeon transformed entirely into an animal, yet still conscious and thinking as a man. Titian reverts to a Roman convention, representing the two states in a purely visual metaphor, so a stag's head sits on Actaeon's human body. Actaeon, now prey, is unrecognized by the pack as they overpower him. He turns in wordless horror, arm flung out toward the now too-distant safety of the wood, reeling under the weight of the onslaught. A horseman shrouded under the dark canopy of trees flies homeward with news of this fresh tragedy.

The momentum of the painting builds from the left. The dogs rise as a continuous leaping rhythm from Diana's feet to Actaeon's head in a sustained and murderous diagonal. The swift flow of the stream mingles with the wild cries of the dogs, hurrying them to their prey, a cold steely light glinting on the broken water.

The scale and presence of Diana's trunk strikes the first note in a series of vertical intervals, of the trees etched against the horizon. The intervals contract as, with mounting tension, the pack surges forward to the kill. The tree placed along the right edge of the canvas encloses the movement, as the narrative pounds to its dramatic conclusion. Ivy swarms over the broad trunk in an echo of the dogs clawing at Actaeon.

Titian painted this group of paintings for Philip II of Spain, although *The Death of Actaeon*, which would have been the sev-

enth of the poesies, was not part of the collection. Titian had been appointed Court Painter by Philip's father, the Holy Roman Emperor Charles I, and later was further decorated as Court Palatine and subsequently knighted, taking the title Knight of the Golden Spur. He painted Philip at Augsburg and following Philip's coronation as King of Spain, conceived of the project to paint the Poesies for the young King. The sensuous paintings were well received by Philip, who was at this time locked into a primarily political marriage with Mary I in England. The death of Mary brought the marriage to a premature end.

Titian's daughter, Lavinia, had married soon after. She died while giving birth in 1560. The youthful, vigorous energetic figure of Diana emerges at this time, painted against the background of this searing personal tragedy, and the picture remained with Titian, in his studio until his own death.

THE RAKE'S PROGRESS, WILLIAM HOGARTH, 1734

The series of eight paintings called *A Rake's Progress*, now held in the John Soane Museum, in London, was painted shortly after its precursor, *A Harlot's Progress*, in 1730. As both a painter and printmaker, Hogarth followed the paintings with the swift publication of engravings after the same subjects. The engravings enabled the wide distribution of the images, which helped to fuel a rise in popular feeling for them.

A Harlot's Progress reflects contemporary metropolitan attitudes to prostitution and alludes to specific people involved in both brothel keeping and subsequent attempts to cleanse the city of the vice and disease for which they were blamed. The six paintings follow the life of Moll Hackabout, from her arrival in the city as an innocent young girl. She abandons vague aspirations to become a seamstress and makes an ill-judged plunge into the life of a kept mistress. Her descent is rapid; jail follows

Atul Vohora, *The Rake's Progress: 3. The Rake at the Rose-Tavern*, after William Hogarth, 1734. The Rake enjoys an evening at the Rose Tavern. His companion surreptitiously relieves him of his purse.

prostitution, and racked by venereal disease, finally she lies prematurely dead, her illegitimate son abandoned to fend for himself in an unsympathetic world.

A Rake's Progress extends the sequential format to eight images. Once again, the city is the location for the narrative, which charts the trajectory of the life of the young Thomas Rakewell, from the moment of his inheritance, to his ultimate loss of both liberty and reason. The paintings also follow the parallel life of a second character, Sarah Young, and her thwarted love for Rakewell. The scope and complexity of the relationships between characters in the narrative holds considerable depth.

The first panel shows the Rake taking possession of his estate, following the death of his father. Servants prepare the large but shabby room for mourning by lining the walls with black. Unearthed wealth, previously hoarded away, litters the floor. A skeletal, underfed cat watches over a trunk filled with silver. Titles and bonds are scattered around it.

Tom, standing at the centre of the composition, is thrust into his new life. Amid the gloomy surroundings of the miserly Rakewell's former house, the youthful and callous Tom is in the process of being measured for a mourning suit, by a rather threadbare tailor. He offers a handful of coins to the weeping girl, Sarah Young and her furious mother. Sarah holds a ring in her hand; letters professing Tom's love for her tumble from her mother's apron. With one hand, the mother points to her daughter's swelling abdomen, the other is raised as if to strike Rakewell. Their interaction is set at the dramatic core of the painting. Behind Tom, the steward drawing up the final accounts, stealthily and judiciously helps himself to his fee.

The painting is densely packed with anecdotal moments. The primary function of the image is to establish the characters and the parts they will take within the fuller structure of all eight paintings. There is a strong sense of the room as a stage set for the unfolding story. The relationship between the central characters, Tom and Sarah, is established through the interaction of their gestures.

Hogarth uses text embedded in the image to fill out and name his cast. An open ledger records a summary account of a visit home by Tom, alongside an account of using a bad coin to pay for a meal. The letters, falling from the gaping apron, identify Sarah. Both names leave no doubt as to the nature of the character, Rakewell being a corruption of the archaic form of rake, rakehell, and Young underlining the innocence and vulnerability of Sarah. The titles of each painting further serve to establish places and identify moments in the narrative sequence. The series demonstrates an interdependence between text and image, which allows the silent images to incorporate information that would otherwise remain beyond their range. The concern with wide dissemination is connected to this insistence on narrative legibility.

The paintings are intended to project a clear moral position. The wealth of supporting anecdotal imagery reduces the need for prior knowledge to decode the message. They reward scrutiny; the many significant objects, from the abandoned walking stick and broken spectacles of the frugal old Rakewell, to the paintings on the wall, all reinforce and illuminate the reading of the painting.

The title of the series, *A Rake's Progress*, is a direct allusion to Bunyan's *Pilgrim's Progress*, and taken in conjunction with the

Atul Vohora, *The Rake's Progress: 8.The Rake in Bedlam*, after William Hogarth, 1734. With Sarah at his side, the Rake is chained to the floor in Bedlam.

earlier *A Harlot's Progress* represent an inversion of Bunyan's text. The pilgrim in question, Christian, follows the arduous path to redemption. In the second part of the text his wife Christiana follows his journey. Hogarth presents cautionary tales, both of which tell of moral collapse and personal ruin. Moll dies young; Tom is naked, shackled and insane in Bedlam, held by a weeping and powerless Sarah. Although continually spurned by the dissolute Tom, she is sucked into his tragic life.

A satirical intention touches the paintings as Hogarth parodies the foppery of Thomas. Seduced by the glitter of an aristocratic lifestyle, Tom rejects the values of work, thrift and loyalty represented allegorically by Sarah Young. Their relationship endures several twists. In spite of his initial rejection, it is Sarah who intervenes at his arrest, paying off the Welsh Bailiffs from her own earnings as a seamstress. Hogarth takes a critical view of this act, showing her unknowingly dropping her sewing equipment, while focused on saving Tom. She is later barred from entering the church with their child to prevent his mercenary marriage to another woman.

Imprisoned at Fleet after having squandered his second, acquired fortune in the gambling house, an impotent Tom sits frozen in a paralytic stupor. He remains delusional. A play he has written as a means of recovering his money lies rejected by the publisher. On finding him in this condition Sarah faints in shock. It is the turn of her child to reproach her.

Finally it is Sarah who cradles the raging Tom in Bedlam. Ironically, he has now become part of the entertainment for the fashionable society ladies visiting the asylum. Hogarth is not entirely condemning of Tom in this pitiable state. He is presented as both predator and victim.

Hogarth described both his Progresses as modern moral subjects. In the idiom adapted from contemporary Dutch and Flemish genre paintings by Adriaen Brouwer and others, he outlines the potential pitfalls of Urban life. Through the use of conjoined visual and verbal imagery, the cast of Hogarth's fictional series confront themes of sexuality, social position and secular morality. In many ways, the paintings are direct reflections of Hogarth's own experience and outlook. In part a reaction against the frivolity of continental rococo life, the Progress alludes to some of the situations Hogarth may have encountered personally. As a child, the family was thrown into turmoil when his father was imprisoned for debt at Fleet. It is possible Hogarth drew on his own experience and memory in making the series.

THE MARRIAGE OF HEAVEN AND HELL, WILLIAM BLAKE, 1790

As a young man, Blake was apprenticed to the engraver James Basire. Later he was to study at the Royal Academy under Reynolds. Given to heightened religious feeling, the young Blake described experiencing visions directly, of seeing a tree filled with angels: 'whose bright wings shone from every bough like stars', while walking in Peckham Rye. From these formative experiences, emerged the artist as poet-painter, printmaker who produced and printed his own work.

The illuminated manuscripts were printed from copper plates using the innovative relief printing process. The prints were then coloured by hand using watercolour, so that while several editions of a work were possible, the nature of the process meant that few copies of each manuscript were made.

In the process of etching, acid corrodes the metal, and when the plate is inked, the ink is retained in the etched grooves. When the plate comes into contact with the paper under high pressure, the ink is transferred from the groove to the paper to produce a line.

Relief printing reverses the action, and the acid bites the metal surrounding the stopped out portions, leaving raised ridges to receive ink. The text was painted onto the plate in reverse, so as to resist the bite of the acid. The images were similarly painted onto the plate in linear form, so that each plate was designed while being executed, and were only truly seen for the first time on the plate. A greatly reduced pressure is sufficient to produce a print. Blake relished the use of acid in the process for its burning and cleansing properties, stripping away the surface to reveal the deeper truth contained in the page of the illuminated manuscript.

In London, Blake found the energy and material for his work. It was only in the city he felt it possible to see visions, and dream dreams. He populated his metaphysical landscape with a cast of invented and reinterpreted figures. Plate 84, taken from the book *Jerusalem* has a description of London, blind and age bent, begging through the streets of Babylon, led by a child, tears running down his beard. The accompanying painting is of a heavily bearded old man following a young boy. They walk past a domed church and on to a Gothic Abbey, an allusion to St Pauls Cathedral and Westminster Abbey, which signify, in Blake's personal iconography, the religion of the state and true religion respectively.

Thick flaming Los is identified with imagination and is aligned with the youthful vigour of Orc who invokes the idea of transgression and revolution. Painted carrying a hammer and tongs in the book *Jerusalem*, Los, as a blacksmith creates thought through the energy of fire and is conceived of in opposition to Urizen, who represents limit and reason. Urizen is associated with the single vision of Newton who brings the darkness of reason and with Theotormon, represents man tormented by law.

The figures are full and muscular, in many ways reminiscent of Michelangelo's male nudes although seemingly released from the material physicality of the Michelangelos. Blake's idea of the body as the visible portion of the soul allows the human

Atul Vohora, *Angel and Demon*, after William Blake, 1790.

figure in his paintings to be light and ethereal, freed from the relentless imperative of gravity.

Energy and passion are emphasized as positive attributes, while reason and temperance are conceived of as inhibiting spiritual insight and self-expression. The oppositional structure of these ideas leads to the possibility of synthesis as an ideal; in Blake's words: 'opposition is true friendship'. Blake describes his series of oppositions, here the contrast of reason and energy, as contraries. In the ethical framework described in *The Marriage of Heaven and Hell*, the conventional moral dimension of these oppositions are re-examined from the starting point of good (heaven) as a passive state obeying reason and evil as the active born of energy (hell). Energy, eternal delight, related to fire, to passion, to desire, comes from hell. 'The fires down below' are then the source of creativity and indeed energy, 'the only Life'. It is with considerable delight that he walks among the fires of hell experiencing what 'to Angels appears as torment and

insanity', as a free 'Son of joy'.

> Prisons are built with stones of law,
> Brothels with brick of religion.

Early experiences of Gothic architecture and decoration, while drawing at Westminster Abbey, contributed to the rich aesthetic of the manuscripts, valorizing extravagance and a full decorative impulse over simplicity.

The painted pages were then bound into volumes to make each book. As the pages were produced and finished by hand in colour, significant variations emerge between copies of the same work. There is some evidence to show Blake altered both the printing and the painting to reflect the nature and beliefs of the potential owner. The autographic nature of the printing process for both the text and the image lends a coherence to each sheet. Painted directly onto the copper plate, these are not

completed layouts that have been transferred. Each plate expresses something of the interplay between the graphic execution of the image and the textual composition. The images and pictures are not always simply translations of the text. The paintings are an integrated part of the whole expression in the manuscript and, as such, are not secondary to the text. While often rooted in the text, the paintings do offer significant deviations, and also refer at times to the text of another author.

The Marriage of Heaven and Hell consists of several units of text, which express interrelated variations on the main themes of the book unified by a single coherent vision. Rather than being contained by a strict linear narrative, the units combine poetry and prose with painted images in expressing Blake's heterodox perspectives. This was clearly not a completed manuscript, which was transferred in its entirety to a series of plates to then be printed; smaller sections were produced and print-

ed as a part of the working process, often not in the sequence in which they appear in the final book. The plates and groups of plates could then be reordered and reassembled as the shape and structure of the book emerged. In this way, the book evolved organically through the act of making it. Two sets of plate numbers in the book *Jerusalem* point to this reordering of autonomous or semi autonomous groups of plates into a single text.

The section near the end of *The Marriage of Heaven and Hell*, beginning with plate twenty and concluding with plate twenty four, forms such a unit within the structure of the whole book. The section is framed by two aphorisms: 'opposition is true friendship' and 'one law for the lion and ox is oppression'. Two paintings bracket the body of text. Before the text begins, a seated man arches his naked body upwards towards the sky. In different editions of the book, the man either sits in front of

Atul Vohora, *Seated Figure with Pyramid*, after William Blake, 1790.

Atul Vohora, *Nebuchadnezzar*, after William Blake, 1790. 'One law for the lion and ox is oppression.'

the celestial splendour of a rising sun or is contained by the triangle of a pyramid. The section closes with a painting of the heavily bearded Nebuchadnezzar crawling on his hands and knees. Similarly naked, he is a symbol of the fallen tyrant, now humbled. The image is reprised from Blake's repertoire of characters, although here is reversed as a result of being painted directly onto the plate.

The text is aimed at the writer Swedenborg and the satirical tone of the writing is reflected in the images. They refer to the theological writings by Swedenborg as well as the text of the Bible. The first painting then is related to the idea of vanity, the second, a tyrant cast down, to the reversal experienced by the Angel in dialogue with the Devil. Law, here in the form of the Ten Commandments, is defined as antithetical to virtue and is toppled from a position of being inviolable.

The highly innovative relief printing process is in itself an expression of the deeply idiosyncratic position Blake held as an artist. The process made possible an integrated and simultaneous evolution of text and image on the single plate. The production of the book was unfettered by the limitations of a more conventional printing process.

The illuminated manuscripts are the result of his urgent desire to create a (personal) system of expression not to be: 'enslaved by that of another man'. A strong and sustained belief in the creative potential of defiance allowed Blake to maintain a critical position in relation to dogmatic religion and its counterpart in contemporary artistic practice. Written against a background of political uprising in both France and America, *The Marriage* is optimistic in outlook. The vigour of his attack on orthodoxy and Swedenborg's New Church contains hope in its desire for

change. The bite of his satire carries something of the cleansing properties of acid, revealing truth by stripping away. The ideal is one of synthesis, which brings freedom.

THE RAFT OF THE MEDUSA, THÉODORE GÉRICAULT, 1818-19

The French frigate the *Medusa* was wrecked of the coast of Senegal in 1816, with 150 soldiers on board. It had set sail for Senegal in the hope of relieving the British occupation of Saint Louis, and reasserting the French colonial presence in the area. The Captain, Hugues Duroy de Chaumareys, was a survivor of the ancien régime, now recalled to service after a twenty-year absence. He found little sympathy with the largely Bonapartist crew. Persisting in his chosen course, the ship ran aground on the Arguin sandbank. The shortage of lifeboats meant the only hope of survival for almost a hundred and fifty of those on board, including women and children, lay with a hastily con-structed and heavily over crowded raft. The perilous condition of the partially submerged raft prompted seventeen to remain with the stranded vessel.

With only meagre rations, the raft was cut loose four miles from shore and drifted aimlessly for the next twelve days as the survivors rapidly dwindled in number. When finally rescued by the *Argus*, only twelve remained alive. Driven to desperation by the ravages of thirst and hunger, those aboard the raft had been plunged into an abyss, resorting to murder and cannibalism in order to guarantee their own survival.

The moral underpinnings of the French colonial project in Africa were thrown into disarray by these revelations. The penal code stipulated the death penalty for a Captain abandoning a vessel while others remained on board. The captain never faced charges. Measures were taken to suppress the shocking truth, and the unavoidable criticisms of corruption that accompanied them. Of the seventeen who had remained with the ship, only three remained alive when they were finally found fifty days

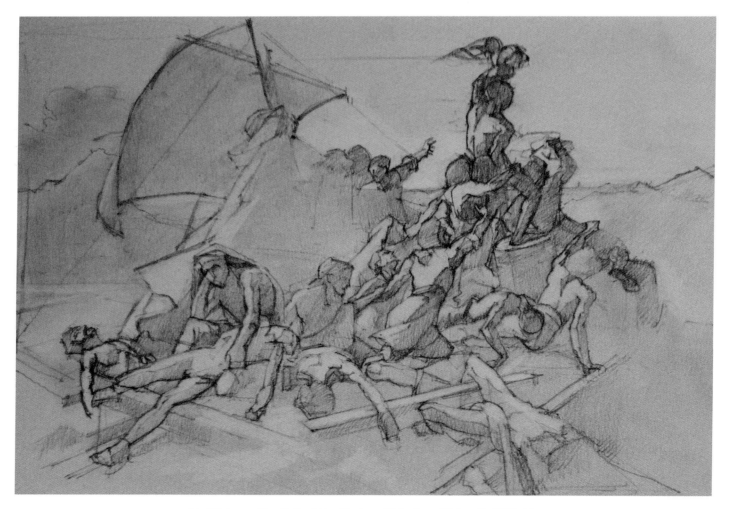

Atul Vohora, *The Raft of the Medusa*, Théodore Géricault, 1818–19.
The rising diagonal of figures spans the composition.

later. Two died shortly after and the third was murdered in his bed in Saint-Louis.

The English forces in Saint-Louis were only too delighted to help expose the confusion and French hypocrisy in the handling of the situation. Vicious responses to dissenting reports reveal an urgent desire to contain any potential damage.

Embittered by the refusal of the government to provide compensation, two survivors of both the shipwreck and the raft published their account of the events in 1818. Alexandre Corréard, a geographical engineer, and Henri Savigny, a surgeon, produced a damning description of the situation, which quickly became an indictment of a corrupt establishment.

Working closely with Corréard, Géricault's painting grew from these firsthand accounts. His preparation for constructing the painting was immersive. He visited the morgue and obtained amputated body parts to observe closely in the studio. He built a model of the figures and raft from wax to help determine the play of light across the pyramid of forms. Through smaller studies he explored several versions of the composition.

A powerful diagonal runs through the painting from the broken and dejected bodies sprawling across the disintegrating deck, up to the lifted figures at the top right waving frantically to a ship as it disappears over the horizon. The direction of the wind almost certainly guarantees the ship is moving away. The diagonal charts a scale of psychological states, seen from a remove. The position of the onlooker is one of proximity rather than complicity. The vanishing ship has something of the effect of a mirage on the shipwrecked figures, who, in their elation seem still subject to desperate hallucinations and delusions. There is no certainty in the prospect of salvation. The looming clouds offer, at best, an ambiguous indication of the outcome, for the desperate huddled mass of lurching humanity. The golden light of the low sun is almost extinguished by the brooding violet sky. A towering wave threatens to engulf the fragile craft entirely.

Although seemingly at odds with the distant setting sun, a strong directional light casts the figures in dramatic relief. The high pitch of the contrast emphatically underscores the narrative of the painting, while the pattern of the light creates a series of diagonal structures across the surface of the painting.

Basing the painting on the firsthand accounts of this sensational, contemporary disaster, Géricault's fascination with the event was, in part, political. The sharp clarity with which he defines the suffering on board the raft makes the full horror of the situation unavoidable. The victims of gross incompetence and callousness, followed by inhuman brutality, the survivors are presented in the mode of grand historical narrative painting. The anti-heroic event afforded an opportunity for a disturbing exploration of states of delusion, despondency and despair. The figures do however retain a certain robust muscularity, which locates them in a classical idiom. The painting was well received; a gold medal at the 1819 Salon provided an endorsement from the establishment. The painting was initially a response to the news of the shocking and scandalous event. It was however not the only shipwreck of the time, nor the only scandal to emerge during the Bourbon restoration.

Subsequently it has reinforced the significance of the event on which it was based, while obscuring the specific brutalities of the fuller context, morphing into a broader celebration of the struggle between humans and nature.

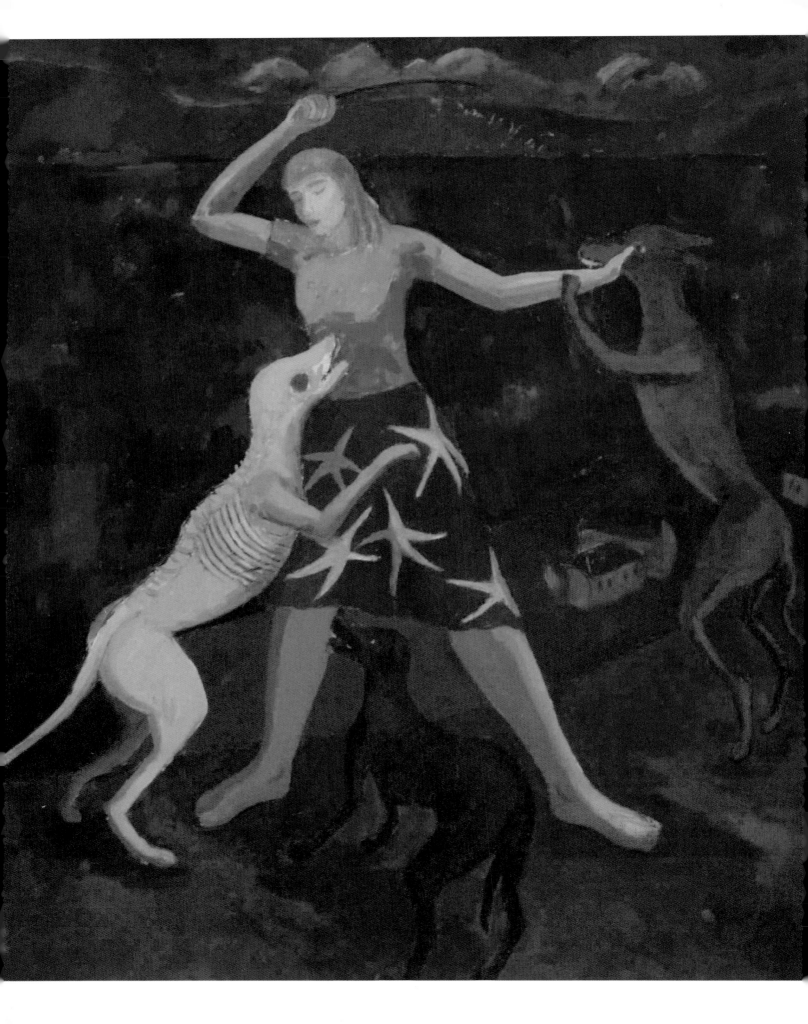

THE BEST TUNES

Painting has the potential to engage directly with some of the profound emotional truths at the core of human experience. The human form allows a direct empathetic response to the image. In the process of recognition: 'this is a person,' lies the unconscious supplementary realization: 'I am a person'. The following chapter relates to recurring narrative themes in painting.

Loss, Exile and Betrayal

THE BLESSED AGOSTINO, SIMONE MARTINI, 1325–26

The Altarpiece commemorates and celebrates the life of the man who came to be known as Beato Agostino Novello. It was painted in the mid-1320s by Simone Martini, after his return to Siena from Avignon. The Altarpiece is composed of three panels: a standing portrait of Agostino flanked by shorter panels either side, each depicting his miraculous interventions. Both the portrait and the adjacent paintings were painted posthumously and would have depended upon textual and verbal accounts for their veracity. The Altarpiece was commissioned by the Augustinian order partly with the intention of popularizing and disseminating the stories of Agostino's intercessions and his efficacy as a protector. The commission is an acknowledgement and demonstration of a belief in the capacity of the visual image to arouse deep and profound responses.

Agostino is dressed in the black habit of the Augustinian order, a symbol of the rejection of worldly or superficial beauty. The closely observed particularities of the habit give a nuanced indication of his position within the order. He is depicted as a loosely shaved and tonsured friar, with the two heavily bearded figures either side at the top of the altarpiece alluding to his later life as a hermit. He towers above four rather diminutive trees in an otherwise emptied landscape. The unadorned simplicity of the painting is itself an echo of the life of the subject, while in the absence of a halo, an angel whispering in his ear lends credence to the holiness of his being. Birds singing from the trees either side of the painting initiate a, no doubt desirable, comparison between Agostino and Saint Francis, which is reinforced by the structure of the altarpiece and depictions of similar interventions by Saint Francis.

The two panels either side are divided in half and depict two scenes each. Within each scene, the narrative structure hinges on the intervention of the now-haloed Agostino for its subsequent closure. At the top, on the right, a rider has fallen into a ravine while passing through the barren rocky landscape. The trefoil arch frames the towering rocky outcrops and a distant town, as well as the disembodied spirit of Agostino, sweeping down diagonally from the right of the picture. Across the diagonal, at the bottom left, the rider kneels unharmed, offering thanks to Agostino.

Opposite this, at the top of the left hand panel, the narrative is set once again outside the city. The elaborate architectural construct of tower and castellated gateway fills the arched panel and frames the grisly scene of a child mauled by a wolf.

LEFT: Greg Ward, *These Days...*, An echo of Actaeon's plight in Titian's *Death of Actaeon* lingers in the nightmare of this encounter.

The gateway divides the painting into two temporal spaces, with the appearance of Agostino above it marking the transition from calamity to the joyous restoration of the healed child to its family.

Below this, the narrative moves within the city. The narrow crowded lane and overhanging balconies, compositionally contained by a square, are suggestive of Siena itself. The build-ings are painted with clear unmodulated fields of colour; the golden sky, an inverted triangle, set in opposition to the visible section of the street. To the horror of its mother, a child has fall-en from the balcony, and plunges arms outstretched and skirt flaring, head first to the ground. The plunging figure is framed by the darkness of an open door. Here Agostino, a shock of black, arcs dramatically into the painting and once again the

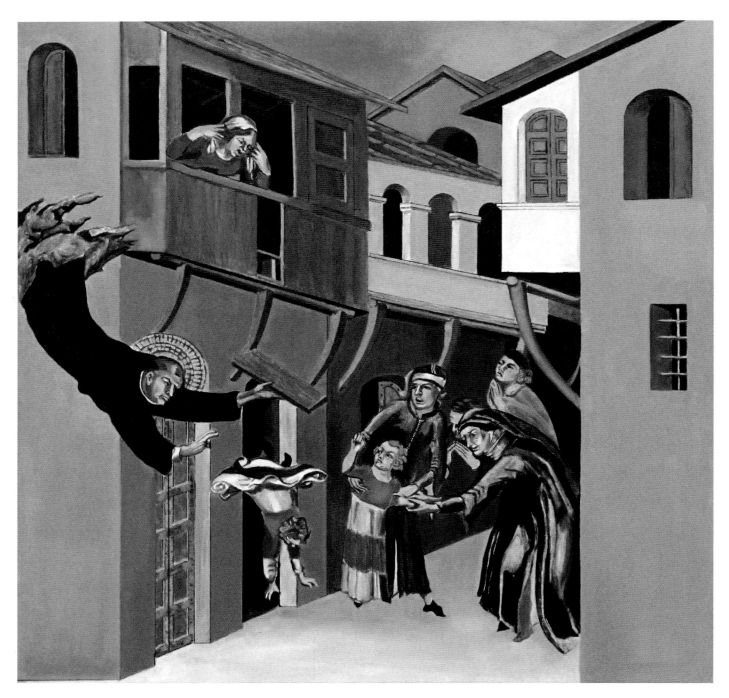

Martin Burrough, *The Blessed Agostino I*, after Simone Martini, c 1325–26. The child plunges from the broken balcony to the street.

child is returned, unharmed. The familiarity of the environment forcefully connects Agostino with the city of Siena and the everyday, domestic life of its inhabitants.

The final scene at the bottom left is set inside a house. Once again constructed from clear planes of unmodulated colour, the building is cut away to reveal its interior. The architecture functions outside the limitations of a purely perspectival space. Rather, the building serves as a structure for the unfolding nar-rative, dividing the temporal progression of the story.

The episode is documented and records anecdotally the inter-vention of Agostino in the life of the child of Margarita and Miguccio Paganelli. A cord of the cradle in which the child swings, tragically snaps, and the child is grievously flung out onto the balcony. Margarita, kneeling in the doorway, is framed against the golden sky and marks the transition between the two physical and temporal spaces. The grandmother Nera,

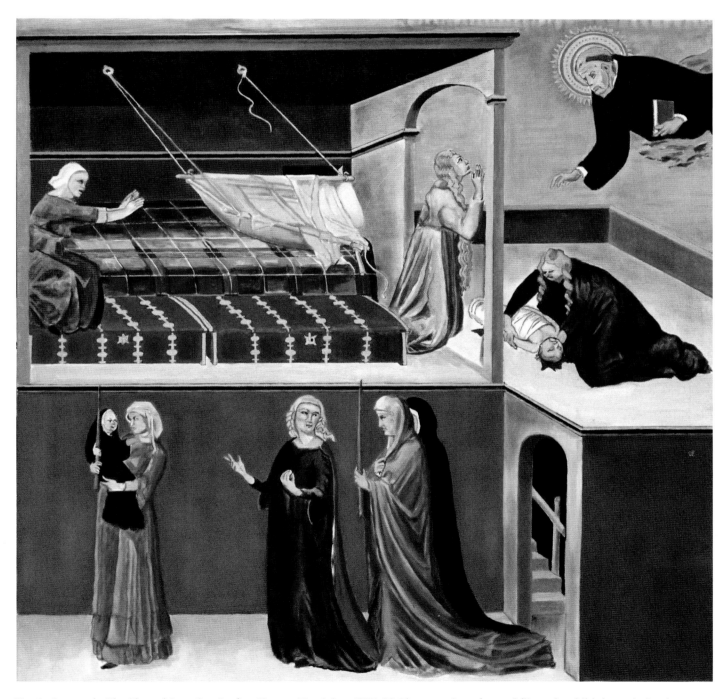

Martin Burrough, *The Blessed Agostino II*, after Simone Martini, c. 1325–26. The snapping of a cord flings the child through the doorway.

dressed in black, gathers the child while promising to bring the child to the altar if Agostino intervenes. He duly appears, book in hand and the scene concludes with the women now walking in procession behind the child carried by its mother. The child is dressed in the robes of a monk to symbolize its dedication to the order of Augustine. A staircase, just visible through the doorway, connects the upper and lower tiers of the scene, and links the images physically and as a metaphor, temporally.

There is a particular emphasis on the vulnerability of children in the altarpiece, with three of the four episodes alluding to the multiple array of potential harm. As a portrait, the altarpiece offers a layered description. Agostino is presented as a tangible and accessible figure, with a particular stress on his posthumous role as patron of the city and protector of domestic family life.

THE ENTOMBMENT, SIMONE MARTINI, 1335–44

The intimate scale of Simone Martini's *Entombment* invites a personal and directly emotional response to the image. The acute pain and intense sorrow of loss is imagined and made visible with compelling power. The silent rituals of entombment that accompany a mother's final embrace of her dead son, now give rise to uninhibited emotional expression. It is as if grief is given tangible form in gesture, as emotion expressed in visible action rather than an exploration of internal psychological states, which defines the emotional pitch of the image. The darkened sky shot through with streaks of red cloud amplifies the emotional tension in the picture.

The dramatic core of the painting lies in the proximity of the two heads of Christ and the Virgin Mary, her searching eyes unmet as she lifts Christ bodily, with the force of her embrace. The densely packed crowd of mourners, rising diagonally to the left, witnesses the tender, stricken moment. Directly behind the sepulchre, three women in red break into expressions of raw emotion. To the left, the first woman tears at her streaming hair; a second gestures, palms thrust forward in open-mouthed disbelief, while directly above the embracing figures, a third figure throws her arms up with a scream of horror. The intensity of her red tunic strikes a vivid note; her raised arms are both an exclamation and a funnel, rechanneling the focus of the painting back to Christ and the Virgin. A towering palm elides with the trunk of the third woman's body in a vertical plunge to the embrace. Similarly the path between the far trees runs through the arms of the second woman, to converge at the two heads.

A strong resemblance between the undulations of Christ's prone body and the high horizon accentuate the sense of horizontal while resisting a reading of spatial depth. The figures at the bottom of the composition are undemonstrative, they do not draw attention from the actual focus of the painting, and by kneeling they do not physically obstruct the entombment,

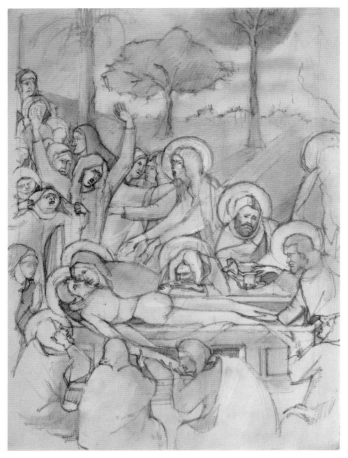

Atul Vohora, *The Entombment*, Simone Martini, 1335–44. The strong structure of the image underpins the full emotion of the painting.

affording an uninterrupted view of Christ's body. As the crowd gathers and presses close to witness the unfolding events, the perpectival construction of the painting is seemingly inverted, so that the figures appear to rise vertically, in a boiling pyramid, rather than receding spatially. The crowd participates actively in the narrative. As an onlooker, the viewer takes a place within the crowd. Highly individuated profiles punctuate the mass of heads, particularly of the nun standing below the palm, included in deference to the concerns of the likely patron, Cardinal Orsini.

The range and depth of emotion expressed by the figures in the painting is extraordinary and profoundly moving. From the loving and gentle embrace of consolation between the two women at the centre of the painting, to the dramatic gestures of their companions, the expression of emotion is defined by gender. Joseph participates in the washing of the corpse's feet without anguish, while John the Baptist is hidden, in his grief. The overt expressions of the women contrast with the hidden and unseen emotions of the men.

As the light is extinguished in the sky and darkness fills the landscape, Christ's pale and broken body forms a penetrating contrast. The rich, vibrant colours of the robes resonate with the heightened emotional pitch of the painting.

EXPULSION FROM THE GARDEN OF EDEN, MASACCIO, 1427

The two naked figures stumble out, through the arched gateway of Paradise, into a harsh, blinding light and unforgiving landscape. They are driven onwards by the commanding presence of a winged angel and the vituperative curses of an inflamed and vengeful God.

The compelling vertical composition forces the two figures together, the tall, unyielding, slender arch behind, contrasting with their crumpled forms. The bodies of Adam and Eve here are seemingly tangible and physical, firmly terrestrial, and bound to the rocky, barren earth by the shadows trailing from their legs. Eve is positioned slightly behind Adam, in a relationship that is spatially coherent. They both stand against a field of clear blue sky, which fills most of the rectangle. The blue field separates the terrestrial plane at the base of the rectangle from the infinite and metaphysical space above. In this blue field, an angel, dressed in flaming, scarlet robes, fills upper portion of the shape, free of the constraints of gravity. The pointed finger of the angel both directs and leads the despairing couple.

Heaviness appears to consume both Adam and Eve. Their bodies are bowed under the load of their transgression and its consequences. They are painted in motion, the restlessness of the exile, walking from paradise into wilderness. The castellated arch of the gate behind them defines the physical limits of the space they are leaving for the unknown and signifies a passing beyond moral boundaries. The painting conflates two episodes in the text, so the prelapsarian nudity of the figures is retained even after their expulsion. It is the knowledge of their own nakedness that is presented as physical and visible, as an exposure of an internal and emotional state.

Light passing around the volume of each limb reveals and celebrates the anatomical muscular presence of the bodies. Both are resolutely human figures, painted with compassion, their heartrending anguish resonates with a very contemporary experience of the horror, loss, sense of abandonment and despair, which accompany exile.

It is the gestures and facial expression that convey heightened emotion and unite the figures. The stance and shapes made by the legs are mirrored between the figures, setting up a series of diagonal rhythms, rising from the bottom of the picture. Alone in their grief, Adam and Eve converge in walking an, as yet, unfound path through the bleak landscape. The gesture of covering the face makes Adam unseeing, as though to implicate seeing with knowing and ultimately sin. His body however is

Coll McDonnell, *Expulsion from the Garden of Eden*, drawing after Masaccio (Tommaso di Ser Giovanni di Simone), 1427. Physical and fully human, Adam and Eve are exiled from paradise.

exposed, as simultaneously virile and extremely vulnerable. Eve covers her body, with the implication of an awareness of being seen, her face raised in a howl of raw emotion.

They walk into a lucid and unblinking light. The position of the fresco in the chapel connects the light in the painting to a high window in the chapel wall, so that the window appears to light the figures. The light, towards which they haltingly begin to walk, is rational, unidirectional and reveals the material reality of the world.

THE TAKING OF CHRIST, MICHELANGELO MERISI DA CARAVAGGIO, C 1602–03

Based on the narrative of the New Testament, this is the moment of betrayal. Judas leans forward to deliver the identifying kiss, followed closely by a huddle of soldiers. Heavily visored helmets cover the heads of the soldiers, hiding their eyes. Their glossy, black armour conveys a sense of sinister, mechanized menace. The encounter takes place at night and the darkness provides a dramatic foil for the shallow frieze of figures, caught in pools of brilliant light, who fill the frame of the painting. The emotional core of the painting is the embrace between Christ and Judas, and the proximity of their heads. The studied realism of the heads and the large scale of the painting invite an empathetic response to seemingly unmediated drama.

The unfolding narrative is in fact carefully and deliberately structured, employing emphatic contrasts as a means of punctuating and defining the emotional tension in the painting. A shaft of light clearly reveals the heads of Christ and Judas, bracketed from above by a billowing crimson cape and below by the confluent arms of Judas and the first soldier. The clasped hands of Christ emerge into the light below, as a physical sign of his internal state.

The sharp ridge of reflected light searing through the rich black armour connects the crowd to the embracing figures. A raised hand holding a lantern introduces a second light source, located within the composition. The lantern throws light across the brow of a man peering over the heads of the pressing crowd. His distance and curiosity mark him as an observer, sharing a similar position to the viewer. The brilliant light on his head closes the painting from the right edge. Immediately the viewer becomes aware of the figure at the opposite side of the painting. Open mouthed and arms thrown out in horror, this figure flees, in a direct emotional response to the imminent taking of Christ.

It is the highly specific and deeply controlled orchestration of these moments of light that give structure to the narrative. Emotionally charged events are bound to each other, against the inky darkness, in a complex pattern of contrasts and multiple light sources.

Atul Vohora, *The Taking of Christ*, after Michelangelo Merisi da Caravaggio, c 1602–03. The light in the painting structures the reading of the narrative. Brightly lit moments are set against the rich blackness of the night.

War

THE BATTLE OF SAN ROMANO, PAOLO UCCELLO, C 1438-40

The painting now hanging in the National Gallery, London, is part of a triptych, which describes the events surrounding the Battle of San Romano. The battle, one of a continuous series of exchanges, was fought between mercenary forces representing the city-states of Florence and Siena. Although by some accounts not entirely decisive, here it is celebrated as a tremendous Florentine victory.

Two powerful diagonals sweep through the surrounding foliage to converge on the rearing white charger at the centre of the composition. One of the only two unmasked riders in the painting, Niccolo da Tolentino leads the Florentine forces; he is closely followed by a tender and seemingly innocent youth. The diagonal axes emphasize the dramatic asymmetry of the painting. The mass of heavily armed mounted soldiers collected at the left side of the picture face a single lone opponent on the right; the loaded inequality is suggestive of an imminent rout.

War is presented here as theatre. The elaborately costumed figures are contained within the stage like arena, pushed for-ward to the front of the pictorial space. Beginning at the left edge, the raised lances create a staccato rhythm, rigid and unyielding against the dense mass of orange trees. A second grouping of smaller, more distant lances forms a sharper, quicker pulse. Progressing across the painting, the intervals decrease, as the tension rises. Blaring trumpets call, open mouthed, into the trailing coils of the banners overhead. With a slow menacing intent, the lances swing to the horizontal, culminating in the unstoppable momentum of a driving charge. Two figures are locked in combat at the right edge, their limbs closing a circle as they exchange blows.

The descending dark shape of the bushes contains and lends emphasis to the figures at the front of the picture. The bushes create a pronounced division between the near space and the distant, pale hillside. Beyond the line of thick foliage, cultivated fields stream away into the distance. As archers reload, two horsemen race for reinforcements. The diminished scale of the far figures lends spatial coherence to the painting, yet the space is discontinuous, separated into two distinct areas by the dark mass of trees.

A curve, turning through the braced body of Tolentino, extends though his extended staff, and elides with the shape cut into the field beyond. This unbroken arc diminishes the sep-

Harriet Piercy, *The Battle of San Romano,* after Paolo Uccello, c 1438–40. The momentum of the painting carries from left to right, building to a galloping charge.

aration of near and far spaces, unifying the front and back of the picture as shapes on the flat surface. A marked resemblance between the far tree and the decorated helmet underlines this connection.

The surface is constructed of clear shapes carved against each other, which serve to define volume and form while reinforcing the integrity of the flat rectangle. The lyrical rhythms of the horses, helmets and armour play against the severe angularity of the weapons. Bands of heavily embossed gold decoration lilt, from horse to horse, through the middle of the painting. The percussive, gleaming discs resonating in both shape and scale with the hanging fruit and the white flowers, which adorn the bushes. Tolentino's turban is richly patterned with shapes of red and gold. The vigorously drawn volume of the turban contradicts the apparent flatness of the pattern.

Broken lances lying across the ground form converging parallels, which allude to a vanishing point, commensurate with single point perspective. The effect is only partial, and while the fallen knight and various objects are painted with a forceful understanding of foreshortening, the painting is not bound by the confines of monocular perspectivalism. It may be tempting to ascribe this inconsistency to a naïve bungling on the part of Uccello, although drawings and studies by him demonstrate a deep understanding of the system. Any overt definition of spatial recession is repeatedly hinted at and simultaneously resisted, in a celebration of the dynamism of the linear design.

The grand heroic spectacle of war is set above a field strewn with fallen bodies and discarded armour. The stacked wooden lances, rolling over each other, create a treacherously unstable platform for the pomp and magnificence of the soldiers, threatening to topple horses and throw riders in swift deflation.

GUERNICA, PABLO PICASSO, 1937

On 25 May 1937, in the wake of turbulence and delay, the Exposition Internationale des Arts et Techniques dans la Vie Moderne opened in Paris. This World Fair, intended to promote the peaceful cooperation and coexistence between nations, became the stage for a swaggering confrontation between conflicting ideological states. The German pavilion designed by Albert Speer and the Russian pavilion, topped by the towering sculpture of muscular workers brandishing a hammer and sickle, by Vera Mukhina, faced each other in a hostile political standoff. Architecturally the pavilions were intended as expressions of power, the windowless stone forms, a deliberate invocation of might and permanence.

Spain, divided by open and bloody conflict, chose to use the World Fair as an opportunity to raise awareness of its domestic situation and elicit support. The elected Republican Government presented a modest pavilion that included works of art. Among these was the painting *Guernica* by Pablo Picasso. The scale and overtly political intention of the work is reminiscent of murals by Diego Rivera and Gabriel Orozco.

Undefended, Guernica was decimated by an airstrike led by German and Italian bombers, in support of the Nationalist cause. The attack signalled a new form of warfare. Saturation bombing followed by incendiary bombing made the destruction inescapable. The attack came on 26 April 1937, barely a month before the World Fair.

A Spaniard in exile, Picasso's painting of the inhuman atrocity was presented in Paris, to a world as yet to be desensitized to imagery of war and its attendant suffering. The monolithic painting is drained of all colour. It is an image of powerlessness and innocence caught in unimaginable horror. Helpless and deeply vulnerable, the women raise piercing cries to an unseen aggressor. The comfortable distance of mechanized destruction is violently deflated with the immediacy of their searingly human suffering. Their screams, mingling with the howls of animals, are rendered mute and silent by the relentless thundering of the bombs.

Movement is frozen in the sudden and harsh light exploding across the canvas. Broken and fragmented bodies are caught in sharp relief against the pervasive darkness. Serrated tongues of flame leap from freshly burned buildings. A partially dismembered soldier lies prone beneath the panicked hooves of a reeling horse. The shaft of a lance penetrates the body of the horse. The fallen soldier still clutches the hilt of a splintered sword. Watched closely by an anguished bull, a woman holds on to the unmoving body of her dead child, her head thrown back in visceral sorrow. A twentieth century cousin of the grieving woman in Poussin's *Massacre of the Innocents*, the collapsing forms of her body make her emotions explicit. A bird to the right of the bull, mirrors her shape.

The tangled mass of bodies rises to the centre of the painting. Fields of colour shift suddenly, punctured by black line and disrupt any sense of stability and wholeness. Above the head of the horse, a bare bulb spits shards of light downwards. The bulb, framed by a lacerating halo of light becomes a kind of unblinking all-seeing eye, disembodied and hovering mercilessly over the scene. This oppressive light throws out darkness. Immediately to the right, a figure sweeps through an open window, arm outstretched and holding a candle. There is a sense of the presence of a witness to the tragedy in the head of the figure. The raised candle offers some hope to the crushed and staggering figure below, and a small flower rises tentatively up through the wreckage, into the light shed by the candle.

The figures in the painting are taken from the characters populating Picasso's work. Here they are recast, propelled from a privately expressive function in his work, onto a world stage. They retain much of their formal inventiveness, now participating in a more fully universal expression of outrage. Exhibited in the same year as the 1937 Degenerate Art exhibition in Munich,

the painting offers a deliberate and politically engaged alternative to the art sanctioned by Hitler's totalitarian regime. The muted colour and bands of stippled marks consciously evoke the mode of reportage and anticipates the rising importance of propaganda in the theatre of war. The cinematic proportions of the painting – it is extremely close to a root five rectangle – reinforce the idea.

The painting is an urgent response to unfolding contemporary events. It is a forceful inversion of the idea of War as heroic. The dramatic tension and pervading atmosphere of despair were not misplaced as the slide into violent conflict spread across Europe.

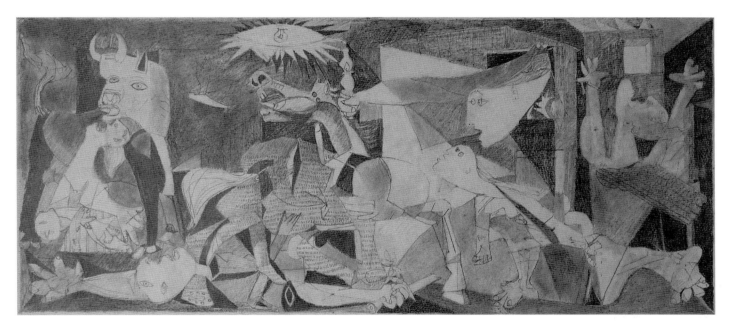

Christopher Dean, *Guernica,* after Pablo Picasso, 1937. Picasso's painting expresses something of the universal horror and suffering of war.

THE MIRROR

To paint one's self is a highly charged experience. In seeking to create an image that represents the self, tensions between appearance and self-perception throw the idea of the self as a construct into sharp relief. The process of painting a self-portrait unsettles the separation between an internal experience of being alive and the external appearance of the body. The mirror allows individuals to participate in the recognition of their own idiosyncratic form. The camera extends this possibility, without the inescapable inversion of a reflective surface. The emerging image of the self is defined in relation to an image of the other. In this sense, the formation of identity assumes a visual dimension. With this comes an increasing awareness of being seen. Aspects of identity are presented visually through the performance of dress, gesture and expression. The extraordinarily complex synthesis of ideas and experiences that, both consciously and unconsciously make up a person, provides a rich source for image making. Painting can be a site for the exploration and untangling of the constructed self.

PHILIP GUSTON, 1913–80

Guston was born in Montreal, Canada. His parents had escaped persecution in Odessa, Ukraine, settling in Montreal. They moved again to Los Angeles, and here Guston's father killed himself.

Emerging from this troubled history of exile and separation, Guston painted in what can be described as an Abstract style during the mature phase of his life. Critical debate surrounding

contemporary painting had hardened into deeply polarized conflicting positions, pitting Abstract painting against figurative. The opposition has certainly since shed most of the aggression and rancour surrounding this sharp divide. Guston himself, making increasingly refined and well-received abstract paintings, came to react against the idea of purity in painting. His rejection of abstract painting entailed a desire to reclaim a personal artistic agenda, freed from the externally imposed terms of the contemporary critical climate. The struggle to escape from the confines of entrenched ideological dogmatism was an urgent one. His statement 'I just want to tell stories' carries the full weight of the painter defining a self-determined objective. The sense of shedding what had come to be the encumbrance of a redundant so-called sophistication, is evident in his stated desire of: 'wanting to paint like a caveman'.

The statement was accompanied by an equally radical departure in form and handling. Guston's late paintings are strikingly 'impure'. Bound by a heavy enclosing line, he invented a strange iconography of signs, with which he began to populate the paintings. This vocabulary of forms is organized into deeply unconventional systems of narrative.

Handled unapologetically, the paint, in variations of red and white, evokes the raw vulnerability of exposed flesh. The paint resonates with a lived experience of flesh, rather than just the appearance of skin, as though painted from the inside of the body. Deliberately coarse, and deceptively simplified, the forms are swollen and pregnant with personal symbolism.

A cast of familiar objects recur in the late work, the discarded

LEFT: Susan Wilson, *Self-Portrait*. The basket, held in a tight embrace, becomes the focus of the radically framed image.

Jason Augustine Carr, *Foot for Philip*, after Philip Guston. The sculpture re-imagines, in three-dimensional form, one of the elements of Guston's alphabet of personal iconography.

the clock on the wall, pointing insistently to the time, and the partially unrolled blind. His other hand, ungloved and blood red, stabs at the white canvas perched on the easel. The vertical ends of the brushes rhyme visually with the stitching on the back of the glove and anticipate the dark vertical slits in the hood. The finger of the easel rises from behind the canvas, its black notches beating out the sharp staccato of the ticking clock on the pink studio wall.

Surrounded by the paraphernalia of the studio, the artist, now hidden, paints his image in profile, as seen by the viewer. Painting against a background of domestic political upheaval, Guston implicates himself in the multiple horrors of his family's persecution in Odessa, the activities of the Klu Klux Klan and the Holocaust, here presented in the mode of savage farce.

In the painting *Head*, 1975, the artist is uncovered once more, now perhaps lying in bed. Painted in thick luscious strokes of creamy crimson, a single swollen, unblinking eye dominates the unpeeled, raw flesh of the head. The gaze of the monstrous eye is relentless and searing. It looks outward surveying and witnessing from a still, mute head shorn of its mouth and nose. A creeping undercurrent of black paint threatens to swamp the image.

The same amorphic form gazes disbelievingly at the empty bottle fallen in a puddle of spilt wine on the table next to it, in the painting *Head and Bottle*, 1975. The disembodied form of the head is unstable and rolling. Set against a field of grey, the stark emptiness of this bleak no-mans land is heightened by the bare bulb swinging pendulously beside the head. The heavily serrated eye set deep in the bristling head finds no release, no darkness in the bottle.

The distended shapes of the head, the hanging bulb and the large unblinking eye are all reminiscent of the iconography of *Guernica*. Indeed the swollen hands and the saturated pinks of the forms would seem to have roots in the paintings of Picasso. Guston makes his engagement with the work of other painters explicit in the painting *Pantheon*. Elements often quoted directly from other painters, for example, the hand of an unseen god, lifted from Giotto, are remade in the personalized idiom of the late paintings.

The paintings embrace, rather than avoid, the cruelty and unintended ironies of living. Primarily autobiographical in nature, the late cycle of pictures engage with multiple narrative arcs, which describe an intersection between Guston's interior, emotional life and his environment. Scenes taken from the world of the studio mingle with moments of domesticity. The narratives are layered, so an inquiry into his own identity as an artist and an immigrant run alongside the rejection of a confining modernist paradigm. These trajectories are embedded within a considered political and social context.

detritus of living, described with a penetrating crudeness. Fragmented body parts erupt from the white ground, they multiply and distend, while claiming a mysterious autonomy, an independence that celebrates unembellished being. The piles of abandoned shoes, of mutilated limbs, of isolated fragments evoke the tragic imagery of the concentration camp.

Hooded Klansmen toting fat cigars perform their grisly business, their identity hidden from prying eyes. The Klansmen are evil and banal in equal measure. Their matter-of-fact presence places them at the centre of the everyday. The almost-endearing simplicity of their shape is disarming.

As symbols of the potential inhumanity latent in contemporary society, Guston reviles and empathizes with their mute and unquestioning forms, going as far as to present himself sheathed in a patched white hood, painting a self-portrait in *The Studio*, 1969. The painting is framed by two thick swathes of red curtain, a reference to Vermeer. Present are the hanging naked bulb, the gloved hand with raised fingers holding a cigarette,

Atul Vohora, *Philip's Studio*, after Philip Guston, 1969. Guston paints himself wearing a white hood. In the painting, with one hand he smokes a cigarette and with the other, he paints a self-portrait.

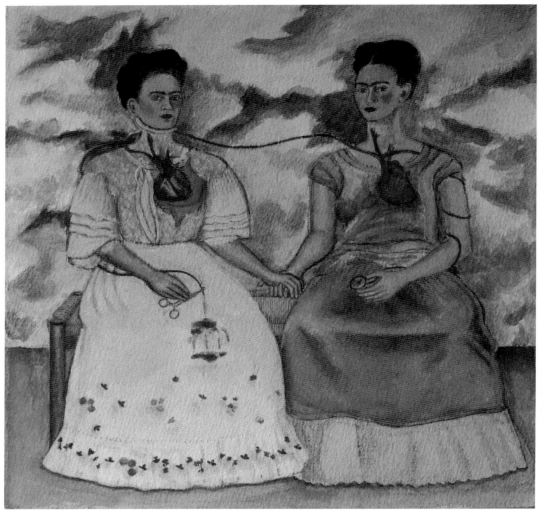

Jennifer Blake, *Two Fridas*, after Frida Kahlo, 1939. Separated although not divided, the painting explores aspects of a hybrid identity.

THE TWO FRIDAS, FRIDA KAHLO, 1939

The idiom of the bared heart, taken from votive iconography, is sheared of the connotations of the Sacred Heart. Here the visible hearts signify emotion restated in secular and biological terms. The exposed ventricles of the two, still beating hearts, are symbols of the biological truth of feeling. A slender artery linking the separate organs forces a mutual interdependence upon the otherwise seemingly whole figures. The totemic figurine clasped in the hand of the figure on the right feeds the hearts with blood. An artery coils its way upward around the arm and on, while a second slender filament sweeps symmetrically into the lap of the figure on the left. Surgical callipers, pinching the end are unable to prevent blood from seeping out. The cascade of crimson droplets, staining the purity of her white dress, echoes the crimson flowers embroidered in the fabric of the skirt.

The two identical figures, self-portraits, are seated together, hand in hand, sharing the same bench. While they exist simul-taneously within an unbroken continuous space, it becomes impossible to see both figures together. To meet the gaze of one is to be watched by her doppelgänger. The discrete identity of both figures is fatally compromised by their conjoined hearts. Neither are they able to be free of their attachment to the totem, which both nourishes and drains the lifeblood from their bodies.

The impassive stillness of the figures is set against the turbulence of the field behind them. The square format of the canvas invokes an idea of unity and wholeness, contrasted with the separation and underlying internal conflict present in the image. The dresses reflect Frida Kahlo's polarized genetic heritage and the attendant cultural and political contradictions in her life. As the child of a European immigrant and an indigenous Mexican, her allegiances diverge. While identifying very strongly with the new Mexico, and politically invested in the idea of popular revolution, she is unavoidably implicated in the dynamics of colonialism. Travelling in America, with her husband, the painter Diego Rivera, she found herself the guest of über capitalists, such as Rockefeller. Exiled and living in fear of

his life, Trotsky became her lover while in Mexico. These disparate positions are acknowledged in the painting, as distinct and yet embracing of each other, holding hands becomes a sign of reconciliation.

The dresses and masklike faces are projections of constructed identities. The pulled and piled hair, the undivided brow and long neck are co-opted as a shorthand for self. The dresses make visible the set of ideas and beliefs that define her two worlds. They too are an externalized set of forms that express internal and invisible states. The exposed hearts are an explicit statement of the desire to uncover, to reveal, to unmask and to make visible, what lies beneath.

The collapse of her marriage is the immediate autobiographical context for the imagery of the painting. The painting becomes in part the site for processing the emotional fallout of this cataclysmic event. The autobiographical dimension of the painting helps Kahlo locate her practice outside the framework of surrealism. Her paintings are not of dreams, but of her own reality. The painting deploys an ostensibly realist mode, to create a hyper real image of lived experience.

The self-portrait, *The Broken Column* painted in 1944, makes direct reference to autobiographic instances in her life and the resulting condition that came to define her everyday experience. The consequences of a car accident in her teenage years continued to haunt her through her life. Multiple operations to reconstruct her shattered bones left her in continuous pain. A handrail, which punctured her body, resulted in her inability to conceive. She paints herself as an isolated figure standing in a barren wasteland. Her body is cleaved in two, revealing a fractured and collapsing classical column, which takes the place of her spine in providing a platform for the head. The shattered stone is supported by a powerful harness, which binds the halves of her body together.

Her face remains unmoving, in spite of the tears flowing freely from her eyes. The joined brow, a mark of identity, now becomes a pair of wings. Pins puncture her skin and spill over the cloth covering her legs. The painting is an unequivocal description of personal suffering, in her own words: 'I am not sick, I am broken'.

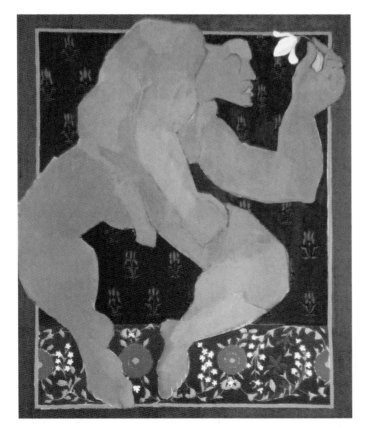

Atul Vohora, *Dancer I*.

Atul Vohora, *Dancer II*.

FURTHER READING

Adorno, Theodor W. *Aesthetic Theory* 1970
Albers, J. *Interactions of Colour* 1963
Albers, J. *Formulation Articulation* 2006
Alberti *On Painting* trans. 1972
Arnheim, R *Art and Visual Perception* 2004
Auping, M. Philip Guston *Retrospective* 2003
Baccheschi E. *El Greco: The Complete Paintings* 1980
Bachelard, G. *The Poetics of Space* 1958
Baker, C. *National Gallery Complete Illustrated Catalogue* 2002
Barthes, Roland *Camera Lucida* 1994
Basile, G. *Giotto: The Arena Chapel Frescoes* 1993
Bell, Clive *Art* 1913
Bellosi, L. *Duccio* 1999
Benoy, K. Behl *The Ajanta Caves* 1998
Berger, J. *About Looking* 2009
Berger, John *Ways of Seeing* 1980
Berger, John *The Shape of a Pocket* 2002
Berger, John *On Drawing* 2005
Bihalji-Merlin O. Grunewald: *The Isenheim Altarpiece* 1984
Blake, William *The Marriage of Heaven and Hell* 1994
Blake, William *Illustrations for Dante* 1953
Bonnetay, Y. *Alberto Giacometti* 2001
British Museum exhibition *Garden and Cosmos* 2009
Brown, C. *Rembrandt Complete Paintings* 1980
Chevreul, M.E. *Principles of Harmony and Contrast of Colours* 1854
Chomsky, N. *Reflections on Language* 1975
Clark, Kenneth *The Nude* 1993
Cole, Bruce *Giotto* 1993
Cole, Bruce *Piero della Francesca* 1991
Collingwood, R.G. *The Principles of Art* 1958
Correard A, Savigny J.B.H. *Narrative of a Voyage to Senegal in 1816* 1818
Corsini, D. *Paulo Uccello: The Battle of San Romano* 1998
Critchlow, Keith *Order in Space* 1969
Dalrymple, W. *Nine Lives* 2009
Delacriox, Eugene *Journal* 1961
Derbes, A. and Sandona, M. *The Usurer's Heart* 2008
Derbes, A. and Sandona, M. *Barren Metal and the Fruitful Womb*, The Art Bulletin 1998
Derbes, A. and Sandona, M. T*he Cambridge Companion to Giotto* 2004
Derrida, Jacques *The Truth in Painting* 1987
Doxiadis, E. *The Mysterious Fayum Portraits* 1995
Duffy, Carol Ann *Standing Female Nude* 2004
Duncan, Carol *Civilizing Rituals* 1995
Eco, Umberto *A Theory of Semniotics* 1979
Elderfield, John *Henri Matisse, A retrospective* 1992
Elderfield, *John De Kooning, A Retrospective* 2011
Flam, Jack *Matisse on Art* 1973
Foucault, M. *The Order of Things* 2002
Fry, R. *Giovanni Bellini* 1900
Fry, Roger *Vision and Design* 2010
Fuentes, Carlos *Frida Kahlo 1907-2007*, Instituto Nacional de Bellas Artes Mexico 2008
Gage, John *Colour and Culture* 1995
Gage, John *Colour in Art* 2006
Geary J. *I is an Other* 2011
Glyka, Matila *The Geometry of Art and Life* 1946
Gombrich, E. *Art and Illusion* 1972
Gowing, Lawrence *Matisse* 1979
Grant, M. *Art and Life in Pompeii and Herculaneum* 1979
Guggenheim *Spanish Painting; El Greco to Picasso* exhibition cat. 2006
Hambidge, Jay *The Elements of Dynamic Symmetry* 1967
Hebborn, E. *Drawn to Trouble* 1991
Honour, H. and Fleming, J. *A World History of Art* 2005
Hughes Ted *Tales from Ovid* 1997
Humfrey, P. *Titian: The Complete Paintings* 2007
Hung, Wu *The Double Screen: Medium and Representation in Chinese Painting* 1996
Hyman, Timothy *Sienese Painting* 2003
Tinterow, G. and Connisbee, P. *Portraits by Ingres*, The National Gallery London 1999
Itten, J. *Art of Colour* 1961
James, T.G.H. *Egyptian Painting and Drawing in the British Museum* 1985
Jay, M. *Downcast Eyes* 1994
Kaplan, Robert *The Nothing That Is* 1999
Kundera, M. and Borel, F. *Bacon: Portraits and Self Portraits* 1996
Lacan *Ecrits*, trans. Sheridan 1977
Langdon H. *Caravaggio* 2000
Langmuir, E. *National Gallery Companion Guide* 2007
Lanvin, Marilyn A. *Piero della Francesca: the Flagellation* 1990
Lanvin, Mary *Piero della Francesca's Baptism of Christ* 1981
Leiris, M. *Francis Bacon: Full Face and in Profile* 1983
Levinas, E. and Hand, S. *The Levinas Reader* 1989
Lightbown, R.A. *Piero della Francesca* 1992
Lord, James *Giacometti* 1986
Lyotard *La Phenomenologie*
Mack, G. *Gustave Courbet* 1970
Matisse *Notes of a Painter* 1908
Matisse *Drawings and Paper Cut-outs* 1969
McDonald, H. *Female Nude in Art* 2001
Mckee, A. *Wreck of the Medusa* 1975
Merleau Ponty, Maurice *Phenomenology of Perception* 2002
Merleau-Ponty, Maurice *Sense and Non-Sense: Cezanne's Doubt* 1964
Metz *Film Language* 1974
Meyer, R. *The Artist's Handbook of Materials and Techniques* 1991
Michell, George *Hindu Art and Architecture* 2000
Munsell and Henry, *A Colour Notation* 10th ed. 1947
Neade, Lynda *The Female Nude* 1992
Penrose, R. *Picasso: His Life and Work* 1981
Pfuhl, E. *Masterpieces of Greek Drawing and Painting* 1955
Plato *Timaeus* 2008
Proust *Essays, Rembrandt and Chardin* 1895–1905
Rewald, J. *Cezanne, a Biography* 1986
Ribeiro, A. *Ingres and Fashion* 1999
Rogers, Carl *On Becoming a Person* 1995
Sacks, Oliver *The Mind's Eye* 2011
Said, Edward *Orientalism* 2003
Satre, Jean Paul *Being and Nothingness* 1969
Schneider, P. *Matisse*, trans. Romer and Taylor 1984
Shastri, Ajay M. *Ajanta* 1980
Spink, W. *Ajanta's Chronology* 1981
Spink, W. *Ajanta; History and Development* 2009
Spurling, Hilary *The Unknown Matisse* 1998
Spurling, Hilary *Matisse the Master* 2005
Srivastava, A.K. *Mughal Painting* 2000
Starobinski, Jean *The Living Eye* 1989
Stokes, A. *Colour and Form* 1937
Stubblebine, James *Giotto* 1969
Sylvester, D. *Looking at Giacometti* 1967
Tate Catalogue *Oskar Kokoschka* 1986
Tuchman, M, and Dunow, E. *The Impact of Chaim Soutine* 2002
Uglow, J. *Hogarth* 2002
Van Gogh, Vincent *Collected Letters* 1958
Verdi, R. *Cezanne and Poussin* 1990
Vernon, M.D. *The Psychology of Perception* 1971
Walters, Margaret *The Male Nude* 1978
Weight, Carol *Painters on Painting*, vol.3 1969
Wheelock, A. *Vermeer, Complete Works* 1998
White, John *The Birth and Rebirth of Pictorial Space* 1987
Wittkower, Rudolf and Carter, B.A.R. T*he Flagellation, Piero della Francesca* 1953
Woolf, Virginia *A Room of One's Own* 2004

DETAILS OF THE PAINTINGS IN THIS BOOK

Frontispiece: Sargy Mann, *Infinity Pool II* (188 x 239, oil on canvas)

Page 9: Atul Vohora, *Nu Jambe Droite Levée*, after Bonnard, 1924 (18.5 x 19.5, opaque watercolour on paper)

Page 6: Atul Vohora, *Tyger* (110 x 152, oil on canvas)

Page 8: Gregory Ward, *Vertical Curve* (90 x 45, oil on canvas)

Page 10: Gregory Ward, *Mary, Red against the Black* (70 x 120, oil on canvas)

Page 11: Patrick George, *Anne Crosby* (152.5 x 101.7, oil on canvas)

Page 14: Michael Dowling, *Hunters in the Snow*, after Breughel (100 x 138, oil on canvas)

Page 15: Harriet Piercy, *Portrait of Margaretha de Geer*, after Rembrandt (80 x 59, pencil on paper)

Page 19: Gabriella Marchini, *Portrait of The Doge, Lorenzo Loredan*, after Bellini (60 x 43.5, oil on canvas)

Page 21: Atul Vohora, *St Michael*, after Piero della Francesca (23 x 10.3, opaque water colour on paper)

Page 30: Atul Vohora, *The Golden Calf*, after Poussin (40.8 x 56.4, oil board)

Page 32: Sarah Richardson, *The Baptism of Christ*, after Piero della Francesca (41 x 29, pencil on paper)

Page 34: Harriet Piercy, *Minerva Protects Pax from Mars*, after Rubens (41.5 x 59, charcoal on paper)

Pages 35 and 60: Atul Vohora, *The Pipe*, after *Maharajah Kirpal Pal of Basholi Smoking* (24.2 x 32.5, oil on board)

Page 35: Atul Vohora, *Genet*, after Alberto Giacometti, 1954–55 (26.5 x 20, pencil on paper)

Page 36: Atul Vohora, *Blue Nude IV*, after Matisse (23 x 15, opaque watercolour, pencil, charcoal)

Page 38: Atul Vohora, *Chauvet Lions* (10 x 11.5, opaque watercolour, pencil, charcoal)

Page 39: David Shutt, *Pan and the Moon* (91.5 x 91.5, oil on canvas)

Page 39: Elizabeth Shields, *Crucifixion*, after Diego Velasquez (59 x 42, pencil on paper)

Page 40: Atul Vohora, *Head*, after Fayum, c.100BCE (23.5 x 15) opaque watercolour on paper

Page 40: David Caldwell, detail from *Sebastian de Morra*, after Velasquez (17 x 12, oil on canvas)

Page 40: Patrick George, *Darla Jane Gilroy* (64.5 x 52.7, oil on canvas)

Page 41: Atul Vohora, *Isis*, after the tomb of Seti I, 1360BCE, *Valley of the Kings* (13.5 x 24.5, opaque watercolour on paper)

Page 42: Atul Vohora, *Egyptian Dancers*, after the Tomb of Nebamun, c.1350BCE (23 x 18, opaque watercolour on paper)

Page 43: Atul Vohora, *Sprinters*, after Euphiletos (17 x 30, pencil on paper)

Page 43: Coll McDonnell, *Drawing of Kordax Dancers*, after fifth century BCE vase (50 x 59, charcoal on paper)

Page 44: Coll McDonnell, *Drawing of Hermes and Satyr*, from an Amphora after the Berlin Painter (36 x 32, charcoal on paper)

Page 45: Coll McDonnell, *Drawing of Achilles*, after the Achilles Painter (95 x 43, charcoal on paper)

Page 46: Atul Vohora, *Maharajah Bakhat Singh*, Nagaur, c.1740, National Gallery of Canada (22 x 15, opaque watercolour on paper)

Page 47: Atul Vohora, *Dancers*, after Matisse (20 x 31, opaque watercolour on paper)

Page 48: Atul Vohora, *Arcadia* (25.5 x 22, pencil on paper)

Page 49: Atul Vohora, *Pax*, after Lorenzetti (42.7 x 31.5, oil on canvas on board)

Page 50: Atul Vohora, *Madame Moitessier*, after Ingres (24 x 18, pencil on paper)

Page 51: Atul Vohora, *Young Woman with a Water Pitcher*, after Vermeer (23.5 x 20, pencil on paper)

Page 52: Hero Johnson, *The Lacemaker*, after Vermeer (25 x 20, oil on canvas)

Page 53: Nichola Collins, *Minerva Protects Pax from Mars* (Peace and War), after Rubens (68 x 100, oil on canvas)

Page 54: Daniel Shadbolt, *Self Portrait*, after Cezanne, 1880-81 (34 x 27, oil on canvas)

Page 55: Atul Vohora, *Grande Baigneuses* after Cezanne, c.1894–95 (19 x 29, opaque watercolour on paper)

Page 56: Atul Vohora, *Ambroise Vollard*, after Picasso (28 x 20, pencil on paper)

Page 57: Atul Vohora, *The Absolute and the Cosmos*, after Bulaki, 1823 (30 x 20, opaque watercolour on paper)

Page 58: Atul Vohora, *The Game of Dice; the Disrobing of Draupadi*, attributed to Nain sukh, c.1765 (24 x 32, oil on board)

Page 58: Atul Vohora, *Skeleton Blue* (150 x 90, oil on canvas)

Page 59: Atul Vohora, *Massacre of the Innocents*, after Duccio (21 x 21, pencil on paper)

Page 60: Atul Vohora, *The Denial of St Peter*, after Duccio (29.5 x 18, pencil on paper)

Page 61: Atul Vohora, *The Temple, the Expulsion of Joachim*, after Giotto (20 x 23, pencil on paper)

Page 61: Coll McDonnell, drawing from Duccio's *The Annunciation* (30.5 x 32, pencil on paper)

Page 62: Atul Vohora, *Three Figures*, after Piero della Francesca (21 x 20, pencil on paper)

Page 63: Atul Vohora, *Diego*, after Giacometti (21 x 16.5, pencil on paper)

Page 65: Atul Vohora, *Portrait of George Dyer Staring at Blind Cord*, after Francis Bacon

(22.5 x 17, opaque watercolour on paper)

Page 66: Atul Vohora, *La Grande Odalisque*, after Ingres (18 x 31.5, pencil on paper)

Page 67: Christopher Dean, *Sleeping Women*, after Courbet (27.3 x 40.2, pencil on paper)

Page 68: Atul Vohora, *Pink Nude*, after Matisse (17.5 x 25, ppaque watercolour, pencil, charcoal)

Page 70: Atul Vohora, *Blue Tie* (80 x 80, oil on canvas)

Page 74: Atul Vohora, *Chuck's Eye*, from Self Portrait, 2007 by Chuck Close (17.5 x 17, opaque watercolour, pencil, charcoal)

Page 76: Georgina Read, *Drawing of Crucifixion*, after Grunewald (54 x 100, oil on canvas)

Page 78: Georgina Read, *Drawing of Resurrection*, after Grunewald (60 x 36, mixed media)

Page 79: Atul Vohora: *Crucifixion*, after Max Beckman (18 x14. opaque watercolour, pencil, charcoal)

Page 80: Alex Cree, *The Flaying of Marsyas*, after Titian (Tiziano Vecelli), 1575–76 (76 x 76, oil on canvas)

Page 81: Georgina Read, *Drawing of Laocoon*, after El Greco (55 x 140, charcoal on paper)

Page 82: Georgina Read, *Drawing of Vision of Saint John*, after El Greco (90 x 55, charcoal on paper)

Page 83: Gabriella Marchini, *Joseph Roulin*, after Van Gogh, Barnes Collection (50.7 x 40.5, oil on canvas)

Page 84: Gabriella Marchini, *Joseph Roulin*, after Van Gogh, Kroller Muller (50.7 x 40.5, oil on canvas)

Page 84: Gabriella Marchini, *Joseph Roulin*, after Van Gogh, MoMA (50.7 x 40.5, oil on canvas)

Page 85: Atul Vohora, *Portrait of a Man, Emile Lejeune*, after Soutine (15.5 x 12, opaque watercolour, pencil, charcoal)

Page 86: Atul Vohora, *Nancy*, after Oscar Kokoschka (20 x 13, opaque watercolour pencil, charcoal)

Page 88: Atul Vohora, *Woman*, after De Kooning (23 x 17.5, opaque watercolour on paper)

Page 89: Karl-Peter Penke, *The Birth of Venus, The Death of Venus* (20 x 29, mixed media)

Page 90: Alex Cree, *Grawp and the Centaurs* (146 x 170, oil on canvas)

Page 92: Michael Dowling, *Bin City*, Page 1 (42 x 28, brush, ink, pencil)

Page 93: Kate Lyddon, *Suddenly I'm Flying* (120 x 160, oil on canvas)

Page 94: Gregory Ward, *Love Alters Not* 152 x 102, oil on canvas)

Page 96: Atul Vohora, *Enrico Kneeling*, after Giotto (20 x 19, pencil on paper)

Page 97: Atul Vohora, *Left Niche*, after Giotto (15 x 15.5, opaque watercolour on paper)

Page 97: Atul Vohora, *Joachim and the Priest* (22 x 25, pencil on paper)

Page 98: Atul Vohora, *The Shepherds*, after Giotto (20 x 17, pencil on paper)

Page 99: Atul Vohora, *Satan, the Last Judgement*, after Giotto (20 x 24, opaque watercolour on paper)

Page 100: Alex Cree, *Charity*, after Giotto (35 x 20, pencil on paper)

Page 101: Atul Vohora, *Joachim and Anna* (19 x 27, pencil on paper)

Page 102: Atul Vohora, *Judas Kisses Christ* (17 x 20, pencil on paper)

Page 102: David Caldwell, *The Lamentation*, after Giotto (71 x 76, oil on canvas)

Page 105: Alex Cree, *Injustice*, after Giotto (32 x 20, pencil on paper)

Page 106: Alex Cree, *Justice*, after Giotto (33 x 19, pencil on paper)

Page 107: Alex Cree, *Folly*, after Giotto (27 x15, pencil on paper)

Page 108: Coll McDonnell, drawing from William Blake's *Hell in Dante's Divine Comedy* (66 x 48, charcoal on paper)

Page 110: Atul Vohora, *Bodhisattva Padmapani, Ajanta* (21.5 x 15.5, opaque watercolour on paper)

Page 112: J.H. Woodward, *Diana and Actaeon*, after Titian (40 x 38, pencil on paper)

Page 113: Jennifer Blake, *The Death of Actaeon*, after Titian (Tiziano Vecelli) (81 x 91, oil on canvas)

Page 114: Atul Vohora, *The Rake at the Rose Tavern*, after Hogarth (17 x16, pencil on paper)

Page 115: Atul Vohora, *The Rake in Bedlam*, after Hogarth (12 x 18, pencil on paper)

Page 117: Atul Vohora, *Angel and Demon*, after William Blake (20 x28, opaque water colour on paper)

Page 118: Atul Vohora, *Seated Figure with Pyramid*, after William Blake (13 x 17, opaque watercolour on paper)

Page 119: Atul Vohora, *Nebuchadnezzar*, after William Blake (15.5 x 19, opaque water colour on paper)

Page 120: Atul Vohora, *The Raft*, after Géricault (19 x 27, pencil on paper)

Page 122: Gregory Ward, *These Days Things are Awful* (56 x 52, oil on canvas)

Page 124: Martin Burrough, *The Blessed Agostino I*, after Simone Martini (60 x 60, oil on canvas)

Page 125: Martin Burrough, *The Blessed Agostino II*, after Simone Martini (60 x 60, oil on canvas)

Page 126: Atul Vohora, *The Entombment*, after Simone Martini (29.5 x 21, pencil on paper)

Page 127: Coll McDonnell, drawing after Masaccio's *Expulsion from the Garden of Eden* (61.5 x 30, charcoal on paper)

Page 128: Atul Vohora, *The Taking of Christ*, after Caravaggio, 1610, (18.5 x 27, pencil on paper)

Page 129: Harriet Piercy, *The Battle of San Romano*, after Paolo Uccello (34 x 59, opaque watercolour on paper)

Page 131: Christopher Dean, *Guernica*, after Picasso (32.3 x 72, pencil on paper)

Page 132: Susan Wilson, *Self-Portrait*, (127 x 76.3, oil on canvas)

Page 135: Atul Vohora, *Philip's Studio*, after Philip Guston, 1969 (20.5 x 18.5, opaque watercolour on paper)

Page 136: Jennifer Blake, *Two Fridas*, after Frida Kahlo (28 x 30, mixed media)

Page 137: Atul Vohora, *Dancer I* (83 x 65, oil on canvas)

Page 137: Atul Vohora, *Dancer II* (76 x61, oil on canvas)

INDEX